The

creative

way

to

paint

David Friend

The creative way to paint

Watson-Guptill Publications / *New York*
Pitman Publishing / *London*

Paperback edition 1986

Copyright © 1966 by David Friend

First published 1966 in the United States and Canada
by Watson-Guptill Publications,
a division of Billboard Publications, Inc.,
1515 Broadway, New York, NY 10036

Distributed in the United Kingdom by Phaidon Press Ltd.,
Littlegate House, St. Ebbe's St., Oxford

Library of Congress Catalog Number: 66-13001
ISBN 0-8230-1126-7

Manufactured in the U.S.A.

1 2 3 4 5 6 7 8 9/90 89 88 87 86

Hundreds of students, who, by their encouragement, made this work possible, deserve to be mentioned individually. Obviously, this is impossible, but I cannot forget the dialectic experiences in various classes, first at the Montalvo Foundation in California, then at Torremolinos, Spain, and recently in New York City.

In discussing creative art concepts, students challenged me to be clear; to speak and illustrate in terms they could accept. In turn, I challenged them to summarize what they had forced me to explain. In this respect, I'm particularly grateful to David Gram Starring, Harry Rhein, and Reverend Ernest Werner for their fine summaries.

Some students performed other services for which I'm much indebted. I thank both Herbert Brean for reading the first draft and offering valuable suggestions, and Jill Morris for editing several chapters. I'm especially grateful to Betty Walker for her patience and perseverance in rendering the many schematic diagrams. I also wish to express a deep sense of obligation to the tireless Werner Steinthal, who photographed all of the various sequences, as I created them, in black and white, as well as in color.

Among the non-students, I thank Paul Juley for taking a few unusually difficult photographs which required special equipment. I extend special thanks to Dr. Ralph L. Wickiser for taking time out of his busy life and heavy responsibilities to write the preface. It's a great pleasure to acknowledge my admiration and appreciation of editor, Don Holden, for his vision, invaluable advice, and for his labor in clarifying and enriching the final manuscript. And my deepest gratitude goes to Florence Shepard Friend who is, as always, the chief sustainer of my efforts.

DAVID FRIEND
New York City

Preface

David Friend's *The Creative Way to Paint* is a book that has long been needed by the serious beginner who wants to explore the secrets of creativity. It is a book filled with the author's personality, his enthusiasm for art and people, and a love for learning. It is not the usual how-to-do-it book that promises much and leaves the reader frustrated and wondering what art is all about.

Primarily for the adult art student, this is a process of aesthetic acclimation. The educational theory begins by sensitizing the reader to aesthetic relationships and then proceeds to the creative tasks at hand, and to the disciplines they demand.

Out of David Friend's long experience guiding beginners into the mysteries of art, he presents those ideas, problems, attitudes, and learning situations that must be confronted by anyone who wants to learn through doing.

The book is especially helpful to beginners because of the author's insights into people and how they learn about art. As a result, the book will be useful to artists at any stage of their development because it deals with those aspects of quality that are essential to all good painting. This is the creative process couched in terms for the beginner.

David Friend's educational philosophy is modern. His methodology is original and forward looking. And, since the proof of any method is the results produced, this book presents visually the success of his methodology.

Over the years the results of his teaching have shown in the high quality of his students' work, the love of art he engenders in the student, and the high standards his students achieve in a short time. This is due to David Friend's own creative attitude and the important sequence of the program. Teaching, to him, is an art, and he explores the student's personality and attitudes to channel them in creative ways. His love for teaching has led him to invent new ways of learning and to combine old and new learning procedures in a way that makes it possible for beginners to grasp the insights of mature artists.

This is, however, not instant art. This book can only, and should only, open the doors to the challenge of art. As David Friend says, "Everybody, at no matter what level, has in art a challenge for life."

The book is beautifully illustrated, and its format and presentation are typical of the concern and deep desire to share the understanding of the art process with other people that David Friend shows in his teaching.

RALPH L. WICKISER, *Director*
Graduate Programs in Art and Design
Pratt Institute, Brooklyn, New York

Contents

Illustrations

14

Color Illustrations

Introduction

ALL OVER OUR LAND, millions of people are painting away. Each year sees more men and women taking up the after-hours brush.

Why are they painting? Many of them are searching for something that will enrich the spirit. Many are seeking a creative release from tension. Others wish to find out whether they have any artistic talent. Still others want to understand what art is all about.

Most of them are dedicated amateurs; they don't really hope to become professionals. They look upon art as a challenging, absorbing part-time interest. At the beginning, they're usually caught up with the emotion of learning to paint. But the time comes when ambitious amateurs become dissatisfied with their paintings. Suddenly they realize that progress has stopped. They can go no further. With a sinking heart, they discover that they've merely been struggling for technique and manual dexterity.

Perhaps for the first time, they look seriously at the long list of art courses in the school catalog. A staggering program is still ahead of them: basic drawing, advanced drawing, basic figure drawing, advanced figure drawing, the human figure in action, pencil sketching, the art of sketching, drawing and sketching in different media, sketching and painting out-of-doors, painting in different media, beginning oil painting, still life painting, portrait painting, basic watercolor, advanced watercolor, art and anatomy, composition and design, understanding and enjoying art, tendencies in contemporary art.

With the limited time at their command, most amateurs are tempted to give up all hope. This broad range of academic skills, required to become competent in drawing and painting, appears impossible to attain.

If this applies to you, don't be disheartened. *You can solve your problems in an entirely new way.* If you've come to believe that lack of talent is to blame, cheer up. You do have talent—and so does everyone else. Naturally, the degree of talent varies with the individual. But you don't need to be born with special talent to paint well. According to the experts, we all have more creative ability than we can ever use. Most of us realize only a tiny fraction of our hidden talent.

What makes a good painting?

First, let's analyze your painting problems in more detail; then you'll understand what the new way holds for you. From a professional viewpoint, over ninety of every hundred amateur paintings fail, in some respect, to qualify as good paintings. Individual passages may be handled with skill, yet a painting may lack unity as a rhythmic whole. It may be labored, re-

worked to death, tight instead of free. It may lack feeling. It may be hackneyed and unimaginative; subject matter may be handled in a trite or monotonous way. Or it may have muddy or commonplace colors; colors may not be related harmoniously to neighboring colors and to the whole.

These problems have nothing to do with your choice of subject matter, with the technique you use, or with whether you paint in a realistic or abstract manner. Actually, a painting is either good or bad, depending upon whether or not it contains *all* of the positive requirements of art.

What *are* the positive requirements? They're the very qualities that most creative persons yearn for in a painting.

What is a good painting? Just this: one that is personal and fresh, alive with feeling. Not static, not copied, but original, bold in imagination, sensitive in color, sound in organization, and integrated throughout. One unified whole. In other words, it is the opposite of the description of a bad painting which I gave a moment ago. A painting is bad when it omits even *one* positive requirement. Like a sum in arithmetic, it fails unless it is 100 percent right.

Is it possible for an amateur to accomplish these things? It's not only possible, but absolutely essential. The professional artist may dabble with these problems during his early training, but he usually doesn't face them seriously until after he has completed his technical training. It's not unusual for him to spend years of trial and error to find out what creativity means, and how to uncover his artistic talent. In this book for students and serious amateurs, these vital elements are woven into the fabric of a total program and applied right from the beginning. It's never too early to plunge into the creative art process.

The frustrations of amateur painters

Most amateurs concentrate exclusively on courses which help them to develop skill in drawing and painting. This sounds logical enough, but how long will it take the beginner to become really competent? It will take ages!

Time, then, is the main reason why amateurs rarely get anywhere taking the traditional approach to art. All those courses—listed a moment ago—may be logical for the beginning *professional*, who is prepared to spend thirty hours a week, for two or three years, to learn the basic mechanics of his craft. But the *amateur*, usually involved in many activities, has only about six hours available each week. Therefore, it would take him five times as long—or *ten to fifteen years part-time*—to arrive at the same point of competence which

the professional reaches in two or three years. Is it reasonable to expect this of the amateur? Of course not! Yet, unless he spends a good deal of time completing *some* sort of training, his paintings will always reveal ineptness.

But this, as I've hinted before, isn't his only problem. When, for instance, will he begin to express his true inner feelings in his paintings? When will he start to concentrate on the whole painting instead of just trying to improve innumerable parts? When will he develop sensitive color relationships?

In other words, when will the amateur get off the merry-go-round of being a perpetual beginner? When will he stop the exercises and begin to paint seriously? For unless he learns to produce paintings of unity and feeling—paintings that have individuality of vision and the essential attributes of real art—he'll be doomed to miss the true pleasure of painting.

Learn by creating

The blame for the millions of poor pictures around the country—and untold numbers of discontented amateur artists—belongs not merely with amateurs themselves, but in great part with the piecemeal type of instruction available to them. The great variety of courses offered to amateurs are required by the beginning *professional* because he must be well-grounded in a broad range of skills. But what may be good for the beginning professional isn't necessarily good for the beginning *amateur*.

To correct this discouraging situation, the new method of study detailed in this book reverses the traditional procedure. You don't begin with the task of imitating or copying directly from a still life. Instead, you start *creating* from the very first day. Creation *precedes* skill. Skill is a natural result of the creative spirit. Creative spirit is *not* a natural result of skill, as you may have been led to believe.

As you read this book, you *will* learn to draw in charcoal and to paint in casein, acrylics, or oil. But these skills won't be taught separately. They'll be unified with other creative activities. This means that you'll devote less time to the skills and more to the fundamentals of creativity—to developing imagination and judgment—with drawing and painting as part of a total program. Then, once the habit of creativity is firmly established, you're free to develop superior skill in any technical field. You may choose at random any course offered to the professional; but until that time, you're not ready. The habit of creativity must come first.

No matter how crude the start, the craftsmanship you build on a sound foundation of creativity will ulti-

mately enable you to create paintings that are acceptable by professional standards.

The program of this book

Do follow the creative procedures exactly as outlined. For this book represents a *program*—tested on over a thousand students—to unlock the imagination. By the time you finish this book, you'll have produced one, perhaps two, paintings that merit professional approval. And if you work at this program seriously, you may even build upon this foundation to win recognition in professional shows.

This last statement may sound incredible to you; but it's definitely possible. Here's the key. Paintings that merit professional approval are all *integrated* paintings.

The aim of this book is to help ambitious amateurs —even those who've never painted before—to learn by *wholes*. The painting as a whole—an interplay of lines, shapes, colors, textures, dark and light—always takes precedence over the subject matter.

In the other way—the academic way—you learn to draw and paint a vase; then, if the vase holds flowers, you concentrate on improving each flower, all at the expense of the whole.

Reading this book, you'll integrate many actions at the same time, just as you do when you learn to drive a car. You'll discover that there is a sequence to creating. The sequence suggested in this book follows the creative art process of the professional in action: how he *sees*, how he *thinks*, how he *works*.

You'll learn first to release your imagination and stir up your memory. In this way, you're assured of attaining a personal quality in your work. You'll start right off to express *yourself*. Four different methods of freeing the imagination and discovering yourself are demonstrated. Try them all to find the one you like best. To your surprise, you'll find that they're not exercises. For you should and *can* create right from the start.

Second, you'll learn how to look at paintings the way the professional does. You'll study masterworks to become aware of the underlying structure, and particularly the organization of the painting as a unified whole. In this way, you'll begin to find answers to the question, "What makes a painting a work of art?" You'll discover the visual essentials which are "musts" in any good painting.

Third, you'll learn what creativity means, how the creative art process unfolds, and how to focus your own creativity. This helps you both personally and in your art. You'll free the most vital part of you—your unique self—within the tried and acknowledged framework of

art. You'll learn to work by *intuition*, thus solving many problems on the unconscious level. For example, when the structural principles of a painting are grasped visually, your unconscious takes over; without apparent effort, your unconscious adapts what you've learned and incorporates this in your work.

Illustrations of the wrong way and the right way are given. This is very important. As you develop facility in analyzing masterworks, you'll be able to evaluate your own work. You'll learn, by progressive stages, how to keep improving your own work until it reaches completion.

Up to this point, only charcoal will be used. By excluding complex subjects such as color, you'll isolate and solve basic creative problems. Thus a firm foundation is laid.

You'll then learn how to work for personalized color. You'll also learn the steps in unifying color relationships. Different procedures and techniques are outlined in detail, demonstrated, and illustrated in color. Then you'll learn how to use texture and line effectively.

As you move further along in the book, you'll see that the chapters are graded to help you understand how to cope with progressively more difficult and baffling problems. The rationale behind various forms of art—historic and contemporary—will be given to help clear up confusions. As each chapter unfolds, you'll find the advice of the masters to help you meet the experiences of creativity.

The challenge of a new way of learning

There will naturally be periods of elation and frustration, since the personal element is an integral part of this process. The way to make rapid progress is to accept the challenge of change. Working in a manner that is just the *opposite* of the method tried by most amateurs—the long, piecemeal, traditional method—involves adjustment. Face it squarely and make an adventure of it. For you'll have to outwit your old habits and reach deeply within you to discover the real hidden artist. You can be assured of one thing: the excitement of self-discovery is a thrill second to none.

A word of caution. While the creative pump is being primed, *exclude judgment* to give the pump a chance to work properly. In spite of this, you may not be able to resist evaluating first efforts prematurely. But try not to be impatient and disappointed if you don't produce a "finished" painting immediately. Most important to the success of this creative program is your willingness to cooperate and let yourself go.

The aims of this method of instruction are much broader than merely learning to draw and paint. If, at

first glance, the program seems formidable, remember that you *already* have within you all the ingredients to master it. Your unconscious, with its wealth of rich experiences accumulated since childhood, is the raw material of art. Also remember that you have a unique personality, different from any other personality in the world. Your own intuition, with its creative impulse and sense of order, will lead you to express this uniqueness. In the process, you'll learn to capture the magic of art upon canvas.

Art is indeed an adventure, a process of search and discovery. Are you ready to begin?

1

Improvise in line

THE BIG QUESTION in everybody's mind is, "How do I begin? How do I go about creating?"

Even as you ask the question, you may tighten up. Insecurity may grip you. Here are some of the doubts and fears expressed by beginners. "I've no imagination." "I've no confidence in myself." "I can't draw." "I've no talent." "Will I fail? I dread making a fool of myself."

If you think I'm going to give you a pep talk, you're mistaken. For one thing, it would wear off. Second, a book can't pinpoint when you, as an individual, require renewal.

But the personal problem exists. That's why I feel that this book will be more meaningful to the adult who is alert and persistent. For example, such a person usually recognizes that he's accumulated mental barnacles since childhood. These barnacles are hindrances. These negative attitudes are usually deeply rooted. They require persistence to overcome them.

The interesting point is this: when your mental attitude is right, the procedures in this book work like magic. On the other hand, when your mental attitude is off, you'll have trouble.

Let me illustrate this with one short story. One of my students was having trouble applying the instruction. Each week, when she brought in her homework for criticism, it wasn't right. This went on for three consecutive weeks. On the fourth week, her homework showed a dramatic improvement. I asked her what had happened at home that week. She replied, "I had a good talk with myself. I discovered that I'd inwardly been fighting the instruction instead of following it."

What's the answer, then? *You*, and only *you*, can break old habits. It requires resolution and a readiness to stand off objectively, and act positively whenever required.

Now we come to your imagination. In a few moments, we're going to get started to deal with it in a practical way. When you say that you've no imagination, I can't agree with you. But, if you say that your imagination isn't functioning at the moment, I can understand. Living in a highly sophisticated world may have dulled your vision. The chances are that you no longer see the world in a fresh, vital way. The spontaneous play of imagination, the simplicity of feeling and perception you had as a child, were *unconscious* acts.

Today, the routine of the adult is involved mainly in *conscious acts*: adjusting to daily living and to meeting the problems inherent in a competitive society. These are mostly acts of the intellect and will. They're far removed from the richness of artistic experience which you, no doubt, desire.

You may feel an awakening, a discontent, an increasing emotional tension seeking release. Yet you may not trust this inner feeling completely. It may not seem to conform to the conventional reasoning, thinking, and judging you're used to in daily life. So your habits plant seeds of doubt and fear. Once again, I say, cast out doubt and fear. Prevent them from interfering with your complete involvement in creative expression.

The first job, here, is to help you open up areas of feeling and visual experience that beg to be released. Improvising in line is one way to release emotional tension and capture visual images.

The masters' way of releasing the imagination

The masters—old and modern—recognized the need, at times, to turn aside from concentrating directly and consciously on three-dimensional subject matter. They did this to allow the unconscious to express itself.

Leonardo da Vinci advised his students to look at rocks and clouds, where you can see landscapes in great variety, figures in action, and an infinite variety of things.

In his book, *The Mind and Work of Paul Klee,* Werner Haftmann reports that Piero di Cosimo saw

FIGURE 1 *Leonardo da Vinci advised his students to look at rocks and clouds, in which you can see landscapes, figures in action, and an infinite variety of things. Here's an example of prepared lines—a substitute for lines made by cracked rocks or clouds.*

FIGURE 2 *Landscape. An example of what can be done by looking at the prepared lines in Fig. 1 right side up.*

FIGURE 3 *Seascape. An example of what can be done by looking at the prepared lines in Fig. 1 upside down.*

FIGURE 4 *Head. An example of what can be done by turning the prepared lines in Fig. 1 to the right.*

FIGURE 5 *Still life. An example of what can be done by turning the prepared lines in Fig. 1 to the left.*

1

1

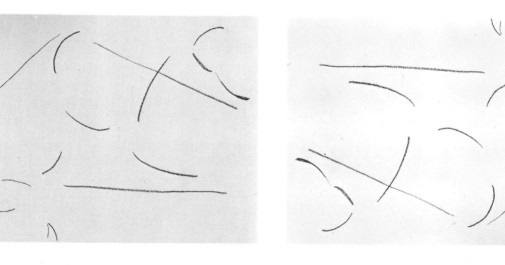

2

3

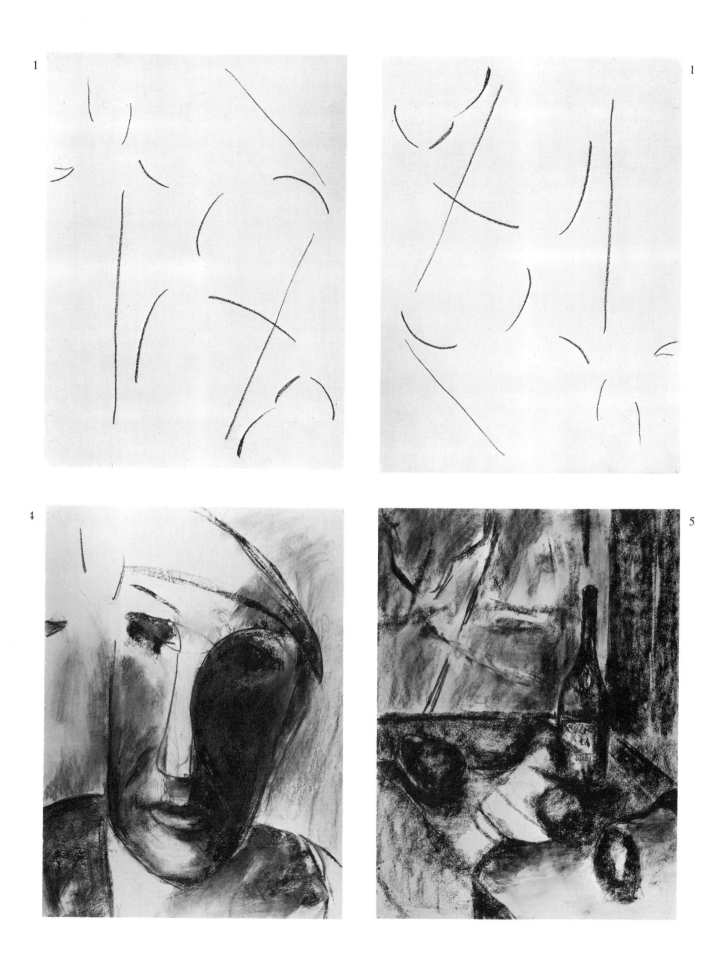

wonderful pictures in the drinkstains on the walls of Florentine taverns. Sung Ti, a Chinese painter of the eleventh century, maintained that landscapes could be discovered in the damp-stains on the walls of bamboo huts.

"The world we see is not the realm in which pictures are born," wrote Haftmann. "The late Paul Klee was able to recapture something childlike and to reach back in the primitive sources of feeling and expression. As a child Klee would stare for hours at marbletop tables in the restaurant owned by an uncle. The elaborate veining of the marble induced dream-images. At such times, the aesthetic sensibility is unusually alert, though we don't know why. If we are disinterested—'have no aim'—are receptive, a picture will suddenly appear before our eyes as if by magic."

Instead of looking at cloud formations, cracks or stains on walls, or marbletop tables, which may be inconvenient to find, this book offers you four substitute devices to release your imagination. One of these methods is demonstrated in this chapter; the others appear in the three following chapters.

Evoke an image from prepared lines

Let's start first with a transitional step. This exercise has been designed especially for those who fear that they lack imagination.

You'll need to buy the following supplies for your

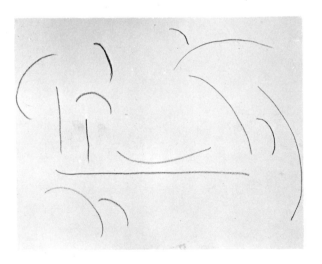

FIGURE 6 *Another example of prepared lines. Transfer (and enlarge) them to an 18 x 24 sketch pad. Don't be concerned if the enlargement isn't exact. First, see what kind of a picture each position suggests to you. Using a compressed charcoal stick, work from the position which interests you most. Remove lines or add lines of your own to evoke the image you have in mind.*

first assignment, and for all the other projects in the next three chapters.

18 x 24 sketch pad (a grade of white paper slightly better than newsprint)
12 pieces of compressed charcoal sticks #1 (Koh-i-noor is excellent)
gum eraser
small chamois or soft rag
Masonite board, 18 x 24
4 clips (to fasten paper to board, available at stationery store)

With these materials, you can now begin the first assignment.

Fig. 1 is an example of prepared lines—a substitute for lines made by cracks or stains—and what can be done by looking at it four ways: right side up (Fig. 2.); upside down (Fig. 3.); then at the two sides (Figs. 4-5).

Now that you've seen what can be done, transfer (and enlarge) the second example of prepared lines in Fig. 6 to the 18 x 24 sketch pad, using one of the compressed charcoal sticks. Don't be concerned if the enlargement isn't exact. Now the fun begins. Turn the page all four ways to see what kind of picture each position suggests to you. Work from the position which interests you most. Add lines of your own to evoke the image you have in mind. If some of the lines aren't needed, don't hesitate to remove or modify them, using the gum eraser or rag. *Go as far as you like in completing the drawing.* See how it's done in the examples, but don't *copy* them. Make your shapes large to fill the paper.

You'll be surprised to see how your imagination works! Naturally, the result will be a modest beginning. Later on, I'll show you how to improve it.

Evoke an image from your own lines

There's a right way—and a wrong way—to prepare your own improvised lines. To evoke some kind of image, the lines should be spread out. The association between the lines and an idea comes mostly from the *contour* of the lines, and these contours need space around them to be seen.

If you're in a hurry to get your lines down on paper because you want to see what image you can create, I'm afraid you're going to be disappointed. You'll probably end up with nothing. The reason will be obvious if you give it a moment's thought. Either you won't have enough lines to suggest the contours of objects, or you'll have too many confusing lines, which won't give your imagination a chance to function. In either case, you may think the method is not for you;

7

8

9

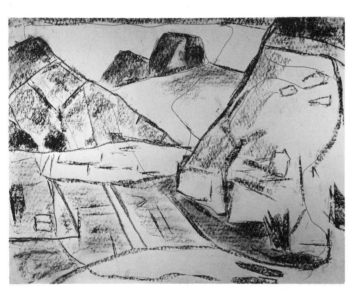

10

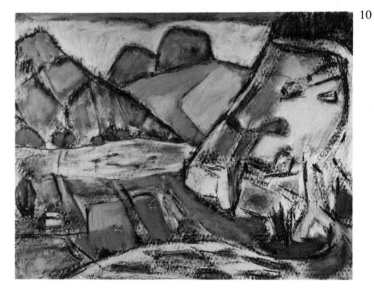

11

FIGURE 7 *Prepare your own improvised lines. Here's an example of an improvised line—a continuous line, drawn at random. Note how much of the paper is covered.*

FIGURE 8 *Here's a follow-through of the improvised lines I made. After turning the lines four ways, I decided to do a landscape. I extended lines and emphasized the contours of the mountains. Then I rubbed in charcoal and smudged in a few areas with a rag.*

FIGURE 9 *I added more grays and blacks, keeping the whole drawing in balance as I worked.*

FIGURE 10 *I added more degrees of gray. Some of the charcoal was rubbed in with great pressure, leaving the surface quite smooth; at other times, I used very little pressure, thus showing some grain; at still other times, I used no pressure, leaving the surface rough.*

FIGURE 11 *In the final stage, to enhance the mood, I added more darks. I worked for stronger contrast of lights and darks, and more varied degrees of grays.*

25

or worse still, you may believe you have no imagination. This would be an unfortunate conclusion, for it isn't true.

I suggest that you proceed according to the advice of the late Florence Cane, a dedicated art teacher who brought the improvised line idea over from England.

If you're right handed, place the charcoal in your *left hand*. The reason for this is that we want no habitual control in the line you're about to produce. Touch the charcoal anywhere on the paper. Now, close your eyes and "take a walk" with a line. Don't run. Make a *continuous* line at random. Do it slowly. Don't think of any subject. Be sure, however, to touch (or come close to) all four edges of the sheet at some point in your wandering, even if you have to grope for the edges. There's a very important reason for doing this, which I'll explain later. Examine the sample (Fig. 7) of an improvised line; note how much of the paper is covered.

When you've made your first improvisation, perhaps you'll find that there's not enough continuous line; now you may add a line, with your eyes open, to fill the paper. However, if you've been too hasty and placed too many lines on the paper, do another improvisation. Or if you think you can retrieve your original improvisation, erase some lines.

Now you come to one of the most important parts of your artistic training! Sit back quietly and look with *half-closed eyes* at what you've done. What picture— or pictures—do your lines suggest? Remember, your imagination works best when all tensions are dropped. You see more when you don't consciously try to see. Don't struggle for ideas; let them come to you effortlessly. Before you make a final decision, turn the paper upside down, and to both sides. Work from whichever view you prefer. Complete the picture, but keep it sketchy. Omit tiny details.

Figs. 8-11 show a follow-through of improvised lines I made. After turning it four ways, I decided to do a landscape. Note how lines are added; also note how darks are smudged in, leaving plenty of light areas in between.

Now for your second assignment, try to do six or more complete drawings—beginning with improvised lines—before you tackle the next method.

A few notes of encouragement

Suppose you don't see anything? Suppose the lines refuse to add up, no matter which way you turn the paper? Start again on the other side, or simply tear it up and throw it away. It's just a piece of paper. Then try again, with a fresh sheet. Soon you'll get an idea; it can be as serious or as silly as you want. Don't be afraid to be serious and don't be afraid to be silly. The artist lives in a wide world and makes all kinds of paintings, some deeply thoughtful, others wild and whimsical.

Everybody has his share of doubts and fears. You may come right out and say, "It doesn't look like *anything*!" Or you'll be silent, but you'll think it. It doesn't matter, at this stage, whether you find the remotest sign of promise in your work. The important point is that you've begun. You're still a beginner and I don't expect your first try to be good. Console yourself with the thought that it can't get worse, only better. So the last thing you should do is fret about it. All other students before you have faced the great "I can't," and by persistence they've won out.

You may find that you make primitive and grotesque drawings, and you're bothered by them. Once again, the world of art is wide open. Primitive and grotesque work can be exciting. So there's nothing to worry about. "*But*," you object, "my life is healthy and orderly; why do I create things like this?" The answer is that we're concerned with opening up your imagination to a little fun, a little abandon, and plenty of child's play! We're all too adult. We cling too much to rules and patterns, sacrificing flexibility and imagination—and fun—to order and regulation.

Like most art students, you may have the uncomfortable thought that I'm talking about developing imagination, but what you want is skill. It may really disturb you that you don't know how to draw. Well, neither did Grandma Moses whom we've all heard about. Nor Henri Rousseau, whose works are in important museums throughout the world.

Look at the example of Rousseau's work in Fig. 12. His people are crudely drawn and out of proportion. They're painted anything but "correctly." But it doesn't matter, because the painting has plenty of feeling, supported by a sound structure; Rousseau's work can be thoroughly enjoyed for what it is.

You'll discover later that distortions exist in all great art. Yes, even in the Parthenon, the Greek temple which is famed for its "perfection." Do you know that the columns of the Parthenon (Fig. 13) vary in height? That the spaces between the columns are not the same? That the columns are curved at each

FIGURE 12 *Henri Rousseau (French, 1844–1910),* The Muse Inspiring the Poet, *57½″ x 38 1/5″, oil on canvas, Kunstmuseum, Basel. Rousseau's people are crudely drawn and out of proportion. They're painted anything but "correctly." But it doesn't matter, because the painting has plenty of feeling, supported by a sound structure. Rousseau's work can be thoroughly enjoyed for what it is.* ▶

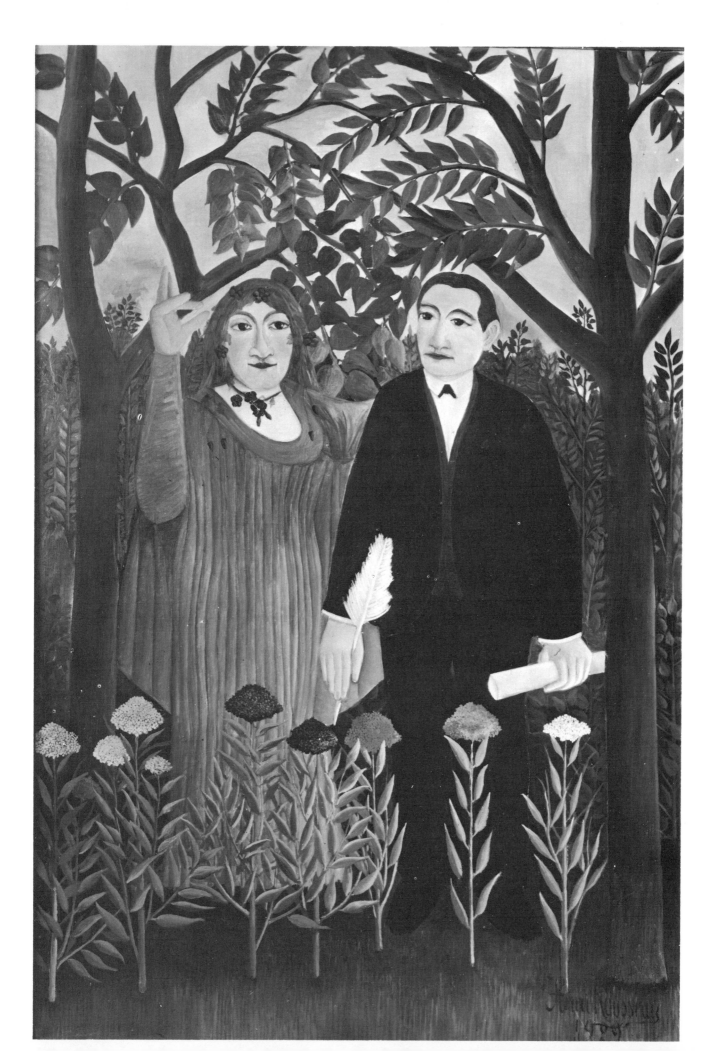

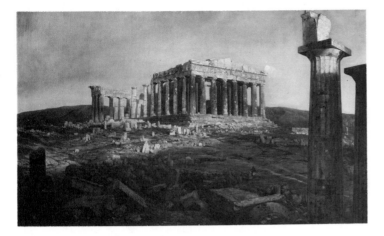

FIGURE 13 *Frederick Edwin Church (American, 1826–1900),
The Parthenon, 44⅛″ x 72⅛″, oil on canvas, The
Metropolitan Museum of Art, New York. Distortions exist
in all great art, even in the Parthenon, the Greek temple
which is famed for its "perfection." Do you know that the
columns of the Parthenon vary in height? That the spaces
between the columns are not the same? That the columns
are curved at each end and not straight? That the steps
vary in height?*

end and not straight? That the steps vary in height?

Why all this variation? Why this deviation from the exact? Variation avoids monotony. Variation and distortion are the natural by-products of inner freedom and intuitive expression. Exact calculation makes for rigidity, usually the result of overly conscious action.

There's no question that the ability to draw is desirable. Nevertheless, the professional artist considers even a crude drawing, done with feeling and freedom, more important than a lifeless drawing which is merely skilled. A course in drawing can never be a substitute for artistic quality.

If you're afraid the first drawings will look foolish to your friends, then don't display them for the time being. If you *must* show your drawings, then stand your ground and begin to educate your friends as you're being educated.

Right now, I just want to relieve your mind a little, to make you feel a bit more secure. So feel perfectly free to go ahead drawing things that *seem* crude and absurd. Let them come as they will. They may not be good yet, but they contain the secret promise of good things to come. Sophisticated work and discipline will come later.

Tips from the masters about pictorial structure

You've made a satisfactory start. Images have emerged. You've improved the drawings by shading

them. Can your drawings be further improved?

This is discussed extensively in Chapters 5, 6, and 7. However, there's no reason why you can't begin to absorb some tips from the masters right away.

Every masterpiece has a hidden structure which supports *every inch* of the painting surface. This structure has very little to do with the subject. Think of it this way: our bodies contain a hidden structure; without the hidden skeleton supporting the body, it would collapse. The same thing is true of a building: without the framework of steel, it would fall apart. The skeleton of steel girders supports *every inch* of the building.

For example, let's look at Renoir's picture of *Madame Charpentier and her Children* (Fig. 14). One can't help enjoying the subject, which is handled with great skill and sensitivity. However, tear yourself away from the details of the subject to *look at it in a special way.*

Glance at the painting as a whole with half-closed eyes. As I've shown in the diagram (Fig. 15), you'll see that it's built upon *a huge triangle* that covers most of the painting. Overlapping it are smaller triangles. Outside of it are other triangles, if you include the edges of the canvas. And by contrast, the background has vertical areas, no two of which are alike in width.

In this case, the main structural motif that supports the painting is the triangle. In other paintings of the masters, you'll find the oval or circle, the rectangle, or (if you break the rectangle down to its component parts) vertical and horizontal lines, diagonals, and numerous other geometric elements.

What significance does all this have for you? How can you put this to use? It means that as soon as you evoke an image—with improvised lines or in some other way—you need to find the over-all basic structure which lies within the image. To do so, it's better to turn your drawing upside down. This way the subject won't interfere with your vision of the whole.

I suggest that you take another look at the third example in the improvised series (Fig. 9). At about this stage, you should study your drawing upside down. In this case, the main geometric structural motif is the triangle. Many of the remaining lines also suggest other triangles varied in size and shape. The fourth example in the series (Fig. 10) shows the contrasting motif of the arc or semi-circle.

Make a start toward strengthening your drawing along these lines. That is, if you've the urge to do so. Otherwise, if you prefer to know more about structural shape relationships first, turn to Chapters 5, 6, and 7. In either case, after you've gone as far as you can in developing the drawings assigned in this chapter, proceed with Chapter 2.

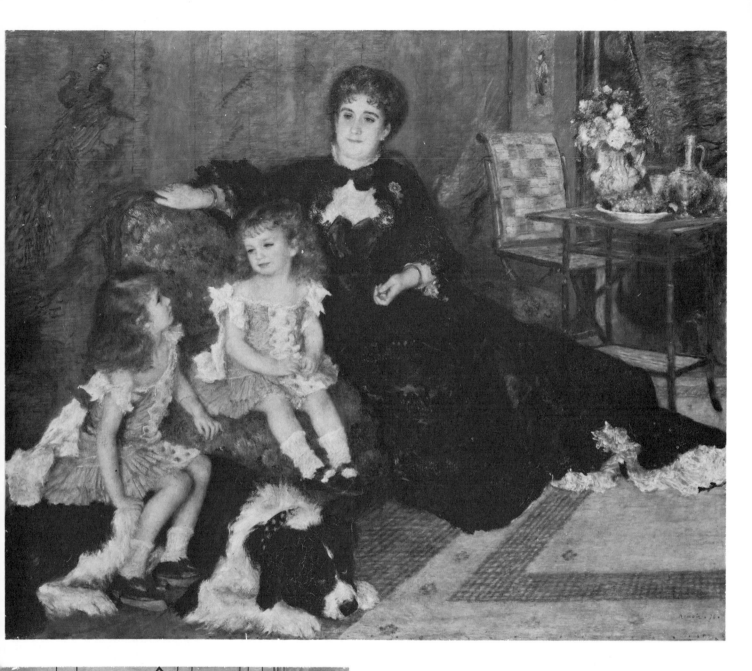

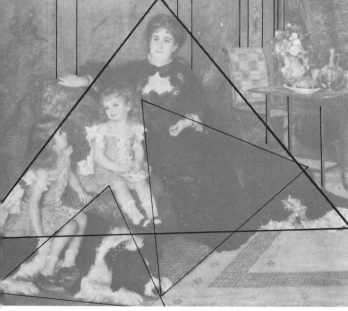

▲ FIGURE 14 *Pierre Auguste Renoir (French, 1841–1919),*
Madame Charpentier and her Children, *60½″ x 74⅞″,*
oil on canvas, The Metropolitan Museum of Art, New York.
One can't help enjoying the subject, which is handled with
great skill and sensitivity. However, glance at it in a
special way: examine it as a whole, with half-closed eyes.
You'll see that it's built upon a huge triangle that covers
most of the painting. Overlapping the big triangle are
smaller triangles. Outside of it are other triangles, if you
include the edges of the canvas. By contrast, the background
has vertical areas, no two of which are alike.

◄ FIGURE 15 *Schematic diagram of Renoir's* Madame
Charpentier and her Children *shows the painting built upon*
a huge triangle that covers most of the canvas. This
triangle is the main structural motif.

2
Evoke an image
from light
and dark shapes

THE SECOND METHOD of releasing your imagination is based on the distribution of lights and darks. The sharp contrast of dark charcoal strokes against the light of the paper can be very stimulating.

Beginning the assignment

First, look at the paper as a whole. Slowly move your eyes over the entire surface. I'll explain why later. With your charcoal, place a dark shape at one end of the paper (Fig. 16). Look at this dark in relation to the remaining space. Say to yourself, "Where do I *feel* that another dark shape belongs?" If you're not sure, tear off a piece of paper about the size of the first shape, and charcoal it black. Move it around on the sheet of paper, trying the dark shape in different areas; watch its relation to the first shape and to the edges of the paper until you *intuitively* find the area where the dark belongs. Then rough in the second dark shape with charcoal (Fig. 17).

For greater control, break the compressed charcoal stick in half. Place it *broadside* in your hand and be ready to draw with the *side* of the stick, not the tip. With eyes open, press down as you move the charcoal to make a shape. By varying the pressure, you'll obtain greater variety of light and dark within the shape.

Keep on placing dark shapes wherever your intuition tells you (Figs. 18-20). However, take your time after each placement to look at the surface as a whole. Sometimes, if you're in doubt, turning the sheet sideways or upside down will help you find the next area to be darkened. Also, as you place the darks, *vary the size and kind of shapes* to avoid monotony.

Study Fig. 21 carefully. Compare it with Fig. 20 to see how some of the shapes have been finally joined together. A common fault is to join the shapes together *too soon,* perhaps at the stages represented in Figs. 18 and 19. What we want is a distribution of darks (Fig. 21) that covers a good deal of the paper. Note also how close the dark shapes come to the four edges.

The next step is to smudge a good many of the shapes (Fig. 22). A soft rag or chamois is an important tool for this purpose. Notice that you rub *gently,* leaving plenty of light and dark areas. Now, with the same rag—coated with the charcoal you've rubbed off the paper—rub *outside* the shape areas, between the darks (Fig.23). This brings the whole picture into a still more harmonious light and dark relationship.

In general, you follow the same approach as in the line improvisation. Sit down. Consciously drop all tension. Turn the picture four ways before you decide what your subject matter will be: landscape,

FIGURE 16 *First look at the paper as a whole. Slowly move your eyes over the entire surface. With your charcoal, place a dark shape at one end of the paper. Look at this dark in relation to the remaining space. Say to yourself, "Where do I feel that another dark shape belongs?"*

FIGURE 17 *Now rough in the second dark shape with charcoal. Your drawing of the shape, its size and placement should be uniquely yours. Don't try to imitate mine.*

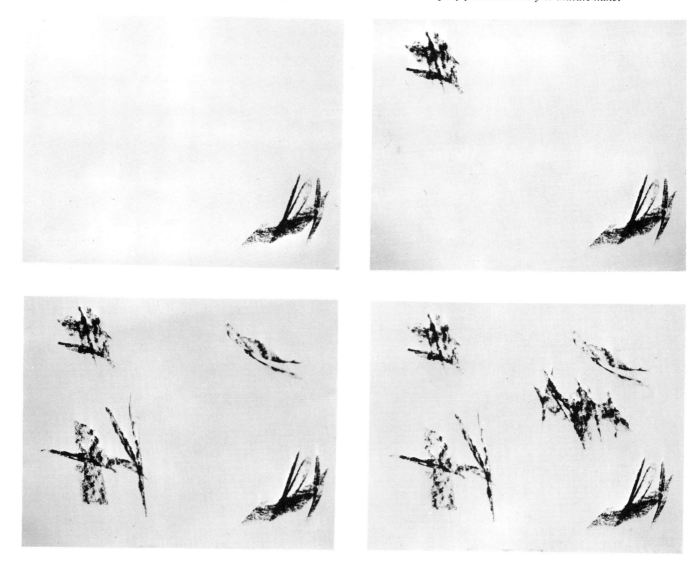

FIGURE 18 *Keep on placing dark shapes wherever your intuition tells you.*

FIGURE 19 *Take your time (after you place each dark) to look at the surface as a whole.*

FIGURE 20 *Sometimes, if you're in doubt, turning the sheet sideways or upside down will help you find the next area to be darkened. As you place the darks,* vary the size and kind of shapes *to avoid monotony.*

FIGURE 21 *Compare this with Fig. 20 to see how some of the shapes have been finally joined together. A common fault is to join the shapes together too soon, perhaps at the stages in Figs. 18 and 19. What we want at this stage is a distribution of darks that covers a good deal of the paper. Note how close the dark shapes come to the four edges.*

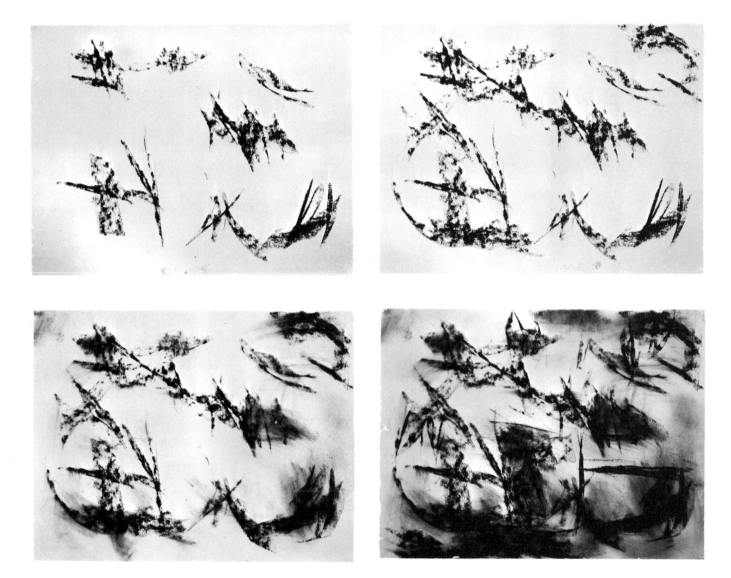

FIGURE 22 *Smudge a good many of the shapes. A soft rag or chamois is an important tool for this purpose. Notice that you rub gently, leaving plenty of light and dark areas.*

FIGURE 23 *With the same rag—coated with the charcoal you've rubbed off the paper—rub between the darks. This brings the picture into a still more harmonious whole.*

FIGURE 24 *Little by little, I added more darks. I stepped back after each addition to see the effect as a whole. In this way, I kept the whole picture in balance intuitively, sometimes working on it upside down, placing darks wherever I felt they were needed.*

FIGURE 25 *Compare this with Fig. 24. Notice where additional darks were placed.*

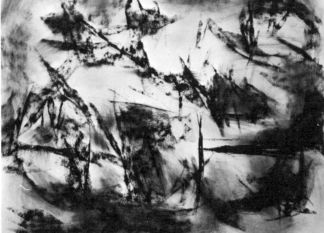

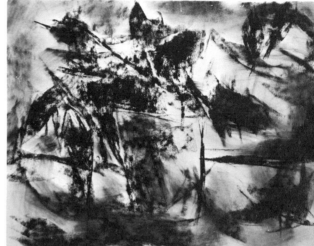

FIGURE 26 *This is as far as I went. The main structural shape motif turned out to be an oval. Contrasting motifs developed into the rectangle and the triangle. All of these were repeated intuitively and varied in size.*

FIGURE 27 *Schematic diagram shows the drawing built upon a huge oval that covers most of the paper. Notice the smaller ovals of varying size which echo the large oval. The same thing happens with the contrasting motifs of rectangle and triangle.*

seascape, still life, figure, or whatever you see in the pattern of dark and light. When you find an image that interests you, add lines and shapes to complete it. Erase any areas which interfere with it.

With Fig. 22 as a starting point, I decided to do a flowering still life. Little by little, I added more darks (Fig. 24). I stepped back after each addition to see the effect as a whole. In this way, I kept the whole picture in balance intuitively, sometimes working on it upside down, placing darks wherever I felt they were needed (Fig. 25-26).

The main structural shape motif turned out to be oval (Fig. 27). Contrasting motifs developed into rectangle and triangle. All of these were repeated intuitively and varied in size.

For your third assignment, do about a half-dozen of these drawings, developing each as far as you can. Turn them sideways or upside down to examine them objectively for the main shape motifs and contrasting shape motifs. If any shapes are repeated monotonously, vary them. Don't be so enamoured with something you've done that you hesitate to change it. If you've done something fine and must destroy it, remember that there are a million images, and better ones, ready to be released from your subconscious.

The importance of light and dark relationships

What is the significance of light and dark gradations? Why are these factors of fundamental importance in a work of art? How do we know when they're in balance?

All of these questions apply equally to a painting or a drawing. The only difference is that a painting has the added factor of color. Let's consider a painting which has yellows and deep blues in it, among other colors. If we photograph the painting in black and white, we see various degrees of gray, in addition to stark black and almost pearly white. Obviously, the yellows come out very light and the deep blues show up black, or close to it. The remaining colors take on various shades of gray.

These light and dark gradations, usually referred to as *values,* have a basic importance quite apart from color. In fact, I suggest that you forget color, for the time being, in order to grasp the full significance of values.

One of the fundamental elements in a good picture is the *harmonious placement* of light and dark gradations. When distributed properly, they enhance the mood and enrich the feeling of a drawing or painting.

In the previous chapter, I suggested that you use my series of demonstration drawings as a guide in completing your own drawings. But since I gave no

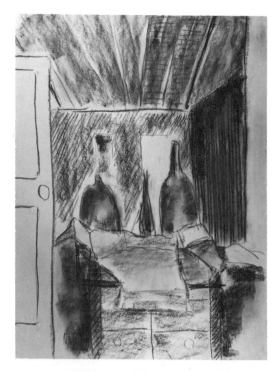

28

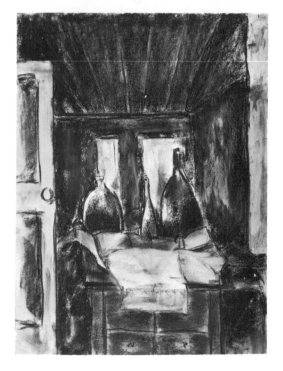

29

FIGURE 28 *Here's a sketch of a still life approached in the traditional manner. Compare it with the following one (Fig. 29). Notice what happens to the mood and feeling of a drawing (or a painting) when you work for the harmonious balance of light and dark relationships, as a unified whole.*

FIGURE 29 *This drawing has more feeling than the previous one. Obviously, more detailed attention was given to the light and dark relationships.*

specific instructions, chances are that you didn't pay enough attention to light and dark relationships. I'm sure that you were more attracted to the images you were releasing. And if the subject matter you evoked didn't interest you, I'm also sure that you didn't bother to go much further to improve the light and dark gradations. This was expected because you weren't really prepared for value relationships.

Which picture creates a mood?

At this moment, I'm particularly interested in showing you what happens to the mood and feeling of a drawing (and later a painting) when you work for the harmonious balance of light and dark relationships, as a unified whole.

Fig. 28 is a sketch of a still life approached in the traditional manner. Compare it with the second one (Fig. 29). Obviously, the second one has more feeling because I've given more detailed attention to the light and dark relationships.

Developing your eye for value relationships

Developing your eye for value relationships is a process of looking, then looking again. As in music, there's a scale. In art, the scale is one of values, not notes. As a musician develops a sense of pitch, *you* must develop a sense of tonal differentiation. This scale, from light to dark, can be represented schematically in a diagram (Fig. 30).

In a work of art, these tonal values are always distributed harmoniously. An artist may use all of them or only a few. In either case, he's definitely aware of the effect and mood he creates. For example, as in the Steichen self-portrait (Fig. 31), he may feel the need for sharp contrasts in light and dark. Fig. 32 is another example of sharp contrasts of value. Or perhaps he decides upon a narrow range, possibly using only the lower, darker part of the scale. This is what I chose to do in *Kabuki Dancer* (Fig. 33).

It's advisable, therefore, as a continuing assignment, to look at black and white art illustrations of paintings—in books and magazines—as often as you can. Study them to become familiar with light and dark relationships, how they balance and harmonize to form a unified whole.

As you look at a picture, try squinting. This blurs the subject matter, permits you to concentrate on the variety of light and dark values, and helps you to see it as a whole.

How do you know whether the values are in balance? Your intuition tells you. There are no rules. It's a matter of *feeling*. If you're in doubt about an

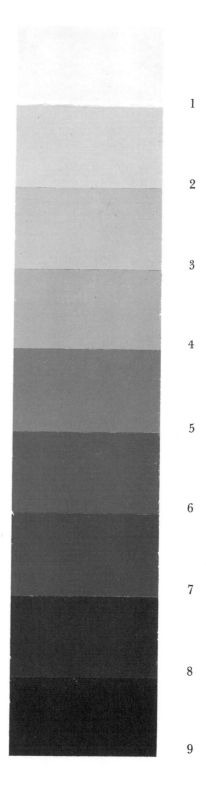

FIGURE 30 *Developing your eye for value relationships is a process of looking, then looking again. As in music, there's a scale. In art, the scale is one of values, not notes. As a musician develops a sense of pitch,* you *must develop a sense of tonal differentiation. This scale, from light to dark, can be represented schematically in a diagram.*

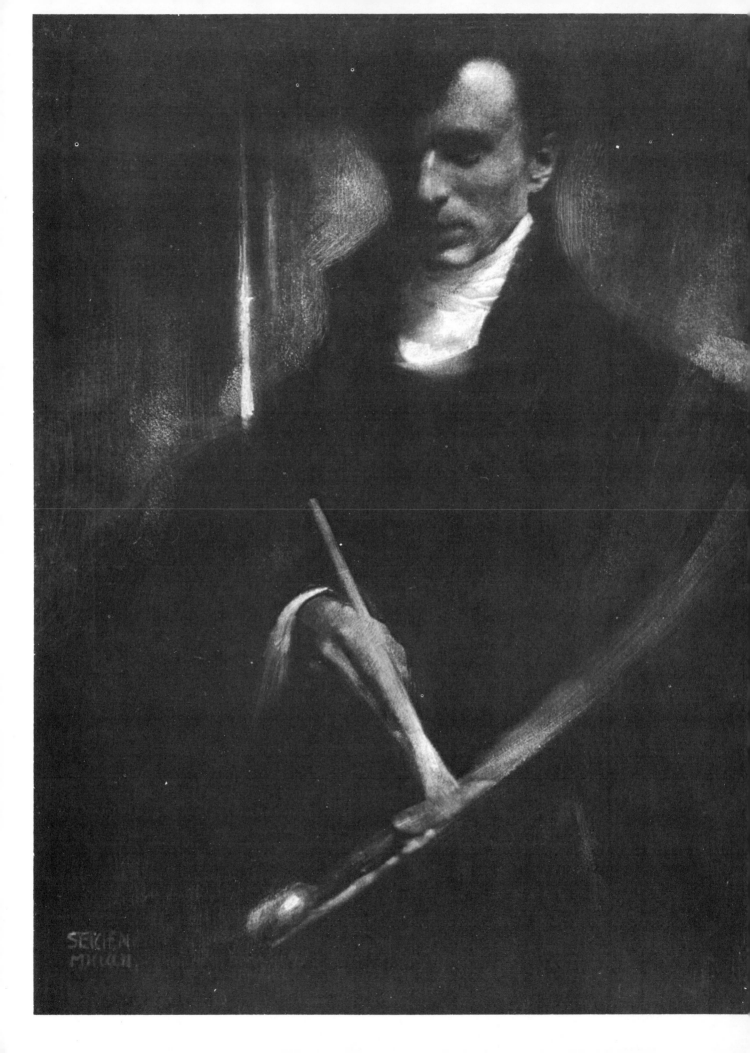

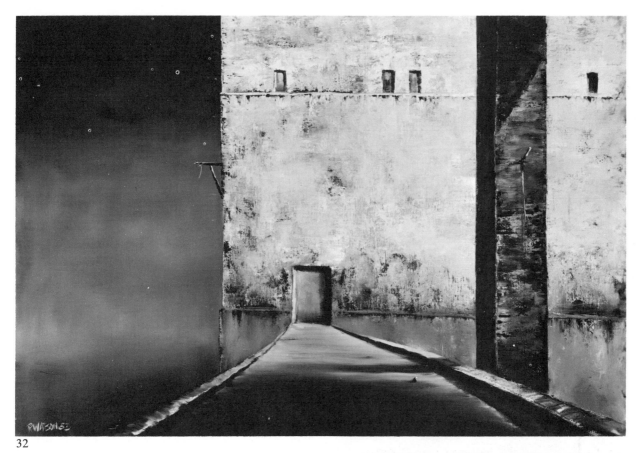

32

33

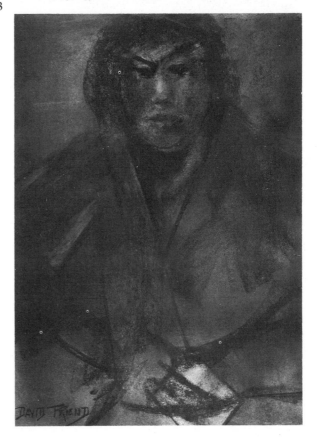

◄FIGURE 31 *Edward Steichen (American, 1879–)*, Self Portrait, *10½″ x 7⅞″, photograph. The Art Institute of Chicago. In a work of art, tonal values are always distributed harmoniously. An artist may use all of the values or only a few. In either case, he's definitely aware of the effect and mood he creates. For example, he may feel the need for sharp contrasts of light and dark, as in this self portrait. Compare the tonal values here with the following two illustrations.*

FIGURE 32 *Robert Watson (American, 1923–),* The Arsenal, *27⅞″ x 42″, oil on canvas, The Toledo Museum of Art, Toledo, Ohio. Another example of sharp contrasts in light and dark. Compare the tonal values with Figs. 31 and 33.*

FIGURE 33 *The artist may decide upon a narrow range of tonal values, possibly using only the lower, darker part of the value scale. This is what I chose to do in my drawing of the* Kabuki Dancer.

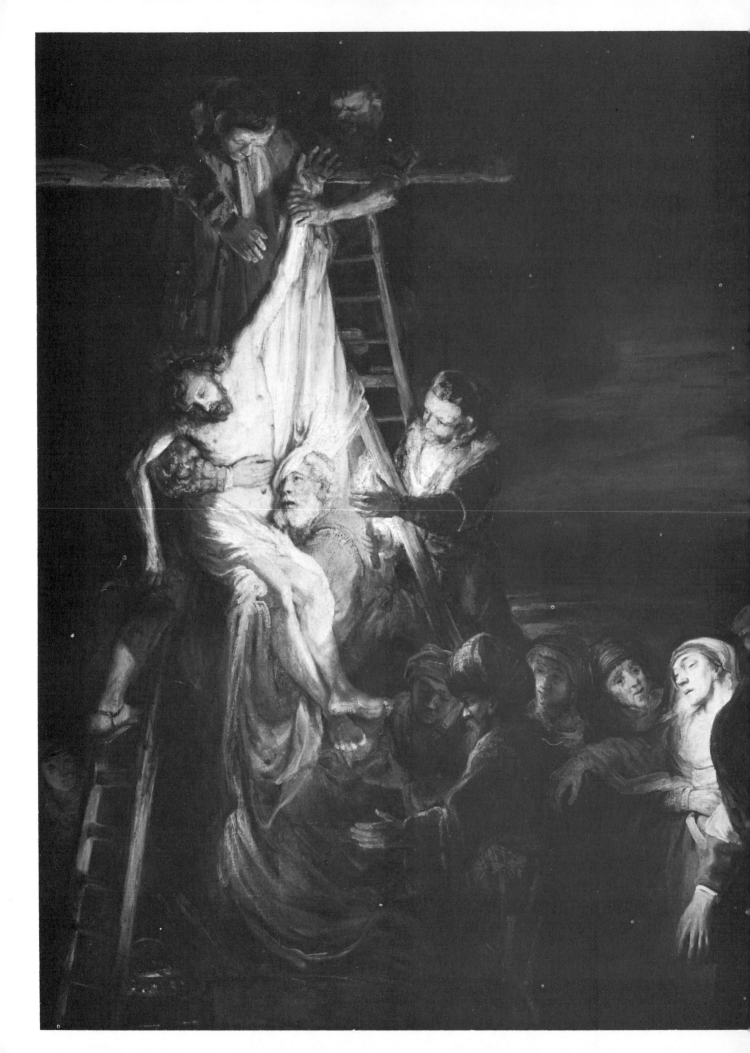

◀ FIGURE 34 *Rembrandt van Ryn (Dutch, 1606–1669),* The Descent from the Cross, *56¼″ x 43¾″, oil on canvas, National Gallery of Art, Washington, D.C. Traditional teachers of art tell us to observe from what direction the light comes. We're told to be consistent in placing our shadows, and to be true to nature. But in creative art, we're not interested in merely developing the skill to show the accidental light and dark as seen in nature. We want to express our inner* feelings. *To do so, we may wish to emphasize certain areas at the expense of others. Look at the way Rembrandt arbitrarily handled light and dark relationships to create a certain mood.*

FIGURE 35 *Photograph of an actual scene painted by Nicolai Cikovsky. Had he painted the scene as it appears in the photograph, the result would have been true to nature, but trite. There's no balanced interplay of lights and darks; the upper part is uniformly, monotonously light; the lower part is dark. Compare it with the painting (Fig. 36).*

FIGURE 36 *Nicolai Cikovsky (American, 1894–),* Shinnecock Hills, *courtesy, Nicolai Cikovsky and W. W. Norton Company, Inc. Note how the artist rearranged the scene, producing a dynamic distribution of light and dark throughout the canvas. To create a mood, he darkened the sky and introduced masses of light clouds.*

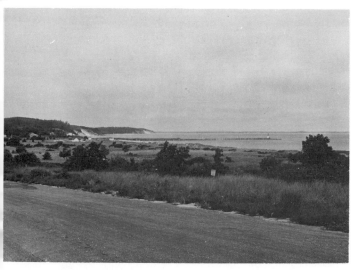

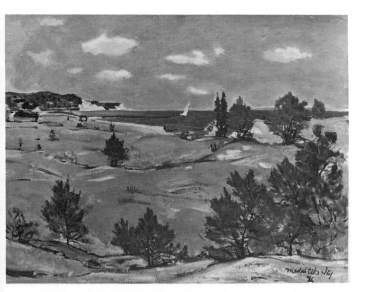

area, block it out with your finger and look at the rest of the picture as a whole. Then take your finger away and, once again, look at it as a whole. If you feel better with less (or more) light or dark, adjust the area accordingly.

How the masters disregarded the light source

Traditional teachers tell us to observe what direction the light comes from. We're told to be consistent in placing our shadows, and to be true to nature. But in creative art, we're not interested in merely developing the skill to show the accidental light and dark as seen in nature. We want to express our inner *feelings*. To do so, we may wish to emphasize certain areas at the expense of others. Look at the way Rembrandt arbitrarily handled light and dark relationships to create a certain mood (Fig. 34).

Which picture is more satisfying?

In the final analysis, it's not the subject matter which controls the distribution of light and dark values. What really matter are the relationships which the artist creates within the whole.

Study the photograph (Fig. 35) of an actual scene painted by Nicolai Cikovsky. Had he painted the scene as it appears in the photograph, the result would have been true to nature, but trite. There is no balanced interplay of lights and darks; the upper part is uniformly and monotonously light; the lower part is dark.

Now look at the painting (Fig. 36). Note how the artist rearranged the scene, producing a dynamic distribution of light and dark throughout the canvas. To create a mood, he darkened the sky and introduced lighter masses of clouds. He unified the painting by creating almost the same degree of dark in the sky as he did in the earth below.

There are no neglected areas. Everything is taken care of; everything is important. To create a sound structure, the artist raised the horizon line: instead of two equal, monotonous rectangles, we now have variety, with one rectangle dominant. The artist spread out the trees, enlarging and darkening them. In doing so, he created a large oval, interlocking the trees with the clouds in the sky. Within this large oval area, there's a smaller, rhythmic oval, an echo of the larger one.

Truthfully, which picture is more satisfying? The photograph of the scene? Or the painting of the scene. adjusted in both value relationships and structural shape relationships? Really there can be no question. A work of art will always win out.

Even the masters have their doubts

So far, you've tried two different methods of releasing your imagination. When you've finished experimenting with the remaining two methods, you'll know which one—or perhaps which combination—you like best.

If you've followed the instructions as outlined, chances are that your head is swimming with new thoughts, new approaches to drawing and painting, and new ways of looking at art. This reaction is normal. As John Canaday, art critic of *The New York Times,* so aptly puts it in *Mainstreams of Modern Art,* "Generally, an artist's beginning may be summed up as one of confusion, hesitancy and groping." It's about the same as you feel after your first driving lesson in traffic.

Perhaps you're meeting the challenge of these assignments with ease. You may also be having severe doubts: "Maybe I haven't any talent" or "Maybe I have no imagination" or "Maybe I should learn to draw first" or "It discourages me to look at masterpieces; it makes me realize that they were done by geniuses, and that I'll never get anywhere."

These are common worries which arise at this stage to plague the beginner. The fact is that *all* professional artists have felt the same way, at some time. The great sculptor, Henry Moore, recalls a period when he was so disheartened that he couldn't pick up a chisel. And the famed contemporary painter, Francis Bacon, is said to have *destroyed* many canvases for each painting he exhibits. The same is true for writers; Gustave Flaubert complained: "You speak of discouragement: if you could see mine! Sometimes I don't understand why my arms don't drop from my body with fatigue, why my brains don't melt away."

Most of us think of the masters as a breed apart. We're inclined to place them on a pedestal, as if we could never have anything in common with them. But it should encourage you to know that every master started as an amateur. They faced the same problems that you face at this moment. What's more, they made the same mistakes that every person makes until he learns. Many of their early attempts weren't much better than the early struggles of the average amateur. The learning process is the same for all of us, though the inherent genius does outdistance us in the end.

If you're tempted to think that your doodling is kid's stuff, remember that many of today's great artists begin with a scribble, even now. Years ago, Joan Miro wrote: "I start drawing without a thought of what it may eventually become. Forms take reality for me as I work; the picture begins to assert itself or suggest itself under my brush. Even a flaw in the canvas, a stain on the board, may suggest the beginning of a picture."

And Henry Moore, whose drawings are represented in practically every important museum, comments: "I sometimes begin a drawing with no preconceived problems to solve, with only the desire to use pencil on paper and make lines, tones and shapes with no conscious aim."

What we call improvising, then, plays an important part in the life of the artist. It is his simplest, most immediate way of expressing what he—and he alone—sees and feels. The artist knows that his lines and shapes, apparently done by chance, actually evolve out of his subconscious.

If you doubt that you have talent or imagination, consider Robert E. Mueller, author of *Inventivity,* who says, "Everybody is original. Everybody can design—if not supremely, at least beautifully." Also W. Somerset Maugham: "Imagination grows by exercise, and contrary to common belief, is more powerful in the mature than in the young." And finally Alex Osborn, in his book, *Applied Imagination:* "Creative thinking calls for a positive attitude. We have to be hopeful. We need enthusiasm. We have to encourage ourselves to the point of self-confidence . . . premature judgment may douse our creative flames . . . we should give imagination priority over judgment . . . for at this point, we are just working up . . . limbering up our imagining muscles."

Trust your intuition

"All right, I'm convinced," you say, "but what lies ahead? Where am I headed? How do I know whether it's going to work out satisfactorily?"

Don't suffer needlessly. No professional artist—even the greatest—knows from the start whether a drawing or painting will work out successfully. He does know that each new painting or drawing is a voyage into the unknown. He's familiar with the creative process because he's been through it before; he's learned to trust his intuition and take his chances. This is all part of the fun.

I can assure you that after you've experienced the creative process of drawing and painting a number of times, you'll find that "nothing succeeds like success." By *experience,* you'll learn to let yourself go. Self-doubt and a feeling of inferiority will arise again and again. Early in his career, every professional has had these feelings. But he was determined to reject them. And so must you. After a while, you'll find that negative attitudes will disappear if you trust in your intuition. Why not take things one step at a time? Let's be like the child who lives in the present.

3
Work from a memory image

THE THIRD METHOD—creating directly from the memory or the imagination—is distinctly different from the first and second methods.

Reviewing what you've achieved

In the first two assignments, you depend upon contoured lines or dark shapes to stimulate your imagination. You associate the shapes or lines with some pictorial idea that stirs you enough to make a start. Then, if your interest is strong and you let yourself go, you express yourself with feeling. You check for shape relationships and you add more darks as you go along. You're over the first hurdle: you've evoked a drawing from your imagination.

If you like the result, so much the better. Actually, the result may be a very fine artistic drawing. In that case, the real problem is often that you don't recognize its true value. Console yourself with this thought: as you come to recognize the standards by which professionals judge art, you will, in time, arrive at a fuller appreciation of your own work.

If, on the other hand, you concentrate more on consciously "perfecting" your drawing, chances are that you'll tighten it up. It will probably lose the spontaneous feeling it had at the outset. We'll be working on this problem as we go along. In time you'll overcome it. In evaluating the steps you take to improve the drawing, you'll pay less attention to the subject matter and more attention to the relationship of the various elements—light and dark values, shapes, lines —to the whole.

But whether your drawing ends successfully or not— and it may be better than you think—you mustn't underestimate your accomplishment. At least you're able to release an idea from your imagination. This is an achievement! Remember that most amateurs feel terribly insecure unless they have some three-dimensional still life before them as they work. They distrust their imagination, their intuition; because they work in this traditional way, they turn out paintings which lack feeling, paintings which are static and lifeless. You're discovering that imagination and intuition come first; this is why your art will come alive.

But perhaps you *haven't* been able to jump this first hurdle. Have you been concentrating too hard, waiting for some profound vision to arise from your improvisations? After all, a master like Van Gogh was satisfied to paint a chair or an old pair of shoes. Why not accept a simple unprofound pictorial idea? Later, when the habit of releasing the imagination is formed, you'll find that more profound ideas will flow.

But maybe the first two improvising methods disturb you. Your imagination refuses to work. What

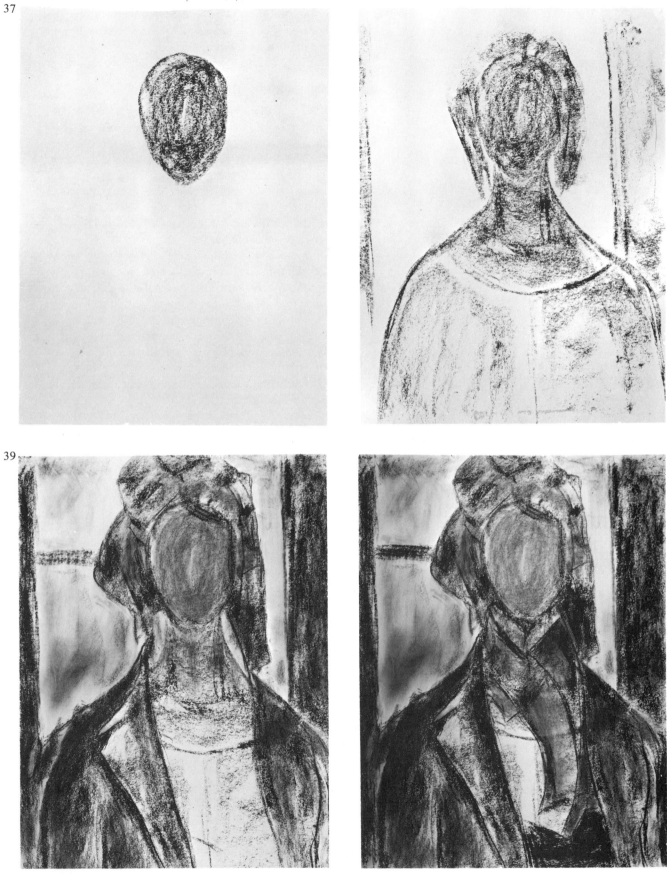

FIGURE 37 *Here's how to develop a figure from memory. First I introduced a dark shape for the head, intuitively feeling its relationship to the four edges of the paper.*

FIGURE 38 *Then I added the body. Notice how I extended it to cover more than half the area of the paper. Next I added hair. Finally, I broke up the negative space by adding vertical areas to the right and left of the head.*

FIGURE 39 *I smudged the face and modeled the hair. I added a horizontal at the left of the head, then turned the paper upside down and introduced a greater range of lights and darks. When I turned the paper right side up, I noticed that I'd achieved variety intuitively: the left side of the jacket shows the lapel clearly while the right side doesn't; one side is lighter than the other; the shapes at the left are different from the ones on the right.*

FIGURE 40 *I added a scarf merely to introduce more varied shape and value relationships. Notice how the drawing is supported by the main geometric motif: two large areas of head and body, composed of ovals (or curves, the component parts of ovals). The contrasting submotif: verticals. Even the hair on the right side reinforces the rhythmic spacing of the narrow vertical band with the broad band next to it. Notice that the narrow vertical band, which is* light *in value, is repeated at the extreme left as a* dark *vertical.*

FIGURE 41 *I added the features in the face. I didn't try to draw in eyeballs and other small details. Instead, I smudged the eyes, using a rag and an eraser to create a mood in the face. Finally, I introduced more degrees of gray, extending the scale of lights and darks all over.*

41

then? Here's a third method which may hold the answer for you.

How to start working from memory

Think of an idea that interests you. It can be a scene from your travels or even from your childhood. Anything. Once you've decided what you want to draw—and you're the least bit excited by your mental image of the idea—let yourself go! Touch charcoal to paper and start!

There's a big advantage in working from memory. Your memory acts like a sieve, drops all non-essentials, holds and emphasizes the essentials. That is, unless you make the mistake of trying to reproduce an *exact place*, let's say, where you had a fine vacation. The vivid details are there in your mind's eye and you insist on drawing every single one. In this case, your conscious mind is interfering and the drawing will become rigid, without feeling.

On the other hand, you may begin to worry after you start, because you can't hold onto your idea. Your memory is playing tricks on you. Then don't try to remember exact details. Don't try to hold onto your idea at all. Use the memory image as a springboard for a new image. Let the shapes you've drawn suggest other things. Relax with your drawing, whatever it turns out to be. And don't worry if it turns out a bit crude. Who cares?

The important point is to get started *creating*. The interesting thing is that your work will turn out to be *new* and *original*. As you continue to do more drawings, you'll be agreeably surprised to find that the process of creating gets easier. The results will provide solid satisfaction.

If you can't think of some special idea from memory, you've still another choice. Do a memory drawing of a general category: landscape, seascape, still life, or figure. For example, when you think of the word, landscape, what image comes to mind? High, rocky mountains? Low hills and large clouds? Large trees? Flat country with long rows of plants under cultivation? In a seascape, does a stormy sea come to your mind? Perhaps with large waves? Or a harbor? An underwater scene with fish and undersea plant life? Sailboats in the moonlight?

Prepare a list in every category, noting how you visualize each subject. Add to it, from time to time, by jotting down notes as the thoughts occur. Usually they'll occur when you least expect them. If you have difficulty, turn the problem over to your subconscious. Just before you take a nap or go to sleep, say to yourself: "Visualize three or four situations that I might draw." Be sure to have paper and pen handy. This

way, when ideas come, you'll arouse yourself and make notes. Otherwise, later you may remember vaguely that you had a good idea, but lost it.

But you may say, "I've chosen a category; I have a good idea, but I can't draw it." If you mean you can't draw it with traditional skill, I'll agree with you. But you'll find you *can* do it with simple, large shapes, letting them extend to the four edges of the paper, or at least fairly close to the edges. Use the *broadside* of the charcoal and work for *dark areas* right from the start. Omit tiny details.

How to develop a figure from memory

Figs. 37-41 are a demonstration of a figure drawn from memory. Note the dark shape for the head in Fig. 37. At the stage in Fig. 38, I added the body. Notice how I extended the shape to cover more than half the paper. Next I added hair. Finally, I added verticals to right and left to break up the negative space. After the stage in Fig. 39 was reached, I turned the paper upside down and introduced a greater range of lights and darks. I did this by stepping back after each broadside stroke, pausing and looking at the whole image during each interval. I placed darks boldly, without conscious thought, wherever I felt they were needed, *always in relation to the whole*. To obtain a dynamic quality, I accepted the risk of spoiling the drawing during this spontaneous process. Actually, the drawing may change somewhat because of this procedure, but it's never really spoiled. You keep changing until it's right.

Note how the darks, placed intuitively around the head, took the shape of verticals (Fig. 40). Even the hair on the right side of the picture reinforces the rhythmic spacing of the narrow vertical band with the broad band next to it. Further, the narrow band is repeated at the extreme left. While it's about the same in width, one band is light, the other dark. The area on the left is broken up by a horizontal, dividing the drawing into unequal but interesting two-dimensional shapes. At one time, I considered carrying the horizontal across to the other side; but I decided to sacrifice the look of a real window, giving preference instead to rhythmic shape relationships.

All of this is supported by the main geometric motif: two large areas of head and body, composed of ovals (or their component parts—curves).

The details of the head were introduced right side up, afterward in Fig. 41. At this final stage, I also introduced more degrees of grays, extending the scale of lights and darks all over. Note, particularly, the handling of light and dark in the face and hair. Don't try to draw in eyeballs and other small details; if you

do, the area will lose its feeling of relationship to the whole. Instead, smudge in the eyes. Use a rag and eraser to create a mood in the face. The point of the charcoal should be used only *sparingly,* when you're nearly finished with the drawing.

Whatever you do, don't try to obtain a specific likeness of someone you have in mind; here again, you may destroy the feeling of the whole. I know the temptation to try is very strong. But I suggest that you reject the urge to produce a likeness during this period when you're trying to establish new habits of balancing relationships as a whole.

If you don't like the mood of the face you've created, keep erasing and smudging the area again and again, until you do like it. However, be careful not to let your personal feelings destroy a good thing. Sometimes we create a vital, fresh, but "ugly" figure. Then, when we try to remove some of the so-called ugliness to make it "acceptable," the drawing loses all its force. It becomes trite and inane. My suggestion is this: If you don't like the mood after you've balanced the picture in value and shape relationships, put it aside for a week or even a month. When you take it out again after this breathing spell, you'll see it more freshly, more objectively. In the meantime, do many others, especially if you like figures. But be sure to let yourself go. This helps to avoid the conscious addition of niggling details. Study Van Gogh's drawing, *Peasant Family* (Fig. 42); he wasn't ashamed to leave out details.

Developing a landscape, seascape, still life from memory

In Figs. 43-56, you have a demonstration of a landscape with high cliffs, a rough sea with a boat in trouble, and an abstraction of flowers, all drawn from memory.

Shifting your attention to the whole

You'll take a giant step forward in improving your drawing—and later your painting—when you overcome the greatest single cause of failure in amateur art: the failure to unify a picture as a whole. You'll appreciate the full importance of this only when you've struggled with the problem—and won.

Naturally, when you look at a picture, or when you work on a drawing or painting, you're attracted to the center of interest with the force of a magnet. You're so eager to reproduce the details of a picture that you simply don't see the whole. Yet I can *guarantee* that you'll create good drawings and paintings only if you'll learn to shift your attention.

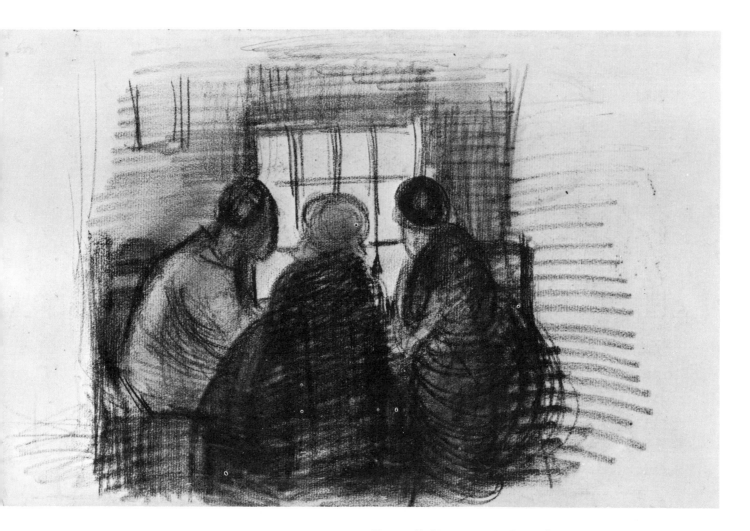

FIGURE 42 *Vincent van Gogh* (*Dutch, 1853–1890*), Peasant Family round a Table at a Window, *drawing, collection of V. W. van Gogh, on loan to Stedelijk Museum, Amsterdam. Study this drawing carefully. Remember, van Gogh wasn't ashamed to leave out details. Let yourself go as he did. Place dark shapes boldly, without consciously adding niggling details. Don't try to obtain a specific likeness of someone you have in mind. You may destroy the feeling of the whole.*

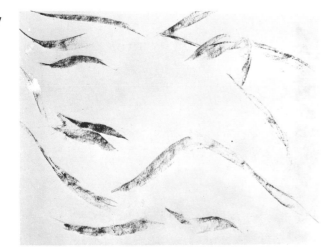

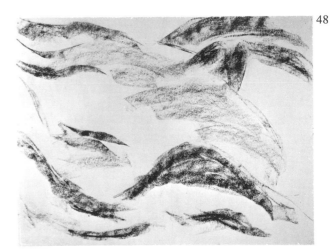

51

FIGURE 43 *For this landscape with high cliffs, I first drew large shapes, which occupy most of the area of the paper.* FIGURE 44 *I added more light and dark grays, gently smudging the negative spaces.* FIGURE 45 *I added more shapes within the larger shapes, as I added more varied dark grays.* FIGURE 46 *In the final stage, a strong mood emerged as I added still more dark grays and blacks.* FIGURE 47 *This is the first stage of a drawing that became a rough sea with a boat in trouble. As in Chapter 2, I started to distribute dark shapes, but this time in a free-flowing manner.* FIGURE 48 *I added more degrees of gray, creating more contrasting light and dark relationships. At this point, I decided the upper right hand corner would be land.* FIGURE 49 *I added more darks and smudged in some grays. I also added a suggestion of a boat. Would I make the foreground land or water? The areas suggested land to me.* FIGURE 50 *I began to feel the surging sea as I continued to add more degrees of dark. At the same time, I smudged in more areas.* FIGURE 51 *In the final stage, I added more darks and used an eraser to create more contrasting lights. Compare this with Fig. 50 to see how the rocks were solidified. Notice, too, that the main structural shape motif turned out to be oval, and the submotif became triangle.*

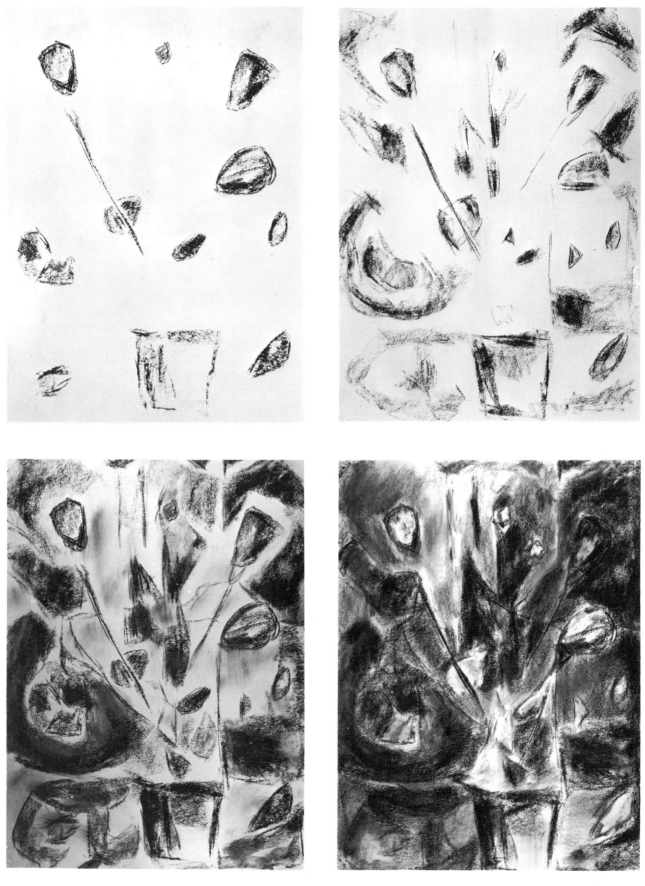

FIGURE 52 *The first stage of an abstraction of flowers. I spread out shapes of varying sizes, making some darker than others. I roughed in a flower pot. Notice that I merely suggested a stem by using a disconnected, uneven line.*

FIGURE 53 *I surrounded the flowers with more shapes in varying degrees of gray and black. As usual, these shapes were spaced intuitively. I added a few tentative, faint lines, feeling for possible divisions of space.*

FIGURE 54 *I added more grays and blacks, as I extended the size of some shapes and added others. Notice how some of the light areas are smudged slightly, to unify the whole.*

FIGURE 55 *I added still more degrees of gray, particularly around the outside of the flowers. Notice how certain values changed. The flowers, which were dark shapes against the white of the paper in the early stages, now appear light against the darkening background.*

FIGURE 56 *In the final stage, I used an eraser to make some of the flowers still lighter. For some reason, the upper left flower fascinated me and I decided to leave it suspended in air to create tension. I lightened the area around it. At the same time, I darkened other areas to vary the whole in tonal values. Notice that the main structural shape is vertical, with contrasting triangles.*

56

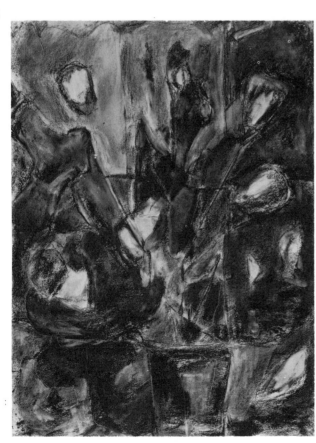

Here's how to go about it. Consciously think about the paper you're drawing on, the whole sheet of paper. Look at the rectangular shape of it. Look at the area within those four edges. Become aware that each mark you place within the whole of that surface is *more important* than the subject you're drawing. This means that every inch of the surface, within the length and width of the paper, is essential to the total effect. Further, become aware that you're working *primarily* to establish a series of relationships, intuitively, over the whole of this surface. These relationships vitalize the mood of the picture and strengthen its structure. One of your jobs, for example, is to translate the shapes of the subject matter into rhythmic over-all spatial relationships.

All relationships of shape, value, color (which in turn is further divided into a series of relationships), texture, and line are always considered as components of an integrated whole.

Give up, forever, the thought of concentrating too closely and too long on fragmented details of subject matter; this concentration narrows the vision. Give up the amateurish striving to solve your picture-making problems piecemeal. From now on, make up your mind that you'll attack the total problem at each step—that you'll permit your artistic sensitivity, your intuitive feelings, to determine order and balance as one rhythmic whole, over the entire pictorial surface.

You say: "OK, I accept the basic premise that the whole is more important than the parts. But how can I look at the picture as a whole and still draw the subject matter at the same time?"

Place the paper or the canvas before you. Sit down and relax completely. Look at the four edges of the picture surface. Spread your vision over the entire surface. Let the whole area sink into your subconscious. Begin to draw or paint. If you're relaxed, your subconscious will take care of the spacing intuitively. Although you *must* make charcoal or brush strokes one at a time, your subconscious will remember that each stroke is part of the whole.

When you're drawing on paper larger than 8 x 10 inches, step back after each sweep of the charcoal; if you're painting, step back after every brush stroke. This requires discipline at first, until it becomes a habit. Relax and look at the whole view of your two-dimensional surface from a distance; it's impossible to see space relationships accurately when you're too close to the picture. This is just what the professional does in the process of solving his own problems in creating a picture: he keeps the picture in a state of unified order by continually stepping back to view the painting or drawing as a whole.

Intuitive spacing of the whole picture area

Do you know that spacing things intuitively is just as easy and as natural as breathing? You do it in everyday life. When you arrange furniture in a room or when you hang pictures on the wall, you're exercising artistic intuition. You're arranging forms in space. This intuition is part of an inner desire to express order, unity, and balance; when achieved, this spatial harmony gives you an inner satisfaction.

That's why, when objects are placed too close to each other in a room, you have a sense of being cramped; not until you separate them, creating a spatial relationship between the objects to satisfy your inner feeling, do you feel comfortable. Furthermore, not until you view the room as a whole, from all sides, do you feel that your intuitive spacing functions satisfactorily. Spacing is intuitive, it's not something you learn in school or from your parents.

In a drawing or a painting, you use the same intuitive ability to organize, change, and eliminate shapes and lines until they, and the spatial intervals between them, "feel right." This includes the negative shapes—the spaces—surrounding the subject matter.

If you approach the task of looking with relaxation and serenity, you'll discover that the power to organize and compose a picture is *already* yours to command. This innate power is just waiting to be confirmed and developed.

Forget perspective for the time being

According to the dictionary, a dimension is a measurement in any one direction. A room, for example, has three dimensions: length, width, and height. So have the objects within a room. But a drawing or painting surface has only two dimensions: length and width. The third dimension—depth—is an illusion created by various artistic devices. One of these devices is perspective: the eternal problem facing the beginner who's learning to draw or paint in the traditional manner.

"How can I keep my mind on intuitive spacing when I'm concerned with making a drawing that shows the illusion of three dimensions in accurate perspective?" This is the question usually asked.

I suggest that you forget about perspective for the time being. I don't mean to imply that the third dimension—the illusion of depth—is unimportant. It's very important. But my purpose is to establish your perception in two dimensions—your feeling for what happens on the *surface* of your paper or canvas—before you begin to think in terms of three dimensions. I repeat: a painting which does not succeed in two dimensions can rarely, if ever, be a work of art in three dimensions.

I suggest that you just keep drawing. Let yourself go and don't think about perspective or any other problem. Space the elements in your drawing intuitively, without worrying about the outcome. Strong inner feelings, expressed in drawing or painting, will more than compensate for any "crudeness" and lack of perspective. Remember, we're interested in unifying the whole; we're not disturbed by the parts. The parts, you'll find, will begin to improve in quite an unexpected way as you proceed, without your applying conscious effort.

I'll discuss the problem of perspective and three dimensions in a later chapter. At that time, the explanation will have more meaning for you than now.

4
How to be stirred to action by a photo

THE FOURTH METHOD of unlocking your imagination makes use of black and white photographs or art reproductions. This method is especially helpful if you actually need to *see* things before you can decide what to draw or paint.

In addition to the subject matter in a photograph—a subject which may stir you to action—the photo (or reproduction) has a number of other advantages. Looking at a photo, you'll find it easier to relate shapes to a whole, because the photograph is rectangular, just like the drawing paper. It's easier to see light and dark relationships, because the problems of color are eliminated. It's easier to see relationships as a *whole,* because the photograph is small. Finally, it's easier to see shapes and values on the flat, two-dimensional surface of the photograph than in *actual* three-dimensional subject matter.

How the masters used photographs or works of art

Of course, you may feel uneasy, even guilty, at the mere thought of using a photograph. You needn't be, provided that you use it properly. You certainly don't want to copy it. Nor do you want to come so close to copying that your drawing or painting retains the essence of the photo. In developing your creativity, you'll find that there's no need for copying.

Masters, throughout the history of art, have been inspired by the works of other masters. Some of them, it's true, actually copied. Matisse, for example, copied a painting attributed to the Dutch painter, De Heem (Fig. 57). But they did so, in most cases, to learn how other masters obtained certain effects. We have no such purpose in mind. However, most of the masters *reinterpreted the subject matter* of the original. And this is exactly what Matisse did years later; note how different Fig. 58 is from the original. Matisse was inspired to create a *new* painting. He *adapted* to meet his own needs.

Such creative adaptation has been tried by the greatest artists. Raphael adapted figures from Michelangelo; Rembrandt, in turn, borrowed from Raphael as Figs. 59 and 60 show. And in our own time, Picasso is probably the most prodigious and creative adaptor of all, dipping into Greek and African sculpture, medieval manuscripts, Renaissance painting, as well as the art of his own contemporaries. He once said: "I'm the world's greatest thief." He meant, of course, that he didn't hesitate to reinterpret any material which inspired him to make it his own.

After the invention of the camera, artists such as Utrillo used the photograph as a starting point. Compare a photograph of a scene in Paris (Fig. 61) with

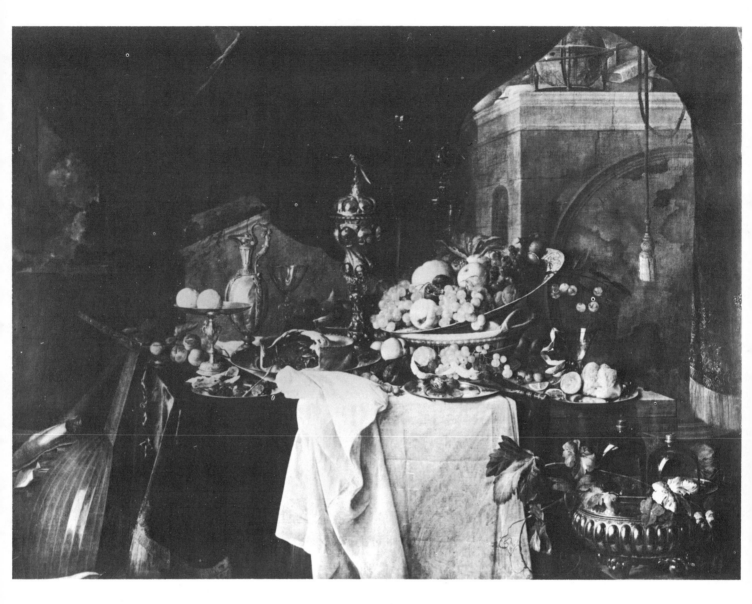

Figure 57 *Jan Davidsz de Heem (Dutch, 1606 ?–c.1684),
Le Dessert, 80″ x 58⅝″, oil, Louvre, Paris. This painting
was faithfully copied by Matisse early in his career.*

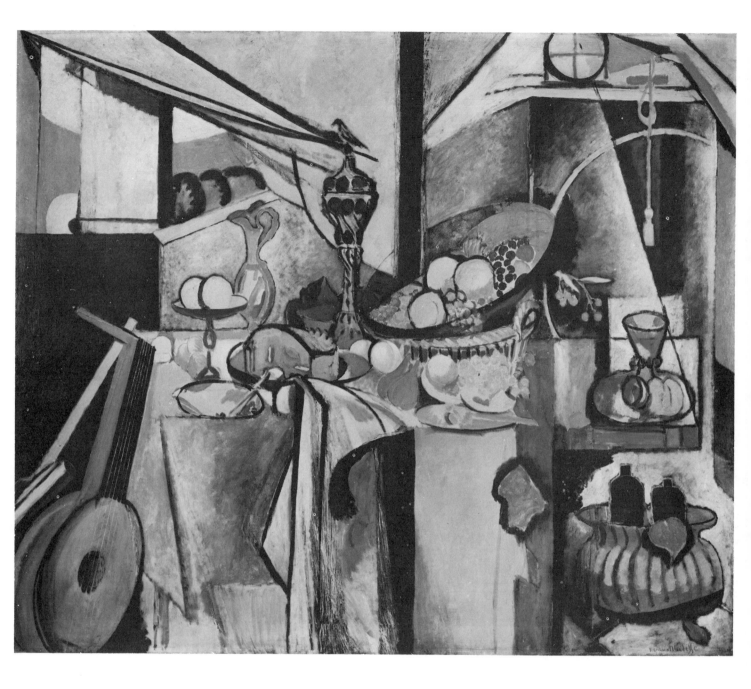

FIGURE 58 *Henri Matisse (French, 1869–1954)*, Variation on a Still Life by de Heem, *71¼″ x 87″, oil on canvas,* The Museum of Modern Art, New York. *This painting (created during 1915, 1916, or 1917) reinterpreted the subject matter of the original. This time, Matisse didn't copy, but* adapted *to meet his own needs.*

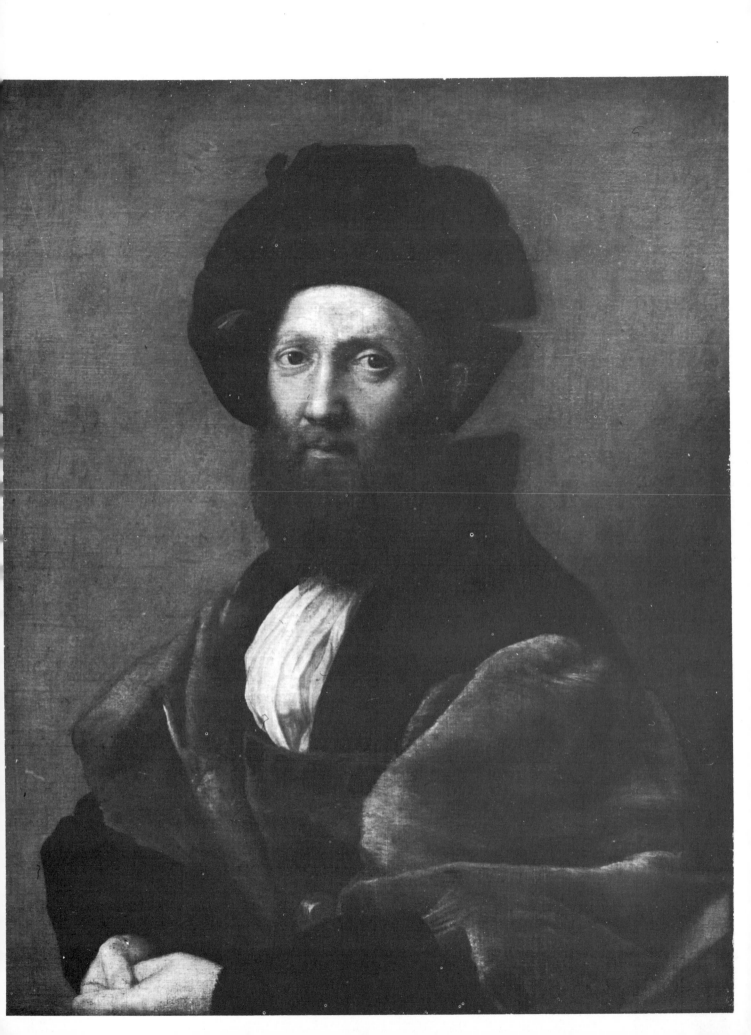

◀ FIGURE 59 *Raphael Sanzio (Umbrian, 1483–1520), Portrait of Castiglione, 32¼" x 26⅜", oil on canvas, Louvre, Paris. Creative adaptation has been tried by the greatest artists. Raphael adapted figures from Michelangelo; Rembrandt, in turn, borrowed from Raphael, as Fig. 60 shows.*

Utrillo's painting (Fig. 62). Degas and Eakins were inspired by photography, using the camera as a tool to study complex poses and movements. As early as the seventeenth century, the Dutch masters used an early version of the camera, before the invention of film; Vermeer studied his subject through the ground glass of this *camera obscura* to visualize his composition and to simplify his light and shade.

How to use a photograph or an art reproduction

Your first step is to collect and file every black and white photograph or art reproduction which attracts you. Magazines and newspapers are excellent sources. And for art reproductions, don't overlook art magazines, catalogs of art exhibitions, as well as art books.

Try to analyze why you like each photograph, or art reproduction, and what use you hope to make of it. Reviewing the preceding chapters, you may find that you particularly enjoyed working directly from your imagination and memory. In that case, a photograph of a landscape, seascape, figure, or any subject may not really function as a "guide," but may simply be the means of starting a new flow of memory ideas.

In Figs. 63 and 64, note how I used a photograph of an interior to start me off. In the drawing, I changed one window into a door. I moved or removed furniture. I also changed the shape of the rugs. Other items were added—not in the original photo—when I worked to adjust structural shape relationships as a whole. In working with a photo, the more changes you make, the more original your drawing becomes. And conversely, the less chance of your copying the original.

Now, let's say that you're attracted to the method in which you improvise in light and dark shapes (Fig. 65). But after you've balanced the improvised shapes all over and turned the paper four ways, you still don't visualize a subject you wish to develop. Here's where a photograph or a reproduction may be used to help you develop your lights and darks further. Looking at the photograph and then taking a fresh look at the distribution of lights and darks in your improvised drawing, you may very well start off with renewed energy and excitement. Figs. 65-71 show a demonstration of how to exploit this combination.

Another variation is to reverse this procedure. Let's say you're attracted to a photograph or reproduction, not for its subject, but for its balance of light and dark values (Fig. 72). You start with a blank sheet of drawing paper and introduce these values—more or less—all over the drawing surface (Fig. 73). Then, as in the light and dark improvisation method, you turn the paper upside down to check the balance of light

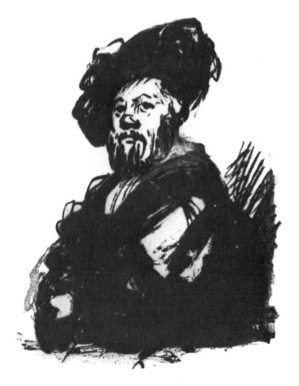

FIGURE 60 *Rembrandt van Ryn (Dutch, 1606–1669), Drawing after Raphael's Portrait of Castiglione (detail), Albertina, Vienna. Compare this drawing with Fig. 59. Later on, Rembrandt did a self-portrait based on this theme.*

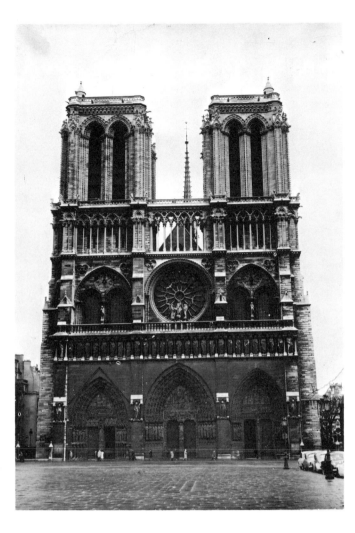

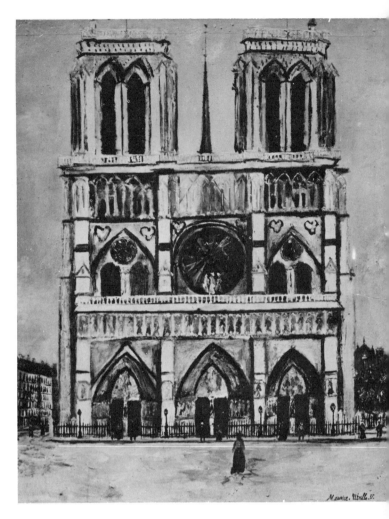

FIGURE 61 *Photograph, frontal view of Notre-Dame de Paris, courtesy, French Cultural Services, New York. Compare this photograph with the painting by Maurice Utrillo, Fig. 62.*

FIGURE 62 *Maurice Utrillo (French, 1883–1955), Notre-Dame de Paris, courtesy, French Cultural Services, New York. Compare this painting with the photograph of the actual scene (Fig. 61). At first glance, the painting may appear to be the same as the photograph. But it isn't. The painting doesn't conform to perspective. Instead, it's been adjusted and related to the spatial area of the canvas. Notice how the tower in the painting has been centered and raised, to add to the rhythmic spatial relationship of the whole. The placement of the four lamp posts also adds to the rhythm of the whole. So do the vertical windows in the lower left buildings; notice how they repeat the verticals in the fence. Finally, note how the verticals in the fence echo all of the verticals in the facade, right up to the top of the painting.*

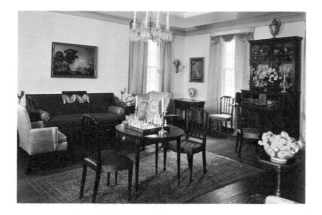

FIGURE 63 *Interior, Oyster Bay, Long Island, ca. 1800, The Benkard Memorial Room, The Metropolitan Museum of Art, New York. Compare this photograph with Fig. 64.*

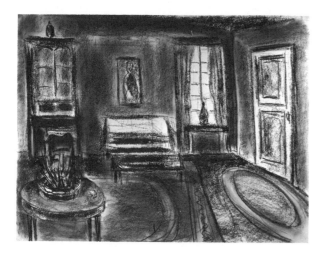

FIGURE 64 *Drawing of an interior. An example of what can be done by starting with the subject matter in a photograph. Using Fig. 63, I changed one window into a door. I moved or removed furniture. Other items were added. Notice how I changed the pattern of the rugs to relate structural shapes to the whole. In working with a photo, the more changes you make, the more original your drawing becomes; conversely, the less chance of your copying the source.*

and dark shapes as a whole. Now perhaps you're ready to think about the subject without using the photo at all.

Make no decision until you've turned the sheet four ways. If a subject suggests itself, develop it as you normally would from your light and dark shapes (Fig. 74).

Or make an arbitrary decision. Let's say you decide to impose a figure on the drawing, even though the photo started out as a seascape or landscape. The adjustment might involve more erasing and changing

than usual; you may have to subtract darks which interfere with your vision. Figs. 75-76 are a demonstration of this method.

If a photograph or reproduction attracts you, the chances are that you'll develop your own method of using it. For instance, try looking at photos *upside down to sideways* to stimulate your imagination for subject matter. The series in Figs. 77-80 is an example.

Or *combine* photos (or works of art, as Rembrandt did in Figs. 81, 82, and 83) using suggestions from each to compose an original picture. Figs. 84-86 demonstrate how this can be done.

Your next assignment is to try any one—or all—of the methods I've demonstrated. Until you find your own photos, I suggest you use those reproduced here. If these are used properly, your results should be original, although you've started from the same source as I used. Here are examples made by different students from a photo of a subway flood in New York (Figs. 87-90). Note how individual each one is.

A photo of the actor, Donald Pleasance (Fig. 91), was the basis of two student drawings (Figs. 92 and 93) and my *Kabuki Dancer* (Fig. 33).

Look for the ideal photograph or art reproduction

As you remember, you work for shape relationships first, then for light and dark. The way to avoid a lot of effort is to look for the ideal photograph or reproduction. It's not easy to find, but discovering one will give you a great deal of pleasure.

The ideal photograph has a subject which attracts you, together with a variety of large shapes. Most important of all, look for the photo with a strong structural shape motif, built in, as well as a possible submotif. Make sure that the contoured shapes are close to the four edges, even if you have to trim the edges of the photo to obtain the effect. In addition, if you find that the light and dark values are balanced all over, you're that much more ahead. The photo of the subway flood (Fig. 87) is an example of an ideal photograph. Fig. 94 is another.

The kind of photograph to avoid may very well be the one which attracts you the most. It usually has too much going on, a lot of fidgety detail—too many lines. This simply means that you're attracted to variety of line. There's nothing wrong with your liking for line, as you'll find when we discuss the subject in a later chapter.

However, at this stage of your development, you don't want lots of lines unless they're *contoured into large shapes*. These shapes will become painting areas later. Unless handled as contoured shapes, lines present special problems which I'm purposely avoiding

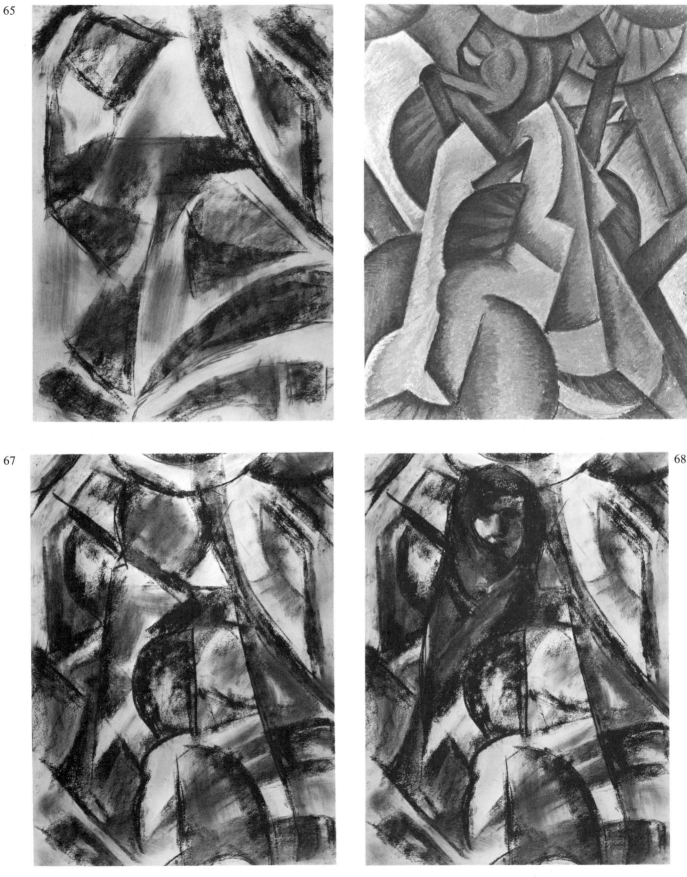

65

66

67

68

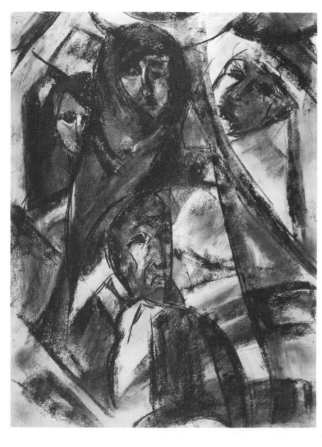

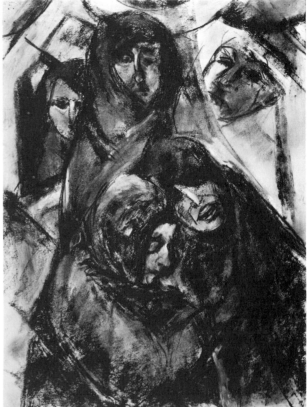

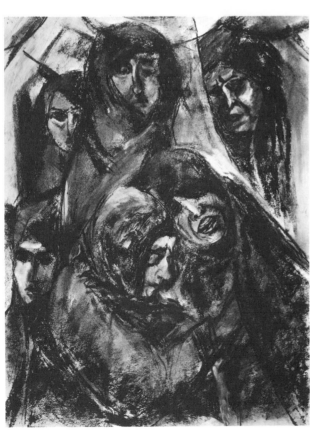

FIGURE 65 *An example of improvised shapes in light and dark values, balanced as a whole, by student Florence Bohanan. This is just the beginning. Let's assume that I've turned the example four ways and still don't visualize a subject. Looking at a photograph—then taking a fresh look at the distribution of lights and darks improvised in the drawing—may start me off with renewed energy. The following photograph (Fig. 66) did that for me.*
FIGURE 66 *Arthur G. Dove (American, 1880–1946),* Pagan Philosophy, *21⅜" x 17⅞", pastel, The Metropolitan Museum of Art, New York. As soon as I saw this painting, I felt that certain shapes in the painting belonged in the improvised drawing. The first changes in the drawing are shown in Fig. 67.* FIGURE 67 *Here's the improvised drawing adjusted after viewing Dove's* Pagan Philosophy *(Fig. 66).* FIGURE 68 *I turned the adjusted improvised drawing four ways. Each way suggested a subject that could be developed. It turned out to be a figure with a shawl.*
FIGURE 69 *As I looked at the figure, I began to think of the women at Nazaré, Portugal—the constant threat of tragedy in their lives, the fishermen lost at sea. I changed and distorted her expression as I began to feel the sensation of tragedy. A figure emerged to the left, plus the faces of two fishermen who had lost their lives.* FIGURE 70 *As the feeling of tragedy mounted in intensity within me, I eliminated the face of one fisherman. In his place, I felt the desire to substitute his family in grief.* FIGURE 71 *In the final stage, I eliminated the second fisherman and substituted his mourning wife. The face of a younger member of the family emerged at the lower left.*

FIGURE 72 *John Marin (American, 1870–1953), Sea and Ledges, Green and Brown, 15½" x 20½", watercolor, The Metropolitan Museum of Art, New York. I was attracted to this watercolor not for its subject, but for its balance of light and dark values.*

FIGURE 73 *Starting with a blank sheet of drawing paper, I introduced the values—more or less—of Marin's* Sea and Ledges (*Fig. 72*) *all over the drawing surface. I then turned the paper upside down to check the balance of light and dark shapes as a whole. I was now ready to think about a subject. The photo had served its purpose. I made no decision until I turned the sheet four ways. I liked it best in this position, upside down, which suggested a still life with fruit.*

FIGURE 74 *Compare this drawing of still life with fruit with Fig. 73, which was a drawing of values based on Marin's* Sea and Ledges (*Fig. 72*) *turned upside down.* FIGURE 75 *I started a second time with the drawing of values (Fig. 73) based on Marin's* Sea and Ledges (*Fig. 72*). *This time I used*

it right side up. I decided to impose *a figure on the drawing, even though the painting started out as a seascape. In this first stage, I angled the figure in opposition to the angle of the mountain ledge. I found little need for erasing.*

FIGURE 76 *In the final stage, I added a bouquet of flowers. I felt the need for circles to repeat the circular movements in the background. Notice that the large triangular shape of of the figure repeats the two triangular areas which divide the painting. The mountain, now extended down to the lower right, makes a huge triangle, if you include the left edge and lower edge of the drawing paper. The same diagonal (the mountain plus the upper and right edges) makes the second triangle.*

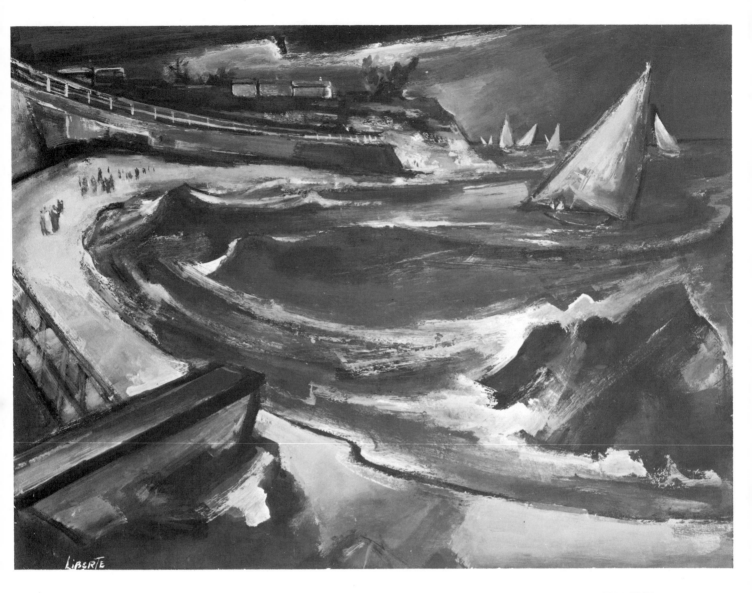

FIGURE 77 *Louis Jean Liberte* (*American, 1896–1965*),
Beach at Rockport, *20½" x 27¾", watercolor on card-
board, The Metropolitan Museum of Art, New York. I
turned this painting to the right to find a hooded figure.*

FIGURE 78 *Starting with a blank sheet of drawing paper, I introduced the values and shapes—more or less—of Liberte's* Beach at Rockport (*Fig. 77*).

FIGURE 79 *As I began to model the figure and work on the face, I evoked a spiritual mood just drawing intuitively.*

FIGURE 80 *In the final stage, the diagonal in the upper left suggested the figure of Christ on the cross. Other lights and darks were added to keep the whole in balance. The shape above the head needed the halo to break up the area and to enhance the spiritual mood.*

FIGURE 81 *Pisanello (Veronese, 1395–1455)*, Gian Francesco Gonzaga, *medal, British Museum, London. Rembrandt used this and Fig. 82 to compose his etching,* The Three Crosses (*Fig. 83*).

◀FIGURE 82 Horsetamer, *from the Capitol in Rome. Detail of the engraving inscribed, "Romae 1584, Claudii Ducheti Formis". Rembrandt used the* Horsetamer *and Fig. 81 to compose his etching,* The Three Crosses (*Fig. 83*).

FIGURE 83 *Rembrandt van Ryn (Dutch, 1606–1669), detail of* The Three Crosses, *slightly enlarged and reversed, etching, The Pierpont Morgan Library, New York. As scholar, Ludwig Munz, has pointed out, Rembrandt used suggestions from Pisanello's medal,* Gian Francesco Gonzaga (*Fig. 81*) *and the engraving of the* Horsetamer, *from the Capitol in Rome (Fig. 82) to compose this etching.* ▶

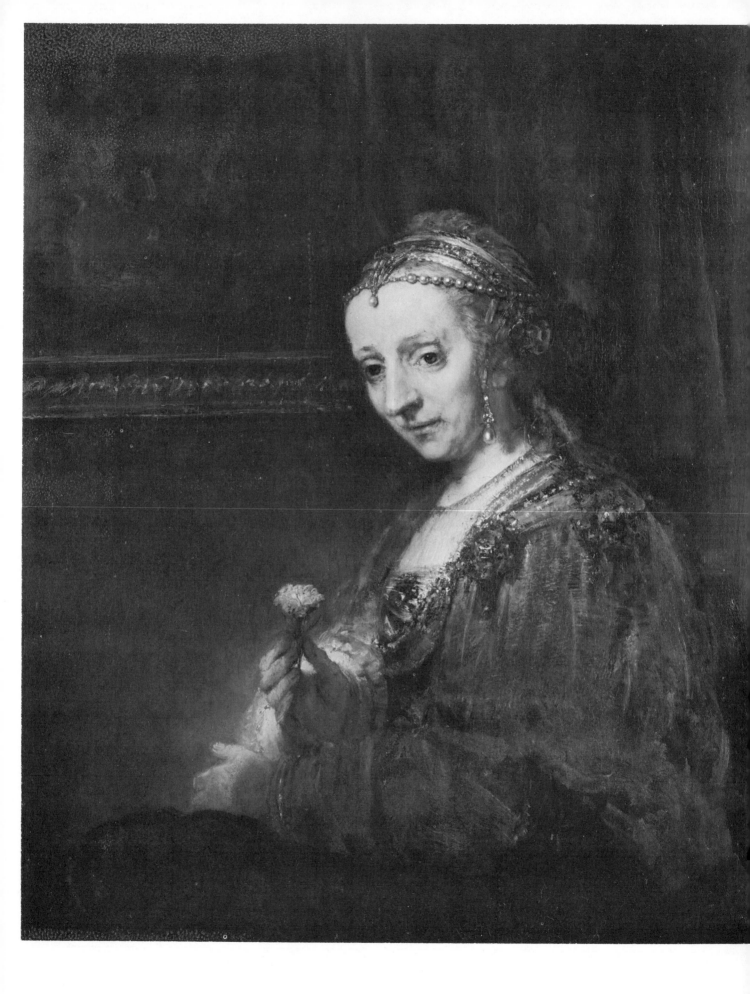

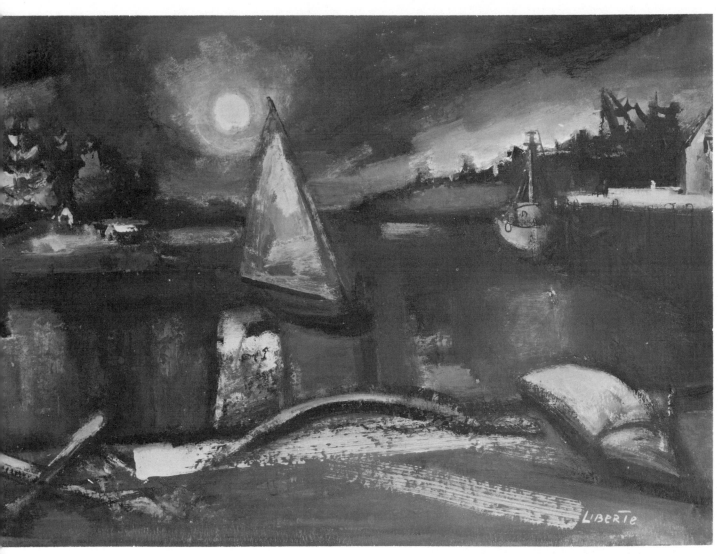

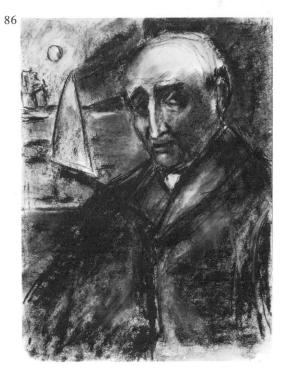

86

◀FIGURE 84 *Rembrandt van Ryn (Dutch, 1606–1669)*, Lady
with a Pink, *36¼" x 29⅜", oil on canvas, The Metropolitan
Museum of Art, New York. I combined photographs of this
painting and Liberte's* Night *(Fig. 85) to compose an
original drawing (Fig. 86).*

FIGURE 85 *Louis Jean Liberte (American, 1896–1965),*
Night, *22½" x 27½", gouache on cardboard, The Metro-
politan Museum of Art, New York. I combined photographs
of this painting with Rembrandt's* Lady with a Pink
(Fig. 84) to compose the following drawing (Fig. 86).

FIGURE 86 *In looking at photographs of Rembrandt's
painting (Fig. 84) and Liberte's painting (Fig. 85), I
visualized a man who was vitally interested in the sea and
boats. The upper left hand corner of Rembrandt's painting
suggested an area which I opened to portray the sea.
Notice the vertical of the nose in Rembrandt's painting and
how I utilized it to help create a vertical in the drawing—
from the top edge, down through the man's nose, to the
vertical in his coat below.*

87

88

89

90

FIGURE 87 *Photograph of a subway flood in New York City,* The New York Times. *Until you find your own photos, I suggest that you use those reproduced in this book. If they're used properly, your results should be original, although you've started from the same source I've used. Fig. 88, 89, and 90 were made by different students from this photo.*

FIGURE 88 *Painting by student, Dorothy Kamsly. She turned the photograph of the subway flood (Fig. 87) upside down. The shapes and values suggested this painting of a freight car siding.*

FIGURE 89 *Painting by student Stella Conklin. The photograph of the subway flood (Fig. 87) suggested a barn to her.*

FIGURE 90 *Non-objective painting by student, Jean Sherr. She turned the photograph of the subway flood (Fig. 87) to the left to create this abstract painting.*

FIGURE 91 *Actor, Donald Pleasance in* The Caretaker. *Photograph by Sam Siegel. My drawing of the* Kabuki Dancer *(Fig. 33) is based on it. So are the paintings done by students, which follow.*

FIGURE 92 *Painting by student, Emanuel A. Korchnoy, based on the photograph of Donald Pleasance in* The Caretaker *(Fig. 91).*

FIGURE 93 *Painting by student, Marie Haines, based on the photograph of Donald Pleasance in* The Caretaker *(Fig. 91).*

until much later in this discussion. Here's a sensitive painting (Fig. 95) in which line predominates. But such a reproduction is not good for our immediate purpose. When you come to painting, how are you going to control all these insistent lines to effect some degree of sensitive feeling? Until you've learned how to handle the lines, you'll be disappointed with the results, which invariably turn out to look harsh and far from sensitive, like so many amateur paintings.

Making a copy original

Despite what I've said in this chapter, you may find yourself intrigued with copying. Not that you want to plagiarize someone else's work; you just may find copying relaxing. This is understandable, because copying requires no creative effort. Creative decisions, on the other hand, always require effort because you're constantly changing and adjusting things. These decisions are always challenging. And for that very reason, they can result in original works of art because you're expressing your true inner self.

Let's say that, for once, you find yourself *copying* a photograph and enjoying it. The photo has many lines or little detailed shapes and you've had the fun of drawing them all. At this point, your drawing is neither original nor will it be easy to paint, even if you wanted to. But you can, if you wish, make it original: something that would express yourself and something that you can use for painting later. Here's how to go about it.

Take a rag and break up some of the little areas into larger shapes. Smudge the lines to make light and dark shapes. Turn the sheet upside down and work for shape relationships, then light and dark relationships. By the time you turn it right side up, chances are that the stamp of your personality will predominate. The drawing will cease to be a copy.

Summary

By this time, I feel sure you've made progress in at least one respect. You should have less fear or doubt about your ability to evoke a picture from your imagination or memory. This step should not be as difficult to accomplish as you once thought.

In fact, you may possibly have reached the point where you've forgotten your initial doubts. And for a very good reason. New doubts and questions may have arisen to take their place.

You may be far from happy about the state of some of your drawings. Some may "feel" right, but others may not. Naturally, the latter are the ones which annoy you. And the questions arise, "What should I do now? How can I improve them to the point where I feel they're complete?"

The suggestions you've been given so far to improve them have been rather sketchy, because the main emphasis was on Step One—releasing an image visually. What you now require is a broader and deeper amplification of the same material. This will be unfolded in Chapters 5, 6, 7, and 8 to follow.

91

92

93

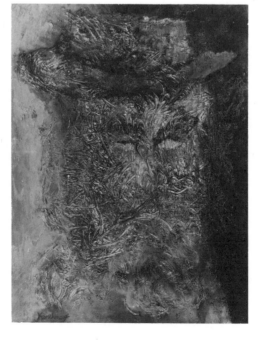
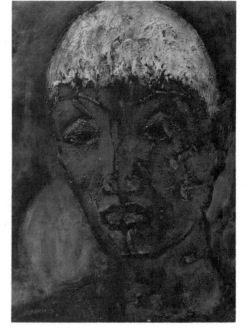

FIGURE 94 *Skimming slag. Photograph by Andes Copper Mining Company, Chile. Example of an ideal photograph for the purpose of abstracting or adapting. It's balanced both in shape and value relationships.*

FIGURE 95 *Ch'ên Shun (Chinese, Ming Dynasty 1368–1644), River Landscape, 7½ ″ x 12⅞ ″, scroll: ink and color wash on paper, The Metropolitan Museum of Art, New York. Here's a sensitive painting in which line predominates. But it's not good for our immediate purpose of creative adaptation. When you come to painting, how are you going to control all these insistent lines to effect some degree of sensitive feeling? Until you've learned how to handle the lines, you'll be disappointed with the results, which invariably turn out to look harsh and far from sensitive, like so many amateur paintings.*

5
How to
analyze paintings

THERE'S ONE SURE WAY to improve your work. Find out more about what makes a painting an effective work of art.

The first step is to get set mentally. Make up your mind to concentrate less on developing technical skill, for the time being, and concentrate more on improving your vision. The idea is to learn to *see* things as you've never seen them before. Where you once saw only details in a painting, strive now to perceive the underlying unity. Where your eye once skimmed surfaces, it should now penetrate to the heart of shape and form. I hope you'll now see the things you've missed. And the things you've seen should now take on definition and vitality.

First *look;* then think. Everything must be firmly based upon what you *see*.

How do you look at a painting?

All right, let's find out what you *see* when you look at a painting. Let's examine a painting by the sixteenth century Italian artist, Andrea Mantegna (Fig. 96). It's entitled *St. Jerome* and now hangs in the São Paolo Museum in Brazil. I've chosen a relatively unknown painting on purpose so that you can approach it with a fresh vision. Take your time and study it carefully. Venture a judgment. Is it an effective work of art?

Every group of beginners offers the same sort of answers. "Yes, it's a great painting; after all, it's by Mantegna." "It must be good; it's hanging in a museum." "Yes, it's beautiful." "Yes, it tells a story." "No, I don't like it."

These aren't really helpful answers. The first two answers assume that a given painting must be good because a famous artist painted it or because a museum bought it; such answers are based on reasoning, not on looking—not on *visual perception*. The painting *could* be a very early work by a master, full of his confusions and struggles. A museum might own such a painting purely for historical reasons.

"Yes, it's beautiful" doesn't tell us anything about the painting either. The painting may be beautiful to you and ugly to someone else. Or you may find it beautiful today, but stale and boring tomorrow. It may be merely a matter of personal taste, which proves nothing.

It's also true that this painting tells a story. Unlike many modern paintings, there's something understandable going on. We can easily recognize each detail. But not every painting with a story is good.

And whether you *like* a painting or *dislike* it still doesn't answer the question: is it good? Again, this is just personal taste.

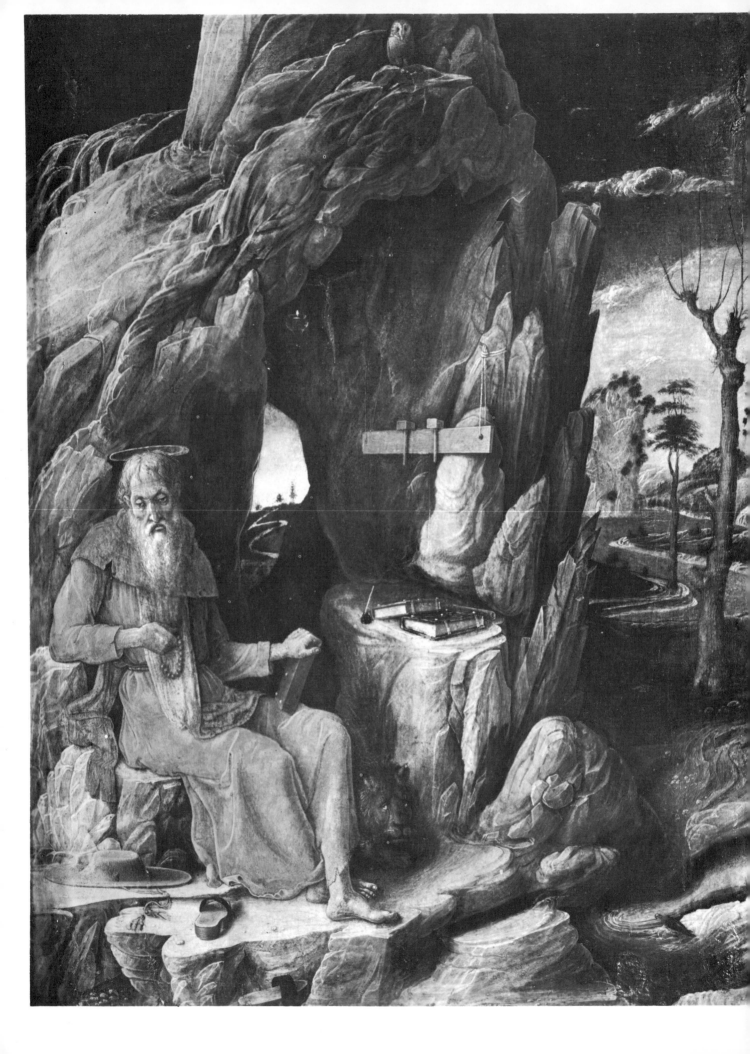

FIGURE 96 *Andrea Mantegna (Paduan, 1431–1516), St. Jerome, 19″ x 14¼″, tempera on panel, Museu de Arte, São Paulo, Brazil. There's one sure way to improve your work. Concentrate less on developing technical skill, for the time being, and concentrate more on improving your vision. The idea is to see things as you've never seen them before. For example, what do you see when you look at this painting?*

FIGURE 97 *Schematic diagram of Mantegna's St. Jerome. First look for the largest shape you can find. You should see a tremendous geometric oval, formed by the cave itself.*

FIGURE 98 *Schematic diagram of Mantegna's St. Jerome. Notice other ovals in the painting, no two of which are exactly alike in size or shape.*

FIGURE 99 *Schematic diagram of Mantegna's St. Jerome. Certain areas of the painting lie outside the main and contrasting geometric shape-motifs. Here, these negative shapes are in the sky areas. Mantegna considered these negative shapes just as important as his subject. Notice how he balanced one negative space against another.*

FIGURE 100 *Schematic diagram of Mantegna's St. Jerome. Can you find other shapes that act as contrasting submotifs? You might have seen horizontals. The artist painted the forearms in a horizontal position. Hold up a finger to block out the board at the entrance to the cave; Decide whether you need that horizontal. The horizontal helps to break up an otherwise large and uninteresting space.*

Two basic standards in judging a painting

But there *are* objective criteria for determining the true quality of a painting. And standards for judgment come, believe it or not, *from life itself.*

We always have moods and feelings. By turns, we're carefree and anxious; pleased and angry; surprised and bored; impulsive and contemplative; active and restful; now cast down, now lifted up again. Do we choose these moods? No, they're generated by our own subconscious activity. But they're always with us, always important, and seldom contrived or forced. Where there's no feeling, there's no life. And, similarly, where there's no feeling, there's no art!

This is our first principle: for a painting to be successful, it must demonstrate a certain quality of *feeling.* A distinct mood must come across to you. What these qualities *are* will be discussed in a later chapter. In Mantegna's *St. Jerome,* we feel the quiet, contemplative *mood* of the scholar, as the artist has rendered him.

But feeling doesn't exist by itself. It's always paired with some sort of structure, as I've mentioned earlier. Think of dancing. Dancing is full of feeling, but it's always supported by rhythm; and rhythm itself is supported by the larger patterns of the music. Dance has a definite beginning, development, and conclusion. So, too, in painting. To support feeling, there must be *structure.*

This is our second principle: the entire two-dimensional painting surface must be *organized.* To put it in the words of Arthur Dow, a famous art teacher, "It must fill a space in a beautiful way."

In life, in the dance, and in painting, both *feeling* and *order* should correspond to our own intuitions. They are not meant to be forced constructions, imposed from the outside. Therefore, we don't have to *work* for them so much as *release* and *develop* them.

Analyzing a painting for shape relationships

Let's return now to *St. Jerome.* Why is the central figure placed over to the left? Why does the artist put a landscape to the right of the cave? Why, unlike most caves, is this one open in back? Why is there a bare tree on the far right? Look carefully and try to find the answers for yourself.

Here are some hints. First, look for the largest shape you can find. You should see a tremendous geometric *oval* (Fig. 97). It's formed by the cave itself. Are there any other ovals in the painting? Yes, several. Notice the oval hat by St. Jerome's feet. Notice the halo. And see how his head and beard form an oval, which is reinforced by their contain-

ment within the larger oval of head, beard, beads, and vestment, all combined. The window in the back of the cave suggests still another oval. The road and lake in the landscape give you two more. And now look at that tree on the far right. See how its branches arch up and to the left. As you follow that line, you'll see how the bottom of the cloud picks up this line, how it's continued through the top of the cave, and how it brings you back to the figure of St. Jerome again. Thus, the landscape, cave, and central figure are united in a single shape, a great oval.

We may say, then, that this painting contains geometric shapes that are *rhythmically related,* quite apart from the subject itself. The term, *rhythmic,* whether in music or painting, implies several repetitions of a movement; the repetitions are related to each other, but are *varied* enough to be interesting, not monotonous. If we consider the oval of the cave as the main shape motif, then the halo and all the other ovals are rhythmically related to the cave and to one another. Schematically, it looks something like Fig. 98.

Can you find any other shapes that act as contrasting submotifs? Just as there are secondary motifs in music, so they exist in painting. The shapes you might have seen are horizontals (Fig.100). Note how the artist painted the forearms in a horizontal position. The wooden board at the entrance to the cave has an important rhythmic relationship to them. Test it yourself: hold up a finger to block out the board; look at the rest of the painting. Now take your finger away and decide for yourself whether you need that horizontal. The chances are that you'll say *yes.* The horizontal helps to break up an otherwise large and uninteresting space.

The blocking-out test is one of the simplest means of checking any creative work. There are still other horizontals. See if you can find them yourself. Also, see if you can find another submotif—the triangle—and see how it's repeated rhythmically.

Negative shapes

Please observe now that certain areas of the painting lie outside of these shape motifs. We call these the *negative shapes.* They're often bordered (in part) by the edge or edges of a canvas. Negative shapes are very important and you'll learn more about them later.

But for the present, think of them this way. You have a figure in the landscape; above this, there's a negative shape, the sky. But the artist considers this negative shape just as important as his subject, so he makes sure to relate this shape to the rest of the

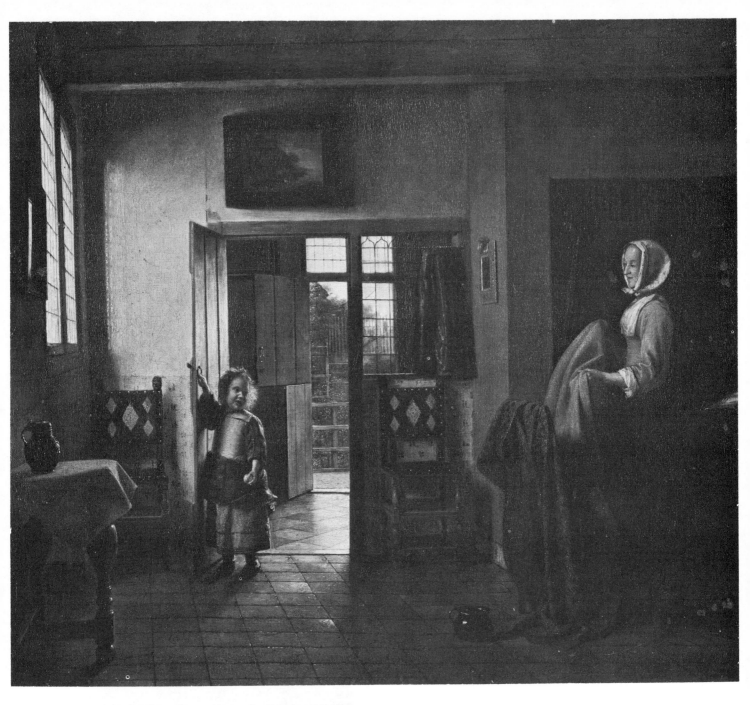

▲ FIGURE 101 *Pieter de Hooch (Dutch, 1629–1683)*, The Bedroom, *20″ x 23½″, oil on canvas, National Gallery of Art, Washington, D.C. The main geometric shape motif is the rectangle. Don't underestimate the simplicity of the rectangle. It has within it the strength and solidity of a building block. Note how the whole surface is broken up into a variety of rectangular blocks, no two alike. As a main shape motif, the rectangle has an added advantage: it's automatically related to the rectangular shape of the canvas. Observe that the figures in the painting don't interfere with the rhythmically related rectangles.*

◀ FIGURE 102 *Schematic diagram of the contrasting motif in deHooch's* The Bedroom. *Curves or arcs, in contrast to the verticals, and horizontals of the rectangles, help to vitalize the painting.*

painting. In *St. Jerome,* Mantegna balances one negative space against another. The sky on the upper left (bordered or *contoured* by two edges of the canvas, as well as two edges of the cave) is related to the sky on the upper right; they aren't related in an exact geometric way, but by repeated sharp angles.

Moreover, the larger sky area on the right is broken up by clouds, so that it contains variety within itself. The variety in the *positive* shapes of the clouds is assisted by variety in the *negative* shapes—the interval *between* the clouds (Fig. 99).

To summarize, we can now begin to see four important points. In testing the relationship of the *parts* of a painting or drawing to the *whole,* the subject matter is seen as two-dimensional massed shapes, like flat pieces of a jigsaw puzzle. The largest shape (or shapes combined) forms a dominant geometric motif, which helps to divide the entire surface of the canvas, including the negative shapes. Shape motifs are rhythmically repeated with variation. And submotifs provide further variety by contrast with the main shape motif.

On the basis of these observations, we can conclude that Mantegna's *St. Jerome* does satisfy the requirements of both feeling and structure. Therefore, it's an effective work of art. Of course, we've made only a beginning. So far, we've considered only two-dimensional *shape relationships.*

Analyzing a painting for light and dark relationships

Now, let's look at the painting once again, this time for light and dark relationships. Half close your eyes. Squint to bring the subject matter out of focus. Do the value relationships "feel right" as a whole? Yes, there's a balanced over-all distribution of light and dark.

Remember how to test it? If you feel that some area seems to stand out too prominently in relation to the whole, block it out. Then look at the rest of the picture as a whole. Next, take your finger away and compare your feeling of the whole once again. If an area feels wrong, you'll know it immediately.

Trust your intuitive reactions to help you to judge. Don't complicate the procedure or feel uneasy because you find it simple to do. The important point is not to strain. Do just the opposite of what the athlete does. He usually gets set by tightening his muscles. To get set in evaluating art, *let down.* This may sound silly, but I assure you that it's very important. Consciously check to make sure that you *sit down,* and that the muscles of your entire body are free and not tight. A good way to do this is to exercise them for a moment, then consciously come to rest. Your physical state does affect your psychological state, as every doctor knows.

Some more examples

I've discussed the importance of developing keener visual perception as a means of improving your work. Now we're going to concentrate on reinforcing your perception and broadening your experience. While all this is an absolute necessity for the creative artist, it's also a source of deep satisfaction in art appreciation.

Once again, let me remind you that we're still considering only the two basic structural elements; variety of two-dimensional shapes, rhythmically related to each other and to the whole; and variety of light and dark values, harmoniously balanced as a whole.

You'll recall that in Mantegna's *St. Jerome* the dominant shape motif was the oval. In Fig. 101, a painting by the seventeenth century Dutch painter, Pieter de Hooch, the main shape motif is distinctly different: the rectangle. Don't underestimate the simplicity of the rectangle. It has within it the strength and solidity of a building block. Note how the whole surface is broken up into a variety of rectangular blocks; no two are alike. As a main shape motif, the rectangle has an added advantage; it's automatically related to the rectangular shape of the canvas.

Observe that the figures in the painting don't interfere with the rhythmically related rectangles. Was this placement of the figures an accident? No more than the placement of St. Jerome in Mantegna's painting. Nor was there any accident in the placement of Madame Charpentier and her children in Renoir's painting (Fig. 14). Remember, subject matter is always subordinated to the whole. A good painting is always integrated as one rhythmically related whole.

The contrasting motif in the De Hooch painting may be more difficult to find. The schematic outline in Fig. 102 may help . . .

What about light and dark? Half close your eyes to throw the subject matter out of focus. *Feel* the placement of light and dark over the entire surface. It's mostly dark, as you see. A lot of dark can be balanced by a little light.

Study another example by the fifteenth century French miniature painter, Jean Colombe (Fig. 103). The main geometric shape motif? The triangle (Fig. 104). The figures are triangulated and so are the beams overhead. Submotif? Verticals. Look carefully for rhythmically related verticals. You'll find them, not only in the posts, but in other unexpected places. Note particularly how the beams break up the negative space of the sky into a dynamic variety of two-dimensional shapes. Test this painting for distribution of

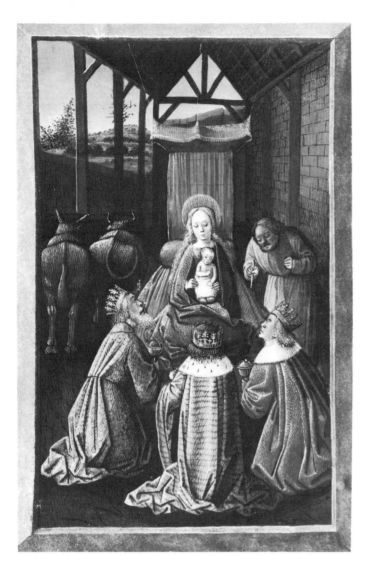 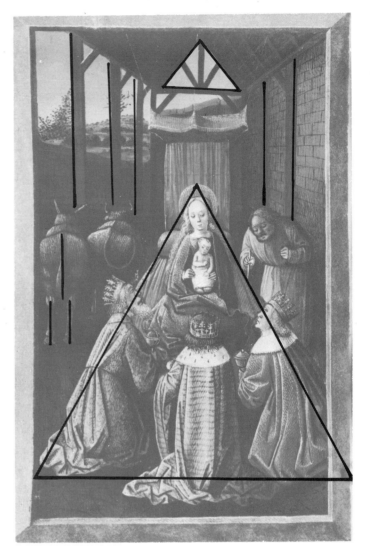

FIGURE 103 *Jean Colombe (French, active 1467–1529),*
Adoration of the Magi, *5¾″ x 4½″, opaque watercolor
and gold on vellum, The Pierpont Morgan Library, New
York. Developing keener visual perception is important as a
means of improving your work. After reacting to the mood
of a painting, consider the two basic structural elements:
variety of two-dimensional shapes, rhythmically related to
each other and to the whole; and variety of light and dark
values, harmoniously balanced as a whole. In this case, what
are the main motif and submotif?*

FIGURE 104 *Schematic diagram of Jean Colombe's*
Adoration of the Magi. *The main geometric shape motif?
The triangle. The figures are triangulated and so are the
beams overhead. Submotif? Verticals. Look carefully for
rhythmically related verticals. You'll find them not only in
the posts, but in other unexpected places. Note particularly
how the beams break up the negative space of the sky into a
variety of two-dimensional shapes.*

light and dark. Feel the balance. Feel how the painting is *unified as a whole* by this light and dark distribution.

Fig. 105 shows the work of the great Flemish painter, Hans Memling. The main motif? Verticals, which carry right up to the top. The edges of the black cloak and the white sleeve are verticals. He's making an artistic statement in verticals. They give a feeling of uprightness and strength. Observe how much dark there is in this painting. It takes only a few carefully selected areas of light to balance against the darks; again there's total distribution, a balanced, unified whole.

You're aware that by now we've seen a number of shape motifs: ovals, rectangles, triangles, verticals, horizontals. And you'll probably remember that, in each case the painting has been a scene of quiet movement or repose. Mantegna's *St. Jerome* sits in quiet meditation. Cikovsky's landscape (Fig. 36) is also calm. While there's motion in the De Hooch, the painting is reposeful as a whole. So with the Colombe and the Renoir. And so, too, with the Memling. How do you portray tension, action, violence?

The use of the diagonal as a basic shape motif is a very simple way to convey action, danger, tension. John Steuart Curry has done just this in his painting of trapeze artists (Fig. 106). Do you see how the diagonals create the feeling of suspense? Notice how variety is obtained: some diagonals are wide, others narrow; some are short, others long. Can you find the submotif? The oval. Notice how the variety of light and dark is tied in with the submotif of the oval. One shadow is a light oval, another dark. And the oval of the body hurtling through space is both light and dark.

Finally, there's the spiral motif. A symbol of organic growth and development, it's seen, for example, in seashells. In Sassetta's painting, the spiral motif unifies three episodes in the journey of St. Anthony (Fig. 107), ending in his meeting with St. Paul.

This poetic, deeply moving painting may appear naive to the beginner. In fact, if you're used to the academic way of painting, you may consider Sassetta crude. The clusters of leaves look like large raspberries. There are no shadows under the trees.

Actually, it's a most sophisticated painting, with a mood that's lyrical and a structure that's completely integrated.

There are no two tree trunks exactly alike. The negative space *between* the trees is handled with unerring sensitivity: no two intervals of space are alike. Even the clusters of leaves are all varied in size and shape.

The spacing of the figures provides an exciting lesson in tension pulls. Test the pull between the upper left figure and the lower right figures. Block out the upper left figure with your finger and look at the rest of the painting as a whole. The area in the upper left cries out for a shape consistent with the lower right shapes of St. Anthony and St. Paul. Now remove your finger. The figure of St. Anthony in the upper left is an *absolute must*. It adds dimension to the painting. We feel the tautness in our musculature as we experience the tension between the upper and lower figures.

Now repeat the blocking out process. This time cover the centaur and St. Anthony on the upper right.

Finally, check this painting out for the distribution of light and dark as a whole. Then, notice how Sassetta varied the values in the figures. The upper left robe is all dark. The upper right robe shows more light than dark. The robes of St. Anthony and St. Paul are balanced in light, dark, and gray.

The schematic diagram (Fig. 108) shows the main motif of the spiral with contrasting triangles. The other submotif, not illustrated, is the vertical repeated in all the tree trunks.

Are geometric shape motifs contrived?

Amateurs often fear that geometric shape motifs devised by the masters are mechanical and intellectual You may also wonder if geometric shape motifs are emphasized at the expense of feeling.

First, let me say that in the paintings of the masters —and in all good paintings—the expression of feeling is fundamental.

Second, although the masters concentrated on shape motifs, it was *not* at the expense of feeling. On the contrary, shape motifs, themselves, appear to arouse feelings and emotions in us. From earliest times, the unconscious has supplied geometric shapes with symbolic and emotional content. We see a circle and we unconsciously think of the romantic moon. Or we see a triangle and associate it with the stability and strength of the mountain. The horizontal merely repeats the axis of the body at rest. And so when our eyes feast on the horizon at sea, we associate this motif with a feeling of rest. If you give this a moment's thought, many other examples will come to your mind.

Finally, geometric shape motifs are not contrived but arrived at *intuitively*.

The primary concern of the masters, to repeat, was *feeling*. Feeling is the foremost factor in art. Feeling must be expressed on a flat surface, bound by the four edges of the canvas. If we create order and rhythm within this entire geometric area, whatever feeling we

FIGURE 105 *Hans Memling (Flemish, c.1430/35–1494),*
The Presentation in the Temple, 23½″ x 19″, oil on wood,
National Gallery of Art, Washington, D.C. The main
shape motif? Verticals, which carry right up to the top. The
edges of the black cloak and the white sleeve are verticals.

He's making an artistic statement in verticals. They give a
feeling of uprightness and strength. Observe how much dark
there is in the painting. It takes only a few carefully selected
areas of light to balance against the darks; again, there's
total distribution, a balanced unified whole.

FIGURE 106 *John Steuart Curry (American, 1897–1946),*
The Flying Codonas, *1932, 36″ x 30″, tempera and oil on*
composition board, Whitney Museum of American Art,
New York. The use of the diagonal as a basic motif is a very
simple way to convey action, danger, tension. Curry has done
just this. Do you see how the diagonals create the feeling of
suspense? Notice how variety is obtained: some diagonals
are wide, others narrow; some are short, others long. Notice
how the variety of light and dark is tied in with the submotif
of the oval. One shadow is a light oval, another dark. The
oval of the body hurtling through space is both light and dark.

seek to express will be *enhanced and strengthened*. Without the unified and harmonious organization of geometric motifs, as well as light and dark relationships, the feeling will be limited, or even lost entirely.

However, there *is* a danger. If geometric shapes are contrived intellectually and drawn self-consciously, they'll lose their magic and will remain mechanical drawings without feeling.

How shape motifs evolve intuitively

How can we recognize whether a shape motif has been evolved intuitively, not intellectually? Only through the freedom of the lines. When shape motifs are arrived at intuitively, you *feel* the *searching* and *groping* of the lines as they move to *find* the shape motif as it relates to other shapes and the four edges of the surface. This is the process of intuitive two-dimensional spacing. On the other hand, when the shape motifs are consciously contrived, the lines which contour the shapes are usually rigid and mechanical.

Compare the four drawings of Michelangelo called *David Slaying Goliath* (Figs. 109-112). Michelangelo was naturally interested first in recording the struggle between the two figures in the most forceful way. Thus, he repeated the theme with more or less variation. But look how the shape motif of the triangle evolved. In the first drawing, the geometric shape motif (if you can call it a triangle) is far from clear. But we can deduce that at some point between this and the next drawing, Michelangelo must have felt the triangular motif; it is so strongly evident in the second, third, and fourth drawings.

The next example is a drawing by Rembrandt called *Joseph Interpreting Dreams in the Prison* (Figs. 113-116). We have no record of the sequence of creation. I imagine that the center figure and the standing figure on the left were drawn in first, because the lines are thin and nervously drawn. It's quite possible that he then added the arc above, creating the large oval shape motif. Perhaps part of the right hand figure was started at the same time. But the fact that some lines are much heavier than others makes me think that these lines were added later.

In any case, the line at the bottom of the right hand figure sweeps around to interlock with the middle figure. Thus we have a second smaller oval, combining both figures. This oval echoes the main motif. I imagine that Rembrandt tied in the right hand figure with the left hand figure later. Notice how the feet of the right hand figure extend close to the foot of the left hand figure. Also, notice that the left hand figure's foot shows heavy lines drawn over light ones to make the tie-in more noticeable. The heavy, broken line

of the right hand figure's robe reinforces this tie-in. Notice how the line swoops down from the shoulder to the feet, continuing the movement up the foot of the standing figure. Finally, I imagine that the remaining negative space, above the figures, was broken up by heavy vertical lines. These lines, felt intuitively, created varied vertical areas as a submotif.

The final example is a series of compositional studies in pencil, plus the finished mural of Picasso's *Guernica* (Figs. 117-121). In the first tentative study (Fig. 117), the details are hardly discernible. Yet we can see the rectangle motif emerging, as well as the submotif of the circle. Notice that the lines are fluid and free, integrated, and felt intuitively as a whole.

In the next study illustrated (Fig. 118), the rectangle motif and more circles and arcs are clearly evident as the subject matter begins to emerge. In the third of this series (Fig. 119), the subject matter is more defined. The rectangle motif is now very clear. Many of the remaining shapes are now angular.

In the fourth study (Fig. 120), the subject matter has been changed and expanded. Sharp contrasting light and dark values help to clarify the shape motifs. The angular shapes have been unified into the triangle motif. The rectangle motif is still very strong.

In the final mural (Fig. 121), the subject matter has been shifted, modified, and expanded once again. The value relationships are more varied than in the preceding study. The contrasts of light and dark create a feeling of more ease in the spatial intervals. The stark symbolism of man's inhumanity to man is expressed with dynamic frenzy. This mood is structured by the dominant triangle motif. The rectangle is a close second.

Compare the finished mural with all the studies in the series. Notice that the shape motifs (as well as values) are always present, always important, and always integrated.

Is one painting more important than another?

A word of caution about judging art. There are many different ways of approaching the subject. If you're not careful, you can get sidetracked very easily.

For example, on occasion I'm asked whether one painting is more *important* than another: Is Leonardo da Vinci's painting, *Mona Lisa,* greater than Mantegna's *St. Jerome?* That's a good question, but a complicated one. Don't attempt, at this time, to judge whether one masterpiece is more important than another. Save this for later on. At the end of the book, you'll find a reading list for more advanced study of such questions.

Right now, don't disperse your energy. Let's simply

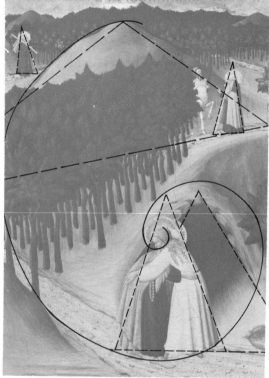

FIGURE 107 *Sassetta (Sienese, 1392–1450)*, The Meeting of St. Anthony and St. Paul, *18¾″ x 13⅝″, oil on wood, National Gallery of Art, Washington, D.C. This poetic and deeply moving painting may appear naive, even crude, to the beginner who is used to conventional painting. The clusters of leaves look like large raspberries. There are no shadows under the trees. Actually, it's a most sophisticated painting, with a lyrical mood and a completely integrated structure. There's great variety of shape relationships. The clusters of leaves and tree trunks are all varied in size and shape. The negative space between the trees is handled with unerring sensitivity. The spacing of the figures provides an exciting lesson in tension pulls. Block out the upper left figure and look at the rest of the painting as a whole. Now remove your finger. The upper left area cries out for the triangular figure. Notice how Sassetta varied the values in the figures. The upper left robe is all dark. The upper right robe shows more light than dark. The robes at the bottom are balanced in light, dark and gray.*

FIGURE 108 *Schematic diagram of Sassetta's* The Meeting of St. Anthony and St. Paul. *The shape motif of the spiral unifies the three episodes. Contrasting submotifs are the vertical and the triangle. Notice how Sassetta varied the size and shape of the submotifs. The vertical submotif (not illustrated) is repeated with variation in all the tree trunks and negative spaces between the trees.*

109

111

0

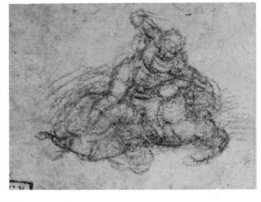

112

FIGURE 109 *Michelangelo Buonarroti (Florentine, 1475–1564), David Slaying Goliath, 2″ x 3⅜″, drawing, The Pierpont Morgan Library, New York. In this first drawing of a series, Michelangelo was interested in recording, in the most forceful way, the struggle between David and Goliath. The geometric shape motif (if you can call it a triangle) is far from clear.*

FIGURE 110 *Michelangelo Buonarroti (Florentine, 1475–1564), David Slaying Goliath, 2¹³⁄₁₆″ x 4⁷⁄₁₆″, drawing, The Pierpont Morgan Library, New York. Compare this with Fig. 109. The triangular shape motif is strongly evident in this later drawing. We can deduce that at some point between this and the previous drawing, Michelangelo must have felt the triangular motif emerge.*

FIGURE 111 *Michelangelo Buonarroti (Florentine, 1475–1564), David Slaying Goliath, 2¾″ x 3⁷⁄₁₆″, drawing, The Pierpont Morgan Library, New York. In this third drawing, the positions of David and Goliath are more or less the same as in the second drawing. The shape motif is still strongly triangular.*

FIGURE 112 *Michelangelo Buonarroti (Florentine, 1475–1564), David Slaying Goliath, 2″ x 2¾″, drawing, The Pierpont Morgan Library, New York. In the fourth drawing, the position of David is reversed, with his right arm upraised —instead of the left arm, as in Figs. 110 and 111. However, the geometric shape motif remains definitely triangular.*

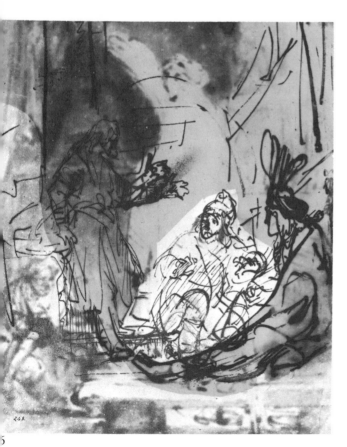

FIGURE 113 *Rembrandt van Ryn (Dutch, 1606–1669),*
Joseph Interpreting Dreams in the Prison, *6⅛″ x 7¼″,*
drawing, British Museum, London. How can we recognize
whether a shape motif has been evolved intuitively, not
intellectually? Only through the freedom of the lines. When
shape motifs are arrived at intuitively, you feel *the searching*
and groping of the lines as they move to find a shape motif.
On the other hand, when shape motifs are consciously
contrived, the lines which contour the shapes are usually
rigid and mechanical. FIGURE 114 *Detail showing the*
center figure and the standing figure on the left. I imagine
these figures were drawn in first, because the lines are thin
and nervously drawn. It's possible that Rembrandt then
added the arc above, creating the large oval shape as the
main motif. Perhaps part of the right hand figure was started
at the same time. FIGURE 115 *Detail showing the added*
figure on the right. Notice how the line at the bottom of the
right hand figure sweeps around to interlock with the middle
figure. Thus we have a second smaller oval, combining
both figures. This oval echoes the main oval motif.
FIGURE 116 *Detail showing the tie-in between the figures*
on the right and left. Notice how the feet of the right hand
figure extend close to the foot of the left hand figure. The left
hand figure's foot shows heavy lines drawn over the light ones
to emphasize the tie-in. The heavy broken line of the right
hand figure's robe reinforces this tie-in. The line swoops
down from shoulder to feet, continuing the movement up the
foot of the standing figure. Finally, the negative space above
the figures was broken up by heavy lines creating varied
vertical areas as a submotif.

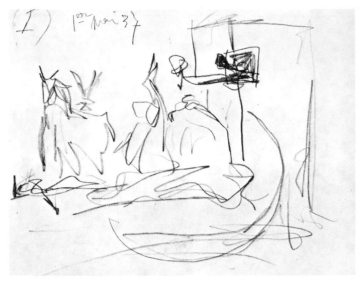

117

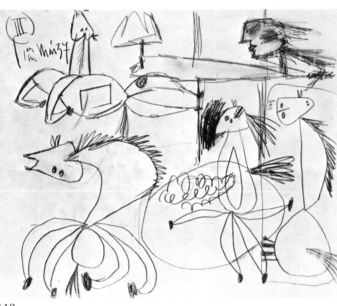

118

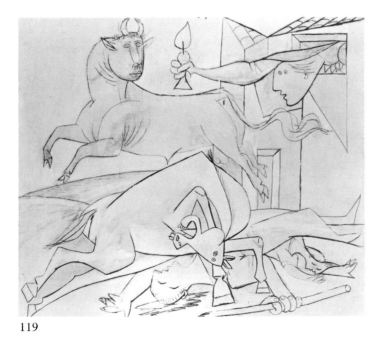

119

FIGURE 117 *Pablo Picasso* (*Spanish, 1881–*), Composition Study 1 for Guernica (May 1, 1937), *8¼″ x 10⅝″, pencil on blue paper, on extended loan to the Museum of Modern Art, New York, from the artist. This is the first tentative study, in which details are hardly discernible. Yet we can see the rectangle motif emerging, as well as the submotif of the circle. Notice that the lines are fluid and free, integrated, and felt intuitively as a whole.*

FIGURE 118 *Pablo Picasso* (*Spanish, 1881–*), Composition Study 3 for Guernica (May 1, 1937), *8¼″ x 10⅝″, pencil on blue paper, on extended loan to the Museum of Modern Art, New York, from the artist. In this study, the rectangle motif and more circles and arcs are clearly evident as the subject matter begins to emerge.*

FIGURE 119 *Pablo Picasso* (*Spanish, 1881–*), Composition Study for Guernica (May 2, 1937), *23⅝″ x 28¾″, pencil on gesso on wood, on extended loan to the Museum of Modern Art, New York, from the artist. In this study, the subject matter is more defined. The rectangle motif is now very clear. Many of the remaining shapes are now angular.*

FIGURE 120 *Pablo Picasso* (*Spanish, 1881–*), Composition Study for Guernica (May 9, 1937), *9½″ x 12⅞″, pencil on white paper, on extended loan to the Museum of Modern Art, New York, from the artist. In this study, the subject matter has been changed and expanded. Sharp, contrasting light and dark values help to clarify the shape motifs. The angular shapes have been unified into the triangle motif. The rectangle motif is still very strong.*

FIGURE 121 *Pablo Picasso* (*Spanish, 1881–*), Guernica (1937), *11′ 6″ x 25′ 8″, mural, oil on canvas, on extended loan to the Museum of Modern Art, New York, from the artist. In the final mural, the subject matter has been shifted, modified and expanded once again. The value relationships are more varied than in the preceding study. The contrasts of light and dark create a feeling of more ease in the spatial intervals. The stark symbolism of man's inhumanity to man is expressed with dynamic frenzy. This mood is structured by the dominant triangle motif; the rectangle is a close second. Compare the finished mural with all the studies in the series. Notice that the shape motifs (as well as values) are always present, always important, and always integrated.*

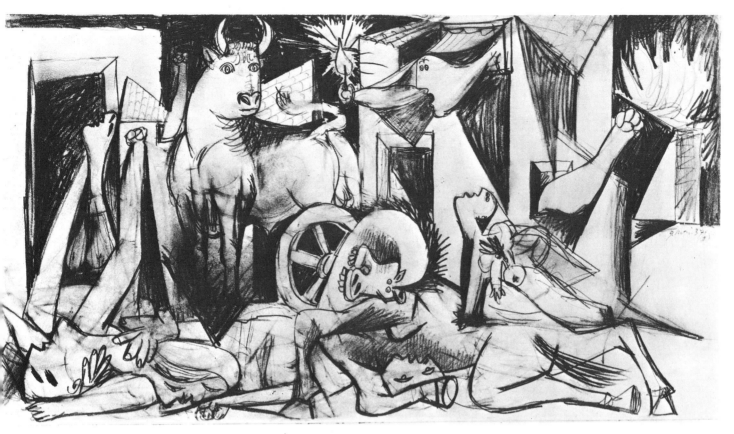

120

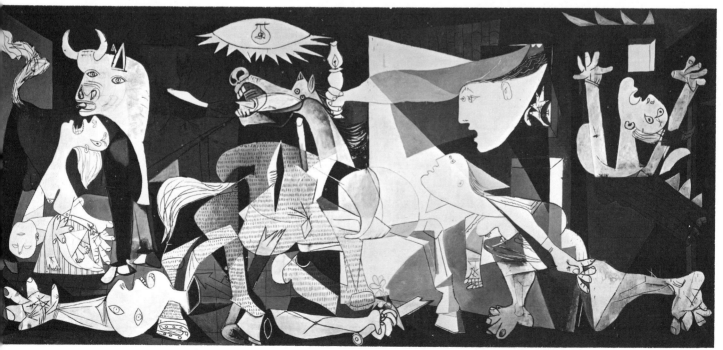

121

FIGURE 122 *How can this still life be improved? This problem was presented in class by a student. It has a certain amount of freedom and feeling, but not enough. The real problem is in spatial relationship. There's no main motif or submotif. Nor are the negative areas around the four edges broken up into shapes rhythmically related to the whole. Neither are the light and dark values balanced harmoniously throughout. Test this by turning the drawing upside down. In short, it needs value adjustment and intuitively felt spacing. Three stages of improvement follow.*

FIGURE 123 *I looked at figure 122, upside down. But first, I consciously remembered to let down—to relax. Immediately, I felt that the shapes were too crowded . I blocked out each shape in turn, looking at the whole each time then made my decision to retain the outer jugs and discard the rest. I felt the need for angled lines which automatically broke up the negative space. The spacing of the small vertical was important to stabilize the angles and curves.*

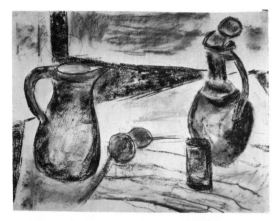

FIGURE 124 *I began to think about what to make of the upper part in Fig. 123. Even though I sat down and relaxed, there was no responsive idea. I decided, in the meantime, to work for light and dark. Later my unconscious began to respond. The space in the center needed further division. I added slightly curved lines which turned into a table mat; then I added an orange and a lemon. Now there was a tension pull between the fruit and the two small ovals at the top of the right hand jug. Finally, I added a glass, creating another tension pull with the vertical dark shape in the upper left.*

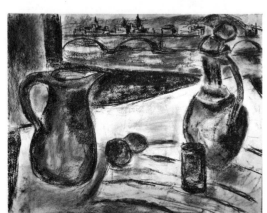

FIGURE 125 *After an interval of rest, I looked at the upper area again. It suggested a decorative wall panel, a painting on the wall or a window with an outdoor scene. I voted for the outdoor scene. But what? No response from the unconscious. I began to work for more light and dark distribution. As I was working, I sensed that a bridge with arches would rhythmically relate to the oval motif. Later I analyzed the drawing to find what I had done intuitively: the main shape-motif turned out to be a triangle, repeated and varied in size and values; the submotif was an oval. The drawing now had a feeling of space and balanced light and dark distribution.*

assume that a good painting is a good painting. Just keep looking at drawings and paintings to determine whether they have two basic requirements of art: feeling and structure.

I suggest that you study as many masterpieces as possible. Look to see how the masters avoided monotony and created a sense of movement by organizing the entire surface into a variety of two-dimensional shapes. See how these shapes were rhythmically related to each other and to the four edges of the canvas. Observe how the artist introduced the second organizing element—variety of light and dark values—which enhances the mood and feeling of the painting.

Why is all this so important? Because the more you study masterpieces for shape and value (light and dark) relationships, the more proficient you'll become in judging any drawing or painting—particularly your *own*.

Put your visual perception to the test

Here's an opportunity to follow through and test your visual judgment in a practical way. This problem was presented in class by a student. How can the still life in Fig. 122 be improved?

The first thing you do, as you look at it, is to ask yourself the following questions:

What's good about it?

Does it express a mood?

Does it have originality? For example, has something been created which never existed in just this way before?

What is the dominant two-dimensional geometric shape-motif?

Is the main motif repeated and varied in size?

Is it rhythmically related throughout the entire surface area of the paper or canvas, including the negative shapes?

What are the submotifs?

Are they varied and rhythmically related?

Are the light and dark relationships harmoniously balanced throughout?

Based on the answers to these questions, what improvement does the drawing need?

What's good about this drawing is that it has a certain amount of freedom and feeling. Does it have originality? Not really. But perhaps it'll become original by the time we check it out and improve it.

What's the dominant two-dimensional motif? It doesn't really have any. If you squint, as you look at the whole, the jugs and bottles *might* be unified into a large, oval shape-motif, covering most of the sheet. Such a motif has something in its favor: there are many small, varied ovals in the drawing already, and

these would repeat the main motif, varied in size. But would it be rhythmically related throughout the entire surface area, *including the negative shapes?* Look at the negative shapes and you'll see that the answer is *no*. Therefore the large, oval shape-motif is out.

In addition, the background contains two varied rectangles with the table edge separating them. Do they stand out strongly enough? Do you *feel* their presence enough to consider the rectangle as a contrasting submotif? I'm afraid not.

Are the light and dark relationships harmoniously balanced throughout? Not quite. Test this by turning the drawing upside down. Get away from subject matter. Where, for example, do you *feel*, intuitively, that the drawing needs more varied degrees of dark? In the upper left as a start, and in other negative areas, I'm sure.

In summary, then, the drawing needs improvement in the adjustment of value relationships. Equally important, it needs vitalizing in two-dimensional shape relationships. It needs a main motif and at least one submotif. In short, it needs *spacing intuitively felt*.

Of course, there are many ways of solving the problems. Here's how I went about it. Still looking at the drawing upside down and without regard to the subject, *I felt intuitively* that the objects (which to me are simply shapes) were too crowded. I blocked out each shape in turn, looking at the whole each time. I made my decision to retain the outer jugs and discard the rest. In the first stage of adjustment (Fig. 123), I narrowed one edge of the left hand jug and removed one handle. Then I added the spout of the jug above. The jug at the right was not changed, except that I added a line on its left side. I felt the need for an angled line for the table edge. I drew it, then immediately, added two other small angled lines to complete the table, each line a different length and varied in thickness. These two small lines automatically broke into the negative space to the right and to the left of the jugs. To judge the effect, compare it with the table area in the original drawing (Fig. 122).

The upper part now required attention. With the curves and angles now playing a strong part, I felt the need for a vertical somewhere to stabilize the action. Looking at the drawing as a whole, I drew *imaginary* verticals in various places. Had I felt confused or in doubt, I might have drawn a vertical on a small piece of paper and moved it about on the drawing to *find* the place intuitively. I placed the vertical where I *felt* the most effective spatial relationship to the whole. Finally, I connected one more angled line to meet the table. The division of space felt right. It was unified, yet varied. I sat down, relaxed, and for the first time began to think about what to make of the upper part.

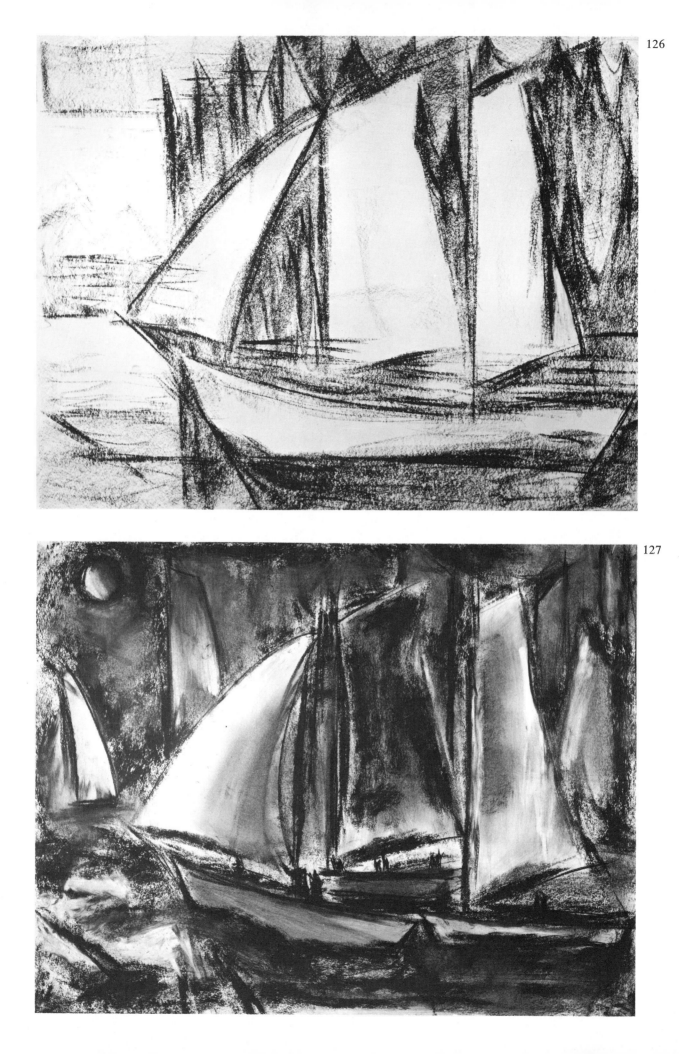

I let down and turned the problem over to my unconscious. I waited about five minutes. No response. I decided in the meantime to work, this time for light and dark (Fig. 124). I started first on the jugs, just a little to get me going. Then I turned the paper upside down and distributed darks wherever I felt they were needed as a whole. I followed the procedure as described in Chapter 2.

I sat down and studied the result again, both right side up and upside down. This time my unconscious began to respond. The space in the center needed a shape. My eye caught the two small ovals at the top of the right hand jug. The answer was some form of circular fruit. Then a second small oval shape was added. Now there was a tension pull between the top of the jug and the fruit. The space in the center still needed a further division. I added slightly curved lines in contrast with the angular lines I'd previously drawn. The new shape turned out to be some form of table mat. Finally, I added a glass, relating the shape to the vertical dark area in the upper left, creating another tension pull. I looked at the over-all result and quit, leaving to my unconscious the job of finding an answer to the upper area. It definitely needed something.

After an interval of rest, I sat down and looked at the upper area in relation to the whole, right side up, upside down, and sideways. The upper area could be a decorative wall panel, a painting on the wall, or a window with an outdoor scene. I voted for an outdoor scene, but what? No answer from the unconscious. I began to work for more light and dark distribution. As I worked, I sensed that a bridge with arches would

rhythmically relate to the oval motif. Shortly thereafter, the drawing was finished (Fig. 125).

Later, I analyzed the corrected drawing to find what I'd done intuitively. The main shape motif: triangle, repeated and varied in size and in light and dark. Submotif: oval. The drawing now had a feeling of space and balanced light and dark.

Fig. 126 is another problem presented in class by a student. In this case, the shape relationships are not bad. But they're not good enough—they're a little contrived. Also, if you check the list of questions I gave you a moment ago, you'll recognize that this drawing lacks a mood. Don't forget that you can inject a mood, or improve a mood, by working for a better balance of light and dark.

Once again, I turned the drawing upside down and began to work for variety in the shapes and in light and dark (Fig. 127). Notice that the middle sail is very dark, while the others are varied. Some sails have more light than dark; others have more dark than light. Compare the shapes in the corrected drawing with the original (Fig. 126). Notice how the shape of the boat in the corrected drawing was broken up into three varied shapes, creating three boats instead of one, giving a feeling of more space. See how the sails in the upper left were simplified and reduced to one shape. Then try to experience how this new simplified shape feels in relation to the larger sail in front of it; and in relation to the smaller sail inserted to the left. Notice, too, the changes made on the right side of the drawing. Finally, consider how a mood was created by working to improve value relationships.

FIGURE 126 *Another problem presented in class by a student. How can it be improved? The shape relationships aren't bad, but not good enough. They're a little contrived. Also, the drawing lacks a mood. Don't forget that you can inject a mood or improve a mood by working for a better balance of light and dark. At the same time, work for more varied shape relationships. Alternate by checking value and shape relationships. Sometimes, as you work for values, you sense the need for changes in shapes.*

FIGURE 127 *Here's how the problem presented in Fig. 126 was handled. Compare the shapes in this drawing with the original. I created three boats out of one, giving a feeling of more space and more variety of shapes. Sails in the upper left (in the original) were simplified and reduced to one shape. Feel its relationship to the larger sail in front and to the smaller sail inserted to the left. Mood was created by improving value relationships. Notice that the middle sail is very dark, while others have more light than dark, and vice versa.*

6
The sequence
of creativity

AT THIS POINT, you may be wondering about the sequence in which paintings "happen." What was Mantegna's procedure in painting *St. Jerome*? We have no written record, but we *can* speculate.

In painting *St. Jerome,* I don't feel that Mantegna started by drawing a large oval and then building the painting around it. I imagine that he drew his first sketch quickly and roughly, from his general knowledge of the subject. The process was partly conscious, partly unconscious. With nothing but a vague image of St. Jerome, the cave and the landscape, Mantegna went to work. The result was a sketch expressing the sum total of his inner feelings, stimulated by his memory of the theological implications of St. Jerome as scholar and hermit.

After he'd improvised as far as his excitement carried him, he probably relaxed and began the task of consciously analyzing the sketch, deciding what he liked and disliked about it and then deciding how to improve it. In studying the sketch, he might have been attracted to the oval shape of the cave, which evolved intuitively; he probably felt its rhythmic relationship to the head and beard of St. Jerome. And because the oval was the largest two-dimensional shape within the four edges of his rectangular drawing paper, he accepted the oval as the main geometric shape and related other shapes to it. The halo, frequently painted as a half circle, was made oval. The tree on the right, as well as the clouds and other shapes, were probably changed and adjusted in later trials until the entire painting surface was rhythmically related, unified as one intuitive whole.

The alternating process of creativity

The creative process, as you've just seen, alternates between feeling and reasoning. First you express your inner feelings unconsciously. Then your conscious intellect takes over to appraise the results, to decide what improvements are needed and where. This information is recorded instantaneously in the unconscious. As you relax and let your intuition take over, the unconscious helps to arrive at the judgments. The unconscious is then ready to support your emotional urge when you start to paint once again.

The amateur, unaware of this *alternating* process of creativity, tries to create and evaluate at the same time, with disastrous results. Worse still, he often tries to do both *consciously*. This is why amateur paintings, showing skill and craftsmanship, so often lack the required artistic qualities. The unconscious isn't given a chance to play its proper part. You, however, have been urged to let loose your unconscious. In fact, all of your assignments have been prepared with this in

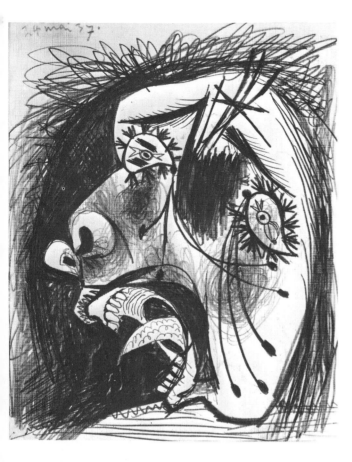

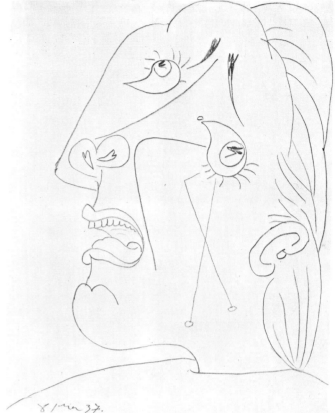

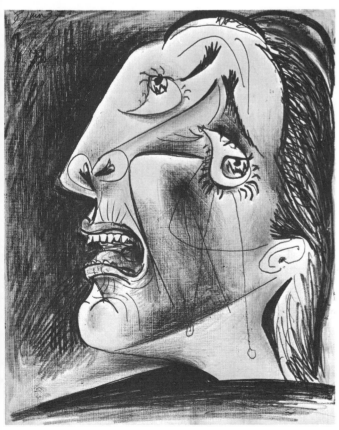

FIGURE 128 *Pablo Picasso* (*Spanish, 1881–*), Weeping Head, Study for Guernica (May 24, 1937), *11½" x 9¼", pencil and wash on white paper, on extended loan to the Museum of Modern Art, New York, from the artist. This is the first of a series of heads.*

FIGURE 129 *Pablo Picasso* (*Spanish, 1881–*), Weeping Head, Study for Guernica (June 8, 1937), *11½" x 9¼", pencil on white paper, on extended loan to the Museum of Modern Art, New York, from the artist. This is the second of the series.*

FIGURE 130 *Pablo Picasso* (*Spanish, 1881–*), Weeping Head, Study for Guernica (June 8, 1937), *11½" x 9¼", pencil, color crayon and wash on white paper, on extended loan to the Museum of Modern Art, New York, from the artist. This is the third of the series of the same subject.*

mind. And should your drawings (and later, your paintings) show obvious crude distortions, it won't make a particle of difference. They'll be considered artistic, provided that you permit your inner feelings to shine through and provided that you evaluate and organize these distorted shapes rhythmically, as a unified whole.

You need only *alternate* the unconscious and conscious processes until the picture is complete. You will then have an artistic result, even without the skill and craftsmanship so avidly sought by amateurs. But, as a matter of fact, as you proceed with this instruction, your skill will improve anyway. In time, your work will become more sophisticated, more skillful, *without sacrificing the artistic qualities.*

In your next drawing, begin to *alternate* the creative process. First, draw intuitively. Let yourself go, without consciously thinking, as far as you can. Then—and then only—evaluate the results. Here again, relax and let your unconscious help you find what needs to be improved. Beware of the urge to improve a *detail*. Evaluate the drawing as a *whole*. As soon as you've analyzed the drawing, don't key yourself up and start *consciously* to rework the picture. As you go back to work, let your intuition—your unconscious—take over again. Your unconscious already knows what to do next. Continue to alternate—feeling and reasoning—until you can't improve the drawing any further.

Repeating a drawing from memory

If you'll examine all the drawings you've done to date, you'll probably find that they vary in quality. Some are not good, many are fair, a few are very good. But keep them all, even the poor ones, as a record of your progress.

You may be disturbed by the large number of poor and fair drawings. The professional, however, looks at his output quite differently. You may not know it, but he, too, produces a lot of fair drawings and some downright failures. But he never worries about them. He knows that he must keep producing many in order to arrive at the few good ones. Only the good ones are the ones he exhibits. The failures he never shows to *anyone*.

The process, then, is like working a mine. You need to sift a great deal of ore to find a small quantity of precious gold. In art, you need to produce many drawings to find the few which will meet professional standards.

In preceding chapters, I suggested that when you can't go any further in improving a drawing, you start on a new one with a different subject. Your next assignment is this: when you can't go any further in

131

132

improving a drawing, *do it over*. Repeat the drawing from memory.

This procedure is common among professional artists. Here's a sequence (Figs. 128-130) of three by Picasso. The subject matter may shock you. Nevertheless, note how each one is unique, yet the theme is the same.

Robert Henri once said, "If you work from memory, you are most likely to put in your real feeling." The memory sifts and selects and embroiders relevant material. It retains only the material which is personal and original, provided that you learn to relax and let the unconscious go to work.

Repeating a drawing from memory is not as difficult as you might think. For one thing, you choose the one to repeat which appeals to you most. Repeating a theme rarely fails, because you develop a momentum which carries over from the earliest stage of the first drawing. Once you make a start, you'll repeat it fearlessly. You can afford to be fearless. Your original achievement is on record; it can't be denied. Therefore, you've nothing to lose by repeating it—and you've much to gain.

Whatever you do, don't keep the old drawing in sight. Don't even be tempted to take a quick peek during the creative phase. Nor should you try to remember any part of it consciously. There should be no conscious thought. Just express yourself daringly. Let yourself go.

Of course, repeating a theme from memory doesn't make sense unless you analyze each repetition before you begin another try. That's why we've been concentrating on developing basic standards by which you can evaluate your own work. Your skill in sensing and adjusting rhythmic shape and value relationships—which you've seen in the great masters—will spell the difference between mediocre and good work.

Your first step is to look over all the drawings you've done as you've read the foregoing chapters. Choose the drawing you like best. This is the one to repeat. As you repeat it, you'll note that it will have more detail; hence, it will look different. More important, you'll find it an improvement over the first. When you've finished the second try, allow an interval of at least a day to elapse. Then you can come back and analyze it with fresh vision. Permit the unconscious to help you find where it might be improved. Then do a third drawing of the same subject from memory. The new drawing, you'll discover, will prove to be still better. Continue to repeat drawing and evaluating until you can't go any further.

My own demonstration of how to repeat a drawing from memory started by looking at the Rembrandt and the Liberte paintings shown in Figs. 84 and 85. The first one in my series (Fig. 131) was done a few days after I had studied the photographs. When I started, I knew there would be some kind of boat showing through a window, also a figure of a man with a straight nose. The vertical thrust of the nose in Rembrandt's painting—and its relationship to the rest of the painting—still haunted me. When my drawing was finished, I analyzed its shortcomings very quickly. The negative space surrounding the boat bore little relationship to the rest of the drawing. The same held true for the negative space in the upper right hand area of the drawing.

In the second drawing done from memory (Fig. 132), the figure turned out to be a seaman. The vertical line of the nose is still there. This time the window overlooked a corner of a harbor. The light and dark values help the mood.

The next day, I decided to do a third drawing, the final one in the series, which you saw earlier in Fig. 86.

FIGURE 131 *The first of three drawings done from memory, started a few days after I'd studied the photographs of paintings by Rembrandt and Liberte (Figs. 84–85). I knew there would be a boat in the window, plus a figure of a man with a straight nose. The vertical thrust of the nose in Rembrandt's painting—and its relationship to the rest of the painting,—still haunted me. When this drawing was finished, I analyzed its shortcomings quickly. The negative space surrounding the boat bore very little relationship to the rest of the drawing. The same held true for the negative space in the upper right.*

FIGURE 132 *The second of three drawings from memory. Don't consciously concentrate on improving the spatial relationships in your previous drawing; you'll merely tighten up and your tension will be reflected in your drawing. Relax and have fun. Trust your unconscious to make corrections, intuitively. Your imagination hitches up ideas and offers suggestions for improvement as fast as you draw. In my second drawing, done as just described, the figure turned out to be a seaman. The vertical line of the nose was still there. This time, the window overlooked a corner of a harbor. The final drawing of the series was shown earlier (Fig. 86).*

7

How distortion improves a painting

D .H. LAWRENCE, well known as a writer, was also a painter. A critic said of his paintings, "They're all distorted; he can't even draw a straight line." "That's true," said Lawrence, "My lines are crooked, but they're *alive."*

There you have one good reason for distorting pictures.

Van Gogh, in a letter to his brother, wrote: "My great desire is to learn to make such inexactitudes, anomalies, changes, as give birth to lies, yes, call them lies if you will, but lies that are truer than the literal truth."

Van Gogh's distortion

As you know Van Gogh's intensely distorted paintings were not accepted by the general public for many years. Why? Because we wanted them to conform to the idea of "realism" we had come to expect in paintings. We were shocked by Van Gogh's paintings. And we resented them. "Are these modern artists painting with tongue in cheek? Are they showing off?" These were the thoughts which came to our minds when we first saw the work of Van Gogh and other modern artists. After all, we all resent being fooled; when we see unfamiliar things, we become wary—to protect ourselves from being hurt.

Says Louis Danz in *Dynamic Dissonance,* "We must learn in our understanding of art, not to be beguiled by that coating of realism which makes the painting attractive to the viewer, but which distracts him from *what lies beyond it."*

What lies beyond Van Gogh's paintings? Was he trying to shock us with his distortions? Was he insincere? Was he trying to make fools of his viewers? Apparently not, for today we've gotten used to his paintings. We relax with them and have grown to love them. In fact, we get a strong sense of excitement every time we look at them! Why? Because we've become aware of Van Gogh's true inner feelings, expressed in every painting. We *feel* his expressive power. His paintings haven't lost their excitement since the time they were painted. They're *vital and alive today*, years after his death.

With the example of Van Gogh in mind, we must accept the fact that distortion has an important role to play, if handled properly.

FIGURE 133 *Mathis Grünewald (German, c.1465–1528),* The Small Crucifixion, *24¼" x 18⅛", oil on wood, National Gallery of Art, Washington, D.C. What is the purpose of distortion? To* emphasize, *to create a feeling of tension—a sense of emotional power—by* exaggeration. *Notice the exaggerated indentations and bulges in the extended arms. Is this proportion or distortion? This fantastic distortion gives the painting its feeling.*

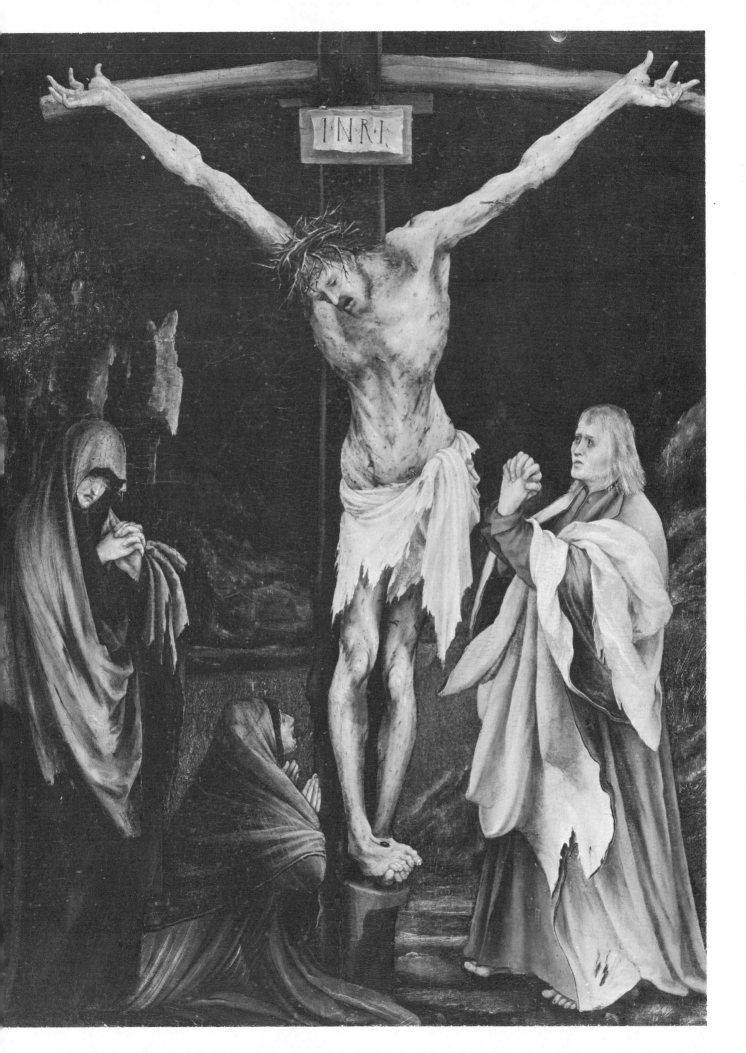

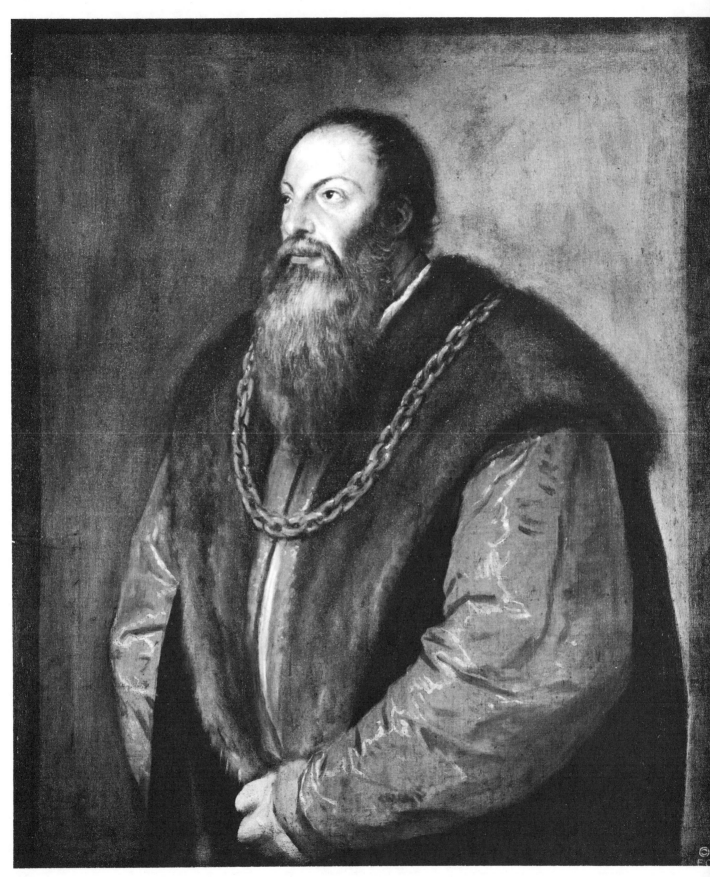

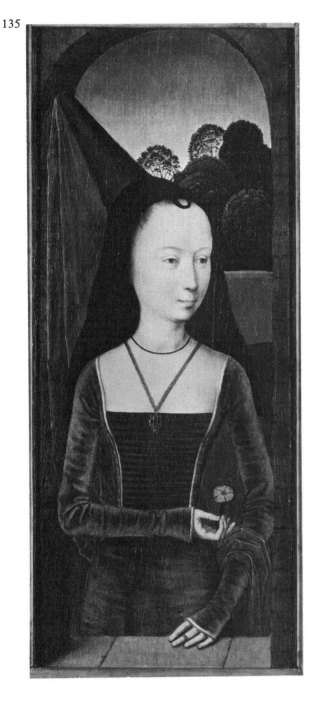

135

◄ FIGURE 134 *Titian (Venetian, c.1477–1576), Pietro Aretino, 40⅛" x 33¾", oil on canvas, The Frick Collection, New York. Titian knew exactly what he wanted to emphasize when he distorted this figure. In this painting he aimed to create a massive effect, a huge body, full of weight and authority. So he broadened the shoulders and chest out of all proportion.*

FIGURE 135 *Hans Memling (Flemish, c.1430/35–1494), A Lady with a Pink, 17" x 17¼", tempera and oil on wood, The Metropolitan Museum of Art, New York. In this painting, the head is large in proportion to the body and arms, creating an effect opposite to Fig. 134.*

The purpose of distortion

What is the role of distortion? What is its purpose? To *emphasize*. Distortion is a device, used by artists from earliest times, to create a feeling of *tension*—a sense of emotional power—*by exaggeration.*

Look at the Grünewald painting in Fig. 133. Notice the exaggerated, unrealistic bulges and indentations in the extended arms. Is this proportion or distortion? It's fantastic distortion; yet this distortion—and others—give the painting its feeling.

Now let's look at Titian (Fig. 134). Certainly he was one of the most famous Italian Renaissance painters, and one of the most sophisticated. In this painting of *Pietro Aretino,* he wanted to create a massive effect, a huge body, full of weight and authority. So he broadened the shoulders and chest out of all proportion. Titian knew exactly what he wanted to emphasize when he distorted this figure.

In the Memling portrait (Fig. 135), the head is large in proportion to the body and arms, creating an effect opposite to that of the Titian.

El Greco's elongation, a form of distortion

Next, compare these two paintings of *St. James as a Sojourner* by El Greco, one of the outstanding artists of the sixteenth century. We can learn a great deal from his work, especially because he repeated a subject many times over, sometimes with slight changes, other times with radical changes.

The first painting (Fig. 136) is from the collection of the Hispanic Society of America, in New York City. The second one (now lost) is from the collection of the late Baron A. Herzog, Budapest (Fig. 137). They are both good paintings. Each has its own individual mood. In each, the tonal values are different, enhancing the mood. Notice that the figures in both are elongated—another form of distortion and another tension builder.

But which of the two paintings is more dynamic? You'll probably say the Herzog painting (Fig. 137), and you'll be right. Let's find out why.

Compare the sinuous folds in the robes. El Greco created more variety of light and dark in the Herzog painting; notice this variety in the sky in contrast to the figure. So the tonal values in Fig. 137 are more dynamic than in Fig. 136. Just as important (if not more so) Fig. 137 is more dynamic because it's more elongated. In this way, El Greco created a more powerful figure. Notice that the figure also displaces more negative space: the head is nearer the top edge of the painting; the right edge of the painting is nearer the body; even the feet are nearer the bottom edge.

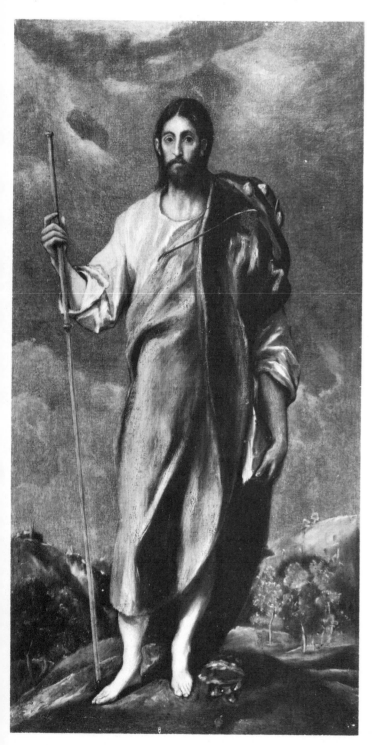

◄ FIGURE 136 *El Greco (Spanish, 1541–1614)*, St. James the Great, *24⅜" x 12½", oil on canvas, Hispanic Society of America, New York. Compare this painting with another version of the same subject (Fig. 137). Each has its own individual mood. Both are* elongated. *Elongation is another form of distortion, another tension builder. Observe how El Greco exaggerated for emphasis, how distortion builds up emotional excitement. But which of the two is more dynamic? You'll probably say Fig. 137, and you'll be right.*

FIGURE 137 *El Greco (Spanish, 1541–1614)*, St. James the Great, *36¼" x 18½", oil on canvas, lost, formerly in the collection of the late Baron A. Herzog, Budapest. There's more variety of light and dark in this painting than in Fig. 136. Compare the sinuous folds in the robes, the sky in contrast to the figure. The figure in this painting is more* elongated, *hence more powerful. Notice, too, that this figure displaces more negative space, creating more tension between the figure and the edges of the painting.* ▶

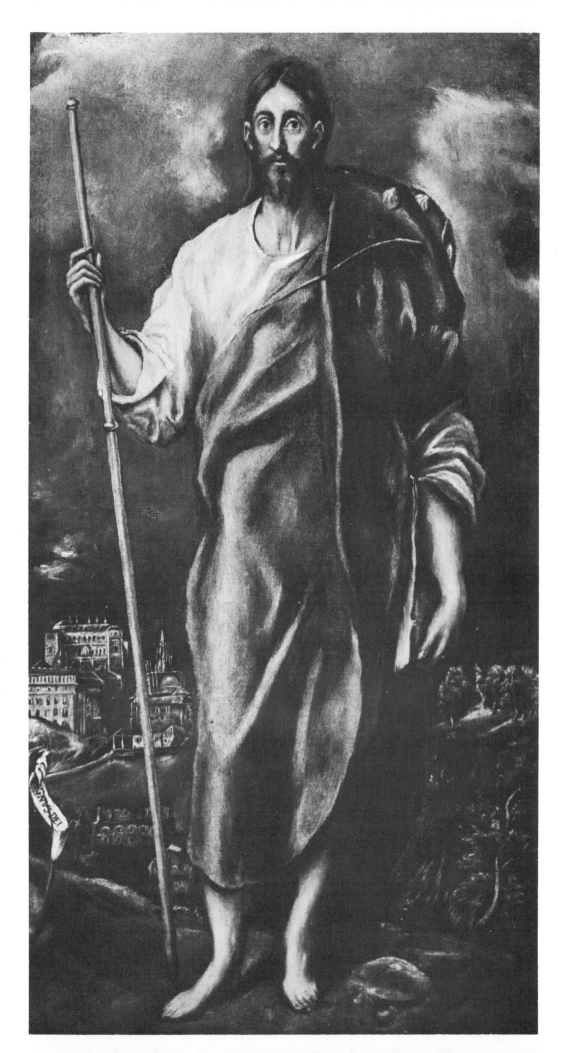

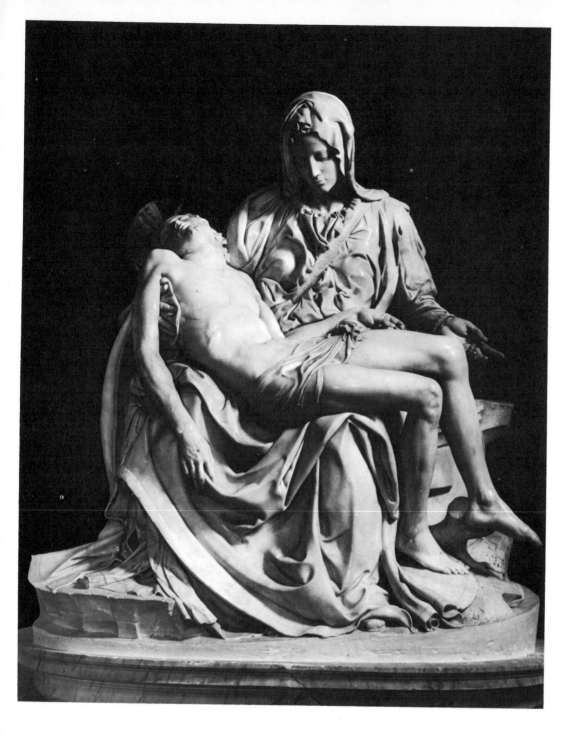

▲ FIGURE 138 *Michelangelo Buonarroti (Florentine, 1475–1564), La Pietà, sculpture, Basilica of St. Peter, Rome, photograph by Alinari-Art Reference Bureau. This finished pietà is perfect. Millions of persons admired it at the 1964–1965 New York's World Fair, when, for the first time in history, the statue was permitted to travel outside of Italy. But compare it with the unfinished pietà (Fig. 139). The latter is rough, far from "perfect." Yet, which of the two is greater?*

FIGURE 139 *Michelangelo Buonarroti (Florentine, 1475–1564), La Pietà, sculpture, Palazzo Rondanini, Rome, photograph by Alinari-Art Reference Bureau. You may find it difficult to accept the possibility that this unfinished pietà is greater than Fig. 138. But listen to Henry Moore, one of the outstanding contemporary sculptors. "Why should I and other sculptors find this one of the most moving and greatest works we know of, when it's a work which has such disunity in it? Michelangelo was near death and his values were more spiritual than they had been. I think he came to know that in a work of art, the expression of the spirit of the person—the expression of the artist's outlook on life—is what matters, more than a finished or a beautiful or a perfect work of art."* ▶

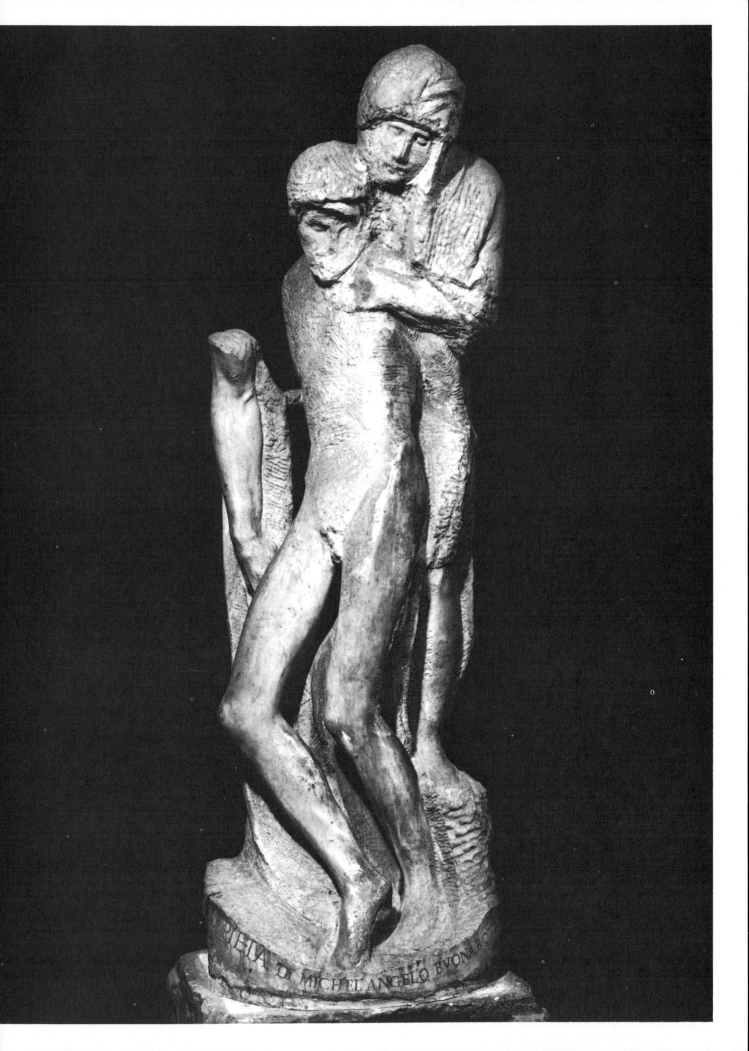

Finally, the staff is angled more; the top of it is nearer the left edge.

Please note that I asked which painting is *more dynamic—not necessarily better.* Remember that I cautioned you earlier about *dogmatic, snap, over-all* judgments about one painting being better than another. The word *better* covers too large an area. Many scholars, philosophers, critics, artists, historians, and writers have spent years weighing the pros and cons of works of art. Don't be surprised to find that the longer you investigate the field of art, the more the area of difference will seem to widen. Paradoxical? Yes. But don't let it worry you. Art is complex.

How can you apply the lesson of the Herzog painting? In drawing, it's important to test whether the intervals between a large, dominant shape and the edges of the paper are *sensitively spaced to suit your intuitive feeling.*

The test is simple. Take another blank sheet of drawing paper of the same size. Place the edge of the new sheet on an edge of your drawing—that is, where an interval between the edge and a shape is to be tested. Now, move the blank paper slowly inward toward the shape. Keep looking at the interval of space as it narrows. Stop at the point where you *feel* right intuitively. Repeat the process with all four edges.

Incidentally, this is the procedure used by photographers, who are sensitive to spatial relationships. Usually, they crop (or trim) their photographs. You can crop your drawings too, if you like. But it is better not to crop so you learn to space *intuitively.*

In summing up this discussion, let's not overlook this fact: distortion, in one form or another, has an honorable history. And the modern artist has revived its use according to his needs.

Michelangelo's finished vs. unfinished pietà

Finally, look at two pietàs by Michelangelo (Figs. 138 and 139). The finished pietà is perfect. Millions of persons admired it at the 1964–1965 New York's World Fair, when, for the first time in history, the statue was permitted to travel outside of Italy. The unfinished pietà is rough, far from "perfect."

Yet which of the two is greater? You may find it difficult to accept the possibility that *the unfinished pietà is greater.* But listen to Henry Moore, one of the outstanding contemporary sculptors . . .

"Why should I and other sculptors find this one of the most moving and greatest works we know of, when it's a work which has such disunity in it?

"Michelangelo was near death and his values were more spiritual than they had been. I think he came to know that in a work of art, the expression of the spirit of the person—the expression of the artist's outlook on life—is what matters, more than a finished or a beautiful or a perfect work of art."

When is distortion bad?

Distortion in a drawing or painting *can* look foolish and unconvincing. Distortion is bad when it's not rhythmically related to the whole. You can't simply distort in one part of the picture without balancing the distortion in another place. Like subject matter, distortion must be subordinated and related to the whole.

It's very difficult to get amateurs to distort if they've had academic training. But beginners who *can't* draw, don't find it difficult. The beginner is better off in many respects. He's able to capitalize on his inability to draw. He makes up in dynamic expression what he lacks in skill.

But once amateurs get started distorting, they frequently forget to stop. They get deeply absorbed in developing the drawing and completing the picture in light and dark values. If they neglect to rhythmically relate distorted shapes, the picture will fail. They forget to stop as soon as the image emerges, which is when they must step back to check it for space relationships, before going on. The distortion relationships are included, of course, in the shape relationships which need checking. Fig. 140 is an example of distortion with shape and value relationships kept in balance.

There's another form of distortion which is bad. Some amateurs have a tendency to try the traditional approach in drawing and painting. To develop traditional or "academic" drawing skill takes many years. Yet, amateurs will try, without traditional anatomical study, to do a figure in complete anatomical detail. The result is not distortion, rhythmically related, but ineptness.

When many amateurs try to distort, the painting reveals that it was done consciously, not intuitively. The distortion fails because it has no feeling.

But you might say, "I do try to distort intuitively." Yes, but without realizing it, you've been working consciously at the same time. They can't be done at the same time; the tendency is for the conscious mind to take over.

All right then, how *can* you distort intuitively, convincingly? *Simplify!* Don't try the academic approach unless you've thoroughly studied academic drawing and anatomy. Even if you know your anatomy, you can still simplify. Simplifying a picture is a *must* in any case, whether simplification becomes a means of

distortion or not. Listen to the modern master, Henri Matisse: "One cannot do successful work which has much feeling unless one sees the subject very simply."

Ugliness vs. beauty

Amateurs often ask, "How can a painting possibly be a work of art unless it's beautiful? For example, has anyone ever heard of a Rembrandt that's ugly?"

Here's a painting by Rembrandt, *The Flayed Ox* (Fig. 141). Obviously many persons would consider the picture ugly because of the gory subject. But I'm sure that Rembrandt received a great deal of pleasure in painting it; artists all over the world have admired this painting. When we study the works of this master —who often painted "ugly" people, as well as sides of beef—we're aware immediately of his deep, sincere interest in what he painted. The beauty or ugliness of his subject matter is irrelevant.

What *does* matter? We must go back to the basic question: does the picture create a deeply felt mood? If it does, we don't have to *like* it or *buy* it, but we must appreciate and respect the degree of expressive power in the picture. And if it fulfills the basic structural and organizational requirements, we'll appreciate it as a completely integrated work of art.

Have you ever witnessed the phenomenon of a person whose homely face begins to appear beautiful before your eyes? Have you seen a child who's funny-looking, yet whose face radiates a quality of beauty? There's an aura which seems to shine through. In the same way, despite an ugly subject, a deeply expressive, well structured work of art *becomes* beautiful.

Here's another example: *Portrait of a Man with his Grandson* (Fig. 142) by Ghirlandaio. Once you overcome the shock of the subject matter, you'll discover an outstanding work of art. Sensitivity, tenderness, and love permeate this masterpiece. Ugliness simply ceases to exist here. It's a beautiful work of art.

FIGURE 140 *An example of distortion, with shape and value relationships in balance. I did this from my memory of a small plaza in Malaga, Spain. The languid mood reflects the summer heat, when most people are invisible during siesta. The circular shape motif which unifies the buildings has a statue at its hub. The submotif is the vertical.*

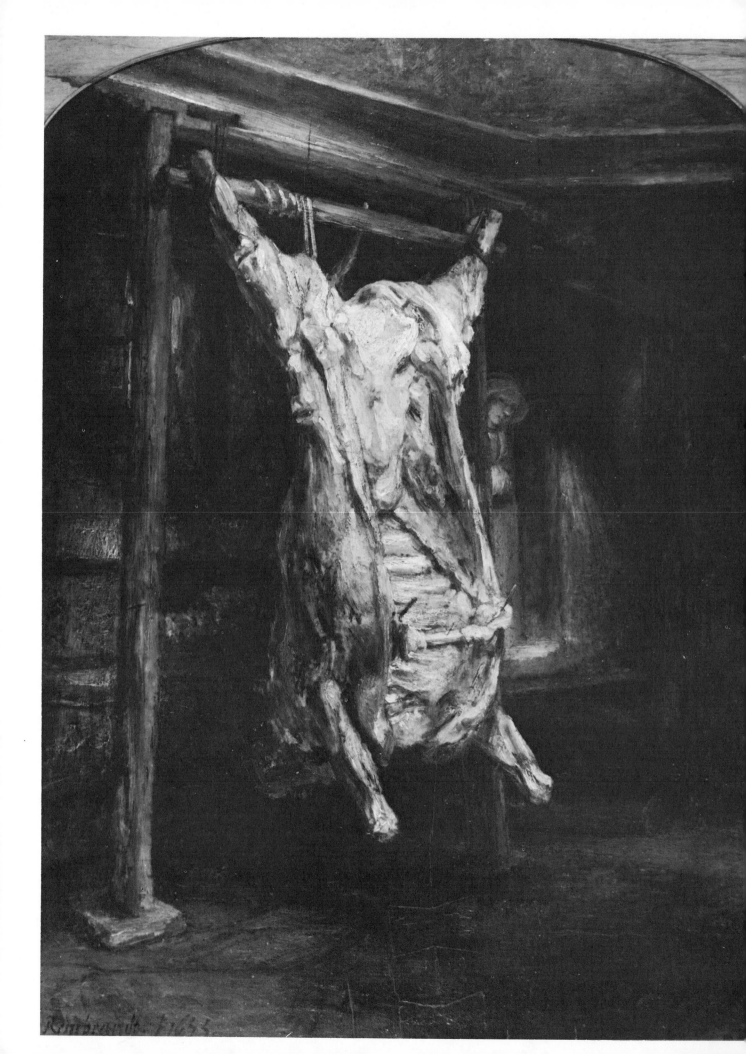

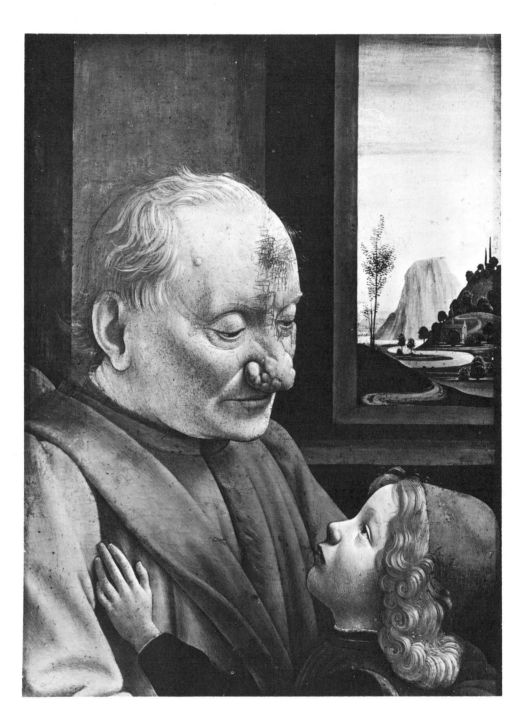

◀ FIGURE 141 *Rembrandt van Ryn (Dutch, 1606–1669), The Flayed Ox, 37" x 25¼", oil on canvas, Louvre, Paris, Many would call the picture ugly because of the gory subject. This master often painted "ugly" people, as well as sides of beef, but we're always aware of his deep, sincere interest in what he painted. The beauty or ugliness of his subject matter is irrelevant. Does the picture create a deeply felt mood? if it does, we don't have to like it, but we must respect the expressive power in the picture.*

▲ FIGURE 142 *Domenico Ghirlandaio (Florentine, 1449–1494), Portrait, Old Man with Grandson, 24½" x 18", oil on canvas, Louvre, Paris. Have you ever known a person whose homely face begins to appear beautiful before your eyes? An aura seems to shine through. In the same way, despite an ugly subject, a deeply expressive, well structured work of art* becomes *beautiful. Once you overcome the shock of the subject matter, you'll discover that sensitivity, tenderness, and love permeate this masterpeice.*

8
A checklist
to improve
your work

To help you improve your drawings, I've concentrated, in Chapters 5 and 6, on your developing the searching eye to recognize the organizing factors that will unify a painting harmoniously. In Chapter 7, I turned to intensifying your feelings. In this chapter, I'm going to concentrate, still more, on expressing feeling and creating a mood in your work. And I'm going to give you a checklist of tips to improve your work.

Be bold—let yourself go

Intellectually, it's not difficult to understand that a drawing or painting without feeling is sterile. Why, then, is it so difficult to put the required feeling on paper or canvas? To start with, you need only be bold: *let yourself go!*

This course of action has very little to do with the mechanics of drawing or painting. It has to do with *you:* your conscious awareness of your own unique personality; your marvelous unconscious, the ever-flowing well-spring of your imagination; your wonderful body, the unique, self-regenerating plant of energy. These are the assets that you were born with; that you exercised, with freedom and imagination, as a child; that you've developed with knowledge and experience since then.

If you increased the use of these assets by a mere 5%, your paintings would be accepted by professional juries for exhibition in gallery and museum shows! Impossible? Listen: in my classes, during the current year, out of 100 students, fifty-one applied and forty-one were accepted in professional shows, even though I'd just call them *semiprofessionals* at this stage.

As personalities, the forty-one were as different as day and night. They came from all walks of life; from all age groups (from sixteen to eighty); from diversified occupations, homemakers, retired people. Did they have anything in common? Yes, a *deep, inner yearning to express themselves,* plus persistence! Without persistence, they could never have overcome their inhibitions, their doubts and fears, long enough to permit their true inner selves to function. Have they overcome their negative habits for good? I doubt it. The negative habits of a lifetime recur again and again. But with persistent, conscious self-discipline, they'll occur much less frequently as time goes on.

You can't expect a book to discipline you. You must make up your mind to discipline yourself. For only *you* really know your good and bad habits. You'll need serene periods of contemplation—self-examination—to allow your unconscious to point up your negative habits. The rest is a matter of patient, quiet, firm, dogged *work.* Please believe me when I say that

143

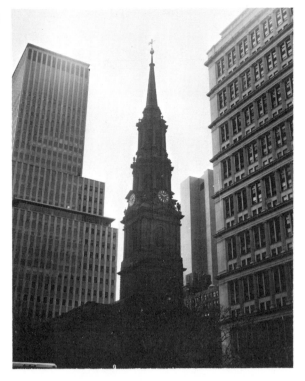

FIGURE 143 *Photograph of St. Paul's, New York. There's need for feeling in a work of art: feeling that emanates from an urgent desire for release; feeling about some idea or some experience; feeling so strong that you want others to share it with you. Let the late John Marin, give you an inkling of this quality of feeling as you compare this photo of St. Paul's with Marin's painting of it (Fig. 144).*

FIGURE 144 *John Marin (American, 1870–1953), St. Paul's Manhattan, 15⅞" x 18⅞", watercolor, The Metropolitan Museum of Art, New York. Talking about buildings in a city, a theme for which he was famous, Marin said: "A work of art is a thing alive. I see great forces at work. Feelings are aroused which give me the desire to express the reaction of these 'pull forces'. Great masses pulling smaller masses, each subject in some degree to the other's power . . . And, so I try to express graphically what a great city is doing. Within the frames, there must be a balance, a controlling of these warring, pushing forces."*

144

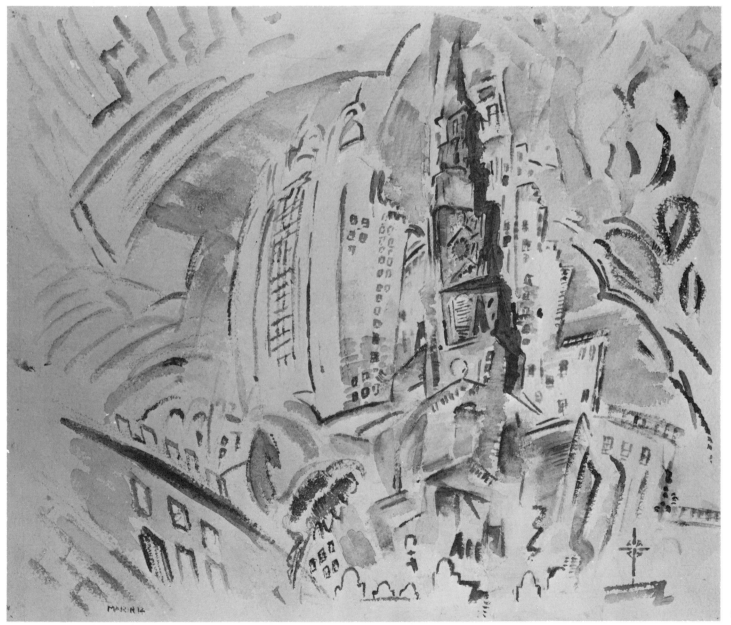

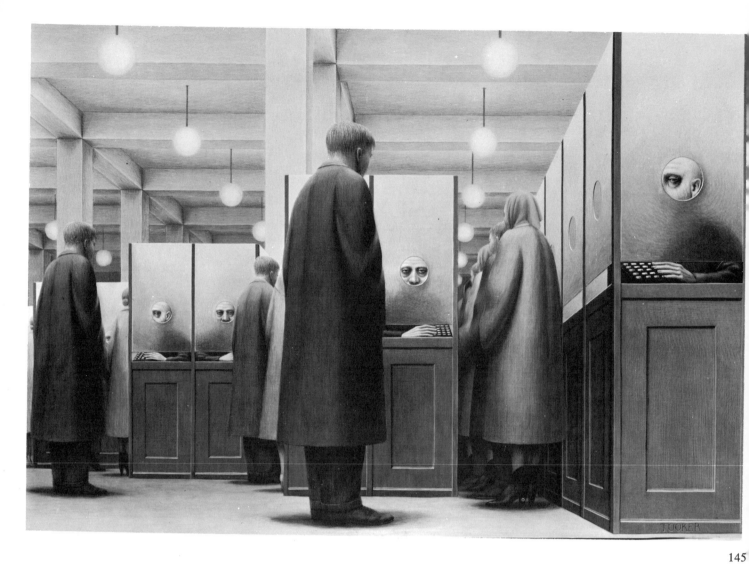

146

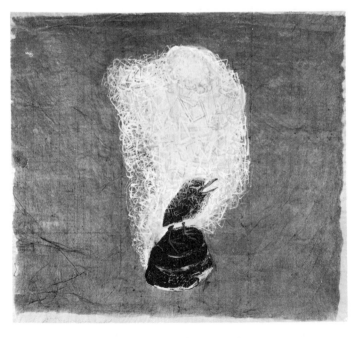

FIGURE 145 *George Tooker (American, 1920–)*, Government Bureau, *19⅝″ x 29⅝″, egg tempera on gesso panel, The Metropolitan Museum of Art, New York. In Fig. 144, John Marin demonstrates a powerful, dynamic mood. In this one by George Tooker, the feeling of fear completely penetrates the painting.*

FIGURE 146 *Morris Graves (American, 1910–)*, Bird Singing in the Moonlight, *26¾″ x 30⅛″, gouache, The Museum of Modern Art, New York. In discussing this painting, the well known artist, Ben Shahn said, "Graves has taken what might be called a trivial moment, but he's captured through it a sense of infinite solitude."*

your success depends not so much upon technical training, as upon your personal growth, your adaptation to the learning process, and your ability to let yourself go!

I can assure you, without question, that *you have artistic talent within you.* Many others have succeeded in expressing their talent. So can you!

On a large, white cardboard, print the motto: "Be bold—Let Yourself Go!" Tack it up where you can look at it each time you draw or paint.

What artists say about feeling

I've emphasized the need for *feeling* in a work of art; feeling that emanates from an urgent inner desire for release; feeling about some idea or some experience; a feeling so strong that you want others to share it with you.

Let the late American artist, John Marin, give you an inkling of this quality of feeling. Talking about buildings in a city, a theme for which he was famous, he said: "A work of art is a thing alive. I see great forces at work. Feelings are aroused which give me the desire to express the reaction of these 'pull forces.' Great masses pulling smaller masses, each subject in some degree to the other's power.

"While these powers are at work pushing, pulling sideways, downwards, upwards, I can hear the sound of their strife. There is great music being played.

"And, so, I try to express graphically what a great city is doing. Within the frames, there must be a balance, a controlling of these warring, pushing forces."

He felt these powerful forces. As a result, they showed up in his work. In this picture, titled *St. Paul's, Manhattan* (Fig. 144), he created a *dynamic* mood. Compare it with a photograph of St. Paul's Church (Fig. 143).

On the other hand, in George Tooker's *Government Bureau* (Fig. 145), the feeling of fear completely penetrates the painting.

In discussing Morris Graves' *Bird Singing in the Moonlight* (Fig. 146), the well known artist, Ben Shahn said, "Graves has taken what might be called a trivial moment, but he's captured through it a sense of infinite solitude."

Whether you like Picasso's work or not, listen to his words. "To draw," he says, "you must close your eyes and sing!"

What we've been discussing is true for all the arts. Read (and take to heart) dancer Martha Graham's words to Agnes de Mille. "There is a vitality, a life-force, an energy, a quickening that is translated through you into action and because there is only one

of you in all of time, this expression is unique. And if you block it, it will never exist through any other medium and be lost. The world will not have it. It is not your business to determine how good it is nor how valuable, nor how it compares with other expressions. It is your business to keep it yours clearly and directly, to keep the channel open. You do not even have to believe in yourself or your work. You have to keep open and aware directly to the urges that motivate you. Keep the channel open."

What artists *do* may be summed up by the statement of Franz Kline: "I paint not the things I see, but the feelings they arouse in me."

To succeed, then, a good drawing or painting must project a deeply felt mood. The mood may be mysterious, joyous, haunting, sombre, compassionate, spiritual—in fact, any basic, universal human emotion which all of us have experienced in our lives.

How you go about expressing your feelings convincingly is important. For example, you can't say, "Now, I'm going to draw a doctor with a worried look, praying inwardly that a sick child passes the crisis." The image has to be *felt*. Andrew Wyeth, one of America's outstanding artists, was taught art by his father, the noted illustrator, N. C. Wyeth. "Andy," his father said, "you must throw yourself wholly into whatever you do . . . If you paint a man leaning over, your *own* back must ache."

Eighteen tips to help you let go

Creative art can be a glorious experience. Yet, we know that personal tensions will arise, from time to time, to throw us into fits of despondency and despair. What can be done about these periods when we feel stymied?

We know from past experience that it's difficult to snap out of a bad mood when we're actually going through it. But much can be done, in quiet periods, to expose and eliminate the sources of these tensions. By being aware of the pitfalls, you can fortify yourself against them.

In this chapter, I'll review most of the common negative attitudes which amateurs display. You'll spot their origin very quickly, I'm sure. They're based on impatience, lack of self-confidence, fear of failure, fixed ideas, and over-anxious pressure. To minimize tensions, therefore, why not give serious thought to their conscious control—in advance?

1. Don't become impatient—creating art takes time

The span of patience in the amateur is usually short.

He wants to complete a drawing or painting as quickly as possible. He wants to enjoy the immediate satisfaction of having accomplished something. This is understandable. But the production of art, unfortunately, takes time, especially producing something of permanent, substantial value.

Matisse once said, "I have worked for three years on 'Europa and the Bull,' and I shall probably have to work on it for quite a while longer. Some people imagine that you can turn out canvases like mass-produced cars. For that picture alone I have already made three thousand sketches—yes, three thousand."

You're not expected to have the patience of a Matisse, but do keep in mind that the creative process takes time. If you're impatient and tired of a particular picture, try another for the time being. Or, do something entirely different for a change; read a book, or just go out for a walk.

2. Don't be surprised if you don't like your result

In creative work, unexpected results may shock you at times. This is all to the good. It means that your unconscious and your imagination are functioning. If your work does shock you, it's sure to be fresh and original, much better than you have any idea.

Trust the professional's judgment, not yours or your friends'.

Whatever you draw or paint, don't be tempted to change your work to conform with pictures you're normally used to. Instead, set it aside until you appreciate and like it. This may take time. But when you do, this will mean you're beginning to relax with it. At that time, check your pictures out in the usual way for shape and value relationships. Then try to improve what you've done.

3. Don't harbor secret high hopes of unusual results

Some people approach their work as if they were at a racetrack, backing a horse to win at great odds. When you set up an inner expectation of big results, you're due for a let-down when you see how little you accomplish during a working session. This isn't only an immature attitude; it shows little understanding of the creative process. Be prepared for *gradual* progress.

As an editorial in *The New York Times* stated, "Once the picture reaches the canvas (or paper), it assumes a life of its own . . . when right, it begins to work from the inside out . . . Art then grows, multiplying its seedlings. If these come out properly, they can be pruned and reshaped . . . Having created them

to begin with, the artist then must follow the course art itself takes."

Let your true inner response run its course. Let things proceed at their own comfortable speed; the quality of your work will grow slowly, steadily. Give up secret high hopes. Such an attitude will invariably lead to disappointment.

4. Don't be influenced by well-meaning friends

Art is long. It must be studied and experienced. You're on the way. Prepare yourself mentally to withstand the criticism of friends or family who haven't studied and discovered creative art. Protect yourself by building a nice, transparent mental wall around yourself. Relax inwardly. Let no one hurt you. If your critic isn't well informed about art, just listen politely, nod, smile, and forget it.

5. Don't resist change

When changes happen in your work *intuitively,* you can be certain it's for the better. Try not to fear or be disturbed by change. As Robert E. Mueller, author of *Inventivity,* says, "An artist . . . experiments blindly, often in the dark, groping for something unknown." In this way he transcends his conscious visual habits to go beyond—to produce something which didn't exist before.

On rare occasions, the unconscious supplies us with a complete drawing or painting almost automatically, without need for change. Most of the time, however, this isn't possible. Picasso states that a picture, like a living creature, changes its demands and moods from hour to hour and from day to day. It changes almost by itself; it seems to "paint itself."

To the amateur, change just seems like something that interferes with the completion of a picture. Frequently, as Anton Ehrenzweig says in *Psychoanalysis of Artistic Vision and Hearing,* "The (immature) artist may experience this as a fear of 'letting go' or 'losing control' . . . The mature artist cherishes its coming as a state of inspiredness."

Examine the different stages of the same painting by Matisse, *La Musique* (Figs. 147-156). These don't show all the changes he made. But the series will give you some idea of how the professional works. He lets changes happen; he never resists.

6. Don't let impatience interfere with your unconscious

Quite often, when you're sitting serenely before an unfinished picture, waiting for the unconscious to

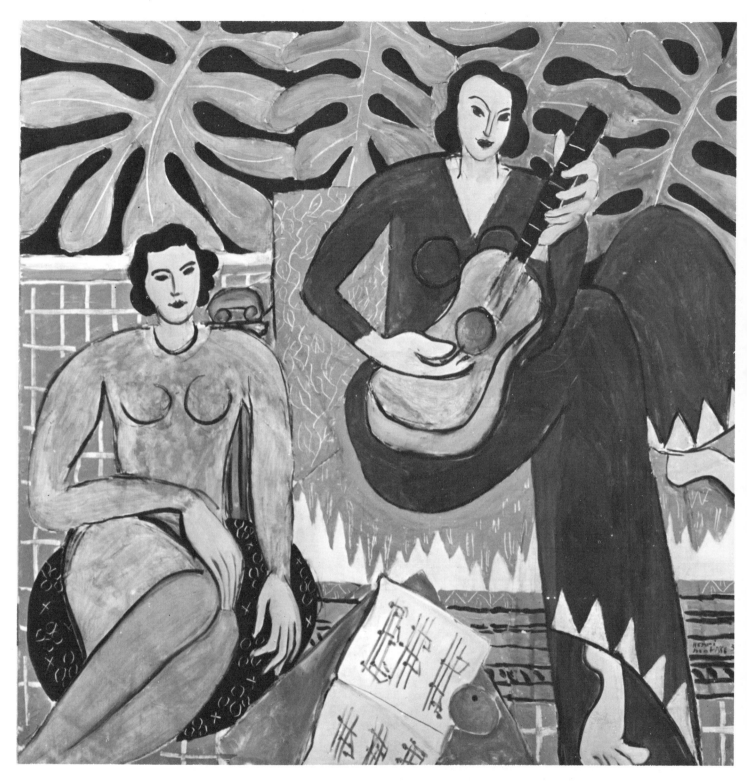

FIGURE 147 *Henri Matisse (French, 1869–1954), La Musique, 45¼″ x 45¼″, oil on canvas, Albright-Knox Art Gallery, Buffalo, N.Y. To the amateur, changes in a painting just seem to interfere with the completion of a picture. But the mature artist welcomes change as a source of inspiration. Study the changes Matisse made in the nine progressive stages (Figs. 148–156), during a period of three continuous weeks, before he found the solution to his problem here.*

148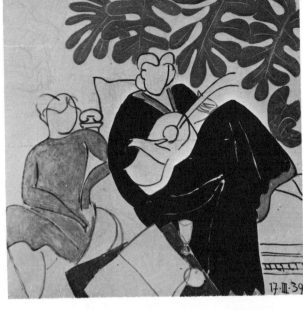

149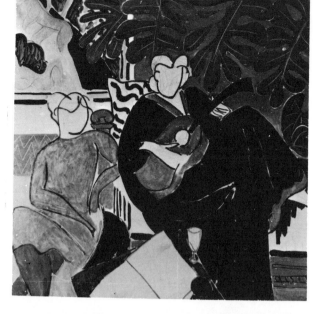

150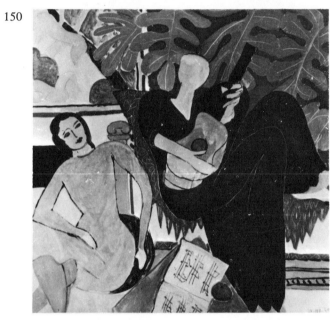

151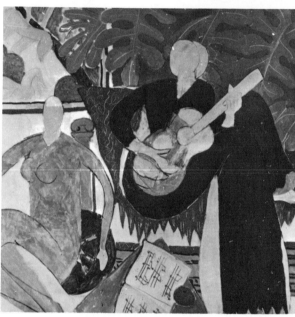

152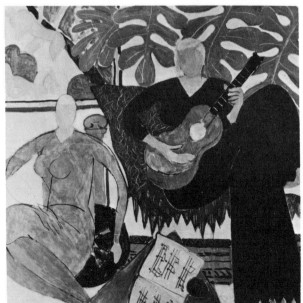

153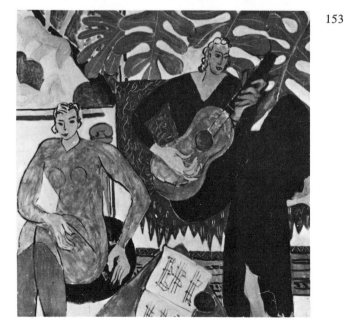

FIGURE 148 *The first impulse of* La Musique *by Matisse. He concentrated on the two figures, particularly on the interlocking of arms. Notice how the lines at the elbow of the left hand figure flow into the line of the musical instrument. There's variety in values, but no main shape motif has evolved yet. The upper left corner is weak, spatially.*

FIGURE 149 *Notice how Matisse solidified the structure of his painting by introducing two shape motifs: the triangle and rectangle. The triangle became dominant when he introduced darks in the upper portion, carrying them across to the diagonal at the upper left (even the musical instrument was darkened). In contrast, he created rectangles. Notice how he carried a vertical from the top edge, down between the figures. The rectangular bands at the left and across the lower right were emphasized in darker values.*

FIGURE 150 *Notice how Matisse lightened the leaves at the top, creating more contrast with the dark background. He lightened and darkened the musical instrument; darkened the table (adding a new shape and details of musical notes, deleting the glass); changed the lower right hand corner, the left figure's hair, and the area left of her head. The shape of the figures has changed; they're not interlocked as before. Smaller triangles now relate to the large triangular motif; note cushioned seat behind and below the right hand figure. The diagonal at the top of the guitar now interlocks with the diagonal of the sheet of music. Notice the straighter, longer vertical at the lower right. One side of the left figure is now vertical, and verticals are repeated to the right.*

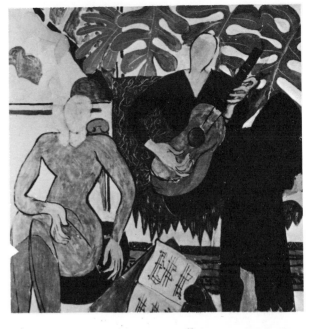

FIGURE 151 *Both figures have been changed once again, with semi-circles now emphasized. The dark area, left of the left figure, has been eliminated. The lower right area has been made smaller by more dramatic substitution of the vertical darks. The small vertical to the left of the left hand figure is an important rhythmic echo to the long, dark vertical on the lower right.*

FIGURE 152 *The right hand figure has been changed, including the area of the lower right. Study the negative space changes in the lower right. The background at the top has been lightened. The guitar has been darkened.*

FIGURE 153 *Once again, both figures have been changed. The small heads against the large bodies make the figures appear much larger and more dominant than in previous stages. The vertical between the figures strengthens the rectangular motif of the whole. The negative space at the lower right has been altered.*

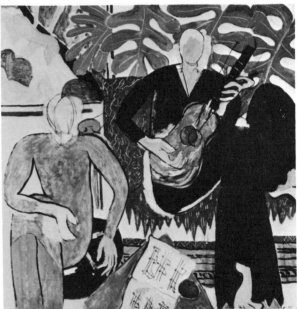

FIGURE 154 *Study the subtle changes made in and around both figures. You'll find them in the negative spaces. Look at the shapes made by the area under the arms of the left hand figure. Notice the two trial positions of the head, which still interfere with the small shape to the right of the head. Once again, check the changes in negative areas in the lower right.*

FIGURE 155 *Once again, check all the negative areas to find the various small shapes which were changed.*

FIGURE 156 *Observe how the head and shoulders of the right hand figure have been raised, little by little, throughout all the stages; now the head has reached its final position near the top edge, strengthening the entire figure right down to the lower edge. The left figure feels much stronger, too, in relation to the right one. Behind the left figure, notice the textural cross-hatching, repeated in the lower right. The background behind the leaves, at the top, has been darkened once again. Check this stage against the final painting (Fig. 147). The most important change he made is in the upper left of Fig. 147. He carried the leaves right across, giving up the triangular shape motif and making the rectangle the main motif.*

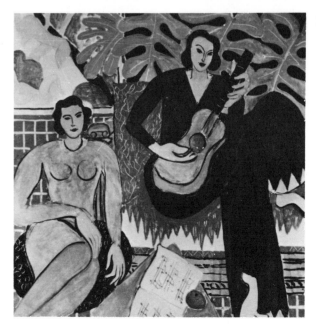

disclose the next step, *nothing happens.* This is the period of incubation, the period when you digest what you've done. You can't hurry it. Don't become impatient. If necessary, do another picture during the interval.

Writing on the genius of Leonardo da Vinci, someone said, "He will never work till the happy moment comes of feeling just fit. To imaginative men, this is the moment of invention."

Again, if you feel the return of an inner drive, don't try to help it along with conscious thinking. Philosopher William James said, " 'Hands off' is the only word for us. It must burst forth unaided."

7. Don't block the unconscious

Adults do a tremendous amount of analyzing and reasoning in their daily lives, practically all on a conscious level. This habit is so ingrained that it carries over and dominates their drawings and paintings. I believe that this is one underlying reason why amateur art often fails. You simply can't make a picture come alive—make it fresh or personal—by consciously thinking it so. That's the job of the unconscious, the place where mental impulses seek an outlet.

What makes the unconscious such a marvelous aid to creativity is that it apparently responds best when we're most relaxed psychologically. It isn't necessary to pull and tug at the unconscious to get it moving. It's much more effective to give the unconscious an opportunity to work at its own speed; wait, at ease, for the unconscious to spur the imagination, then act on the ideas that your imagination supplies.

Another valuable function of the unconscious is that it stores up images and ideas, which emerge just when we seem to need them. Once stimulated, your unconscious can produce a continuous stream of ideas.

Therefore, the source of your artistic talent is hidden *below the conscious level.* Give your inner self a chance to function by carefully setting aside tranquil, contemplative periods—many more than you've ever done before—not for work, just to develop the habit of letting your imagination go. Detach yourself from yourself, is the advice of poet and art critic, Sir Herbert Read. These quiet periods can be found anywhere, any time. Your unconscious will respond day or night. Let your imagination flow as you relax and listen to music or look out the window. You'll be alerted and sensitized. Your imagination and originality will surge forth in unexpected ways. The emotions they arouse will move you to express these moods in your drawings and paintings.

When you *do* start to draw or paint, try one more idea for unblocking the unconscious and releasing the imagination: allow yourself no more than twenty minutes to evoke an image. This time limit will reduce the chances of your *conscious* mind interfering. During that time, express yourself with all the feeling you can.

Remember that a work of art, to be complete, must be a unified whole. The mood must permeate every inch of the canvas. In working, you must spread your emotional feeling to encompass the entire area, not merely the center of interest.

8. Don't disparage "accidental" results

When you're working properly, your spontaneity may produce a delightful drawing or painting with ease. You may not be inclined to accept the result because you consider it an accident.

Alan W. Watts, the authority on Zen Buddhism, says: "Artistic technique is discipline in spontaneity and spontaneity in discipline . . . This does not mean that art forms are left to chance. It is in reality the art of artlessness or what Sabro Hasegawa has called the *controlled accident.*"

On the contrary, be *glad* that your intuition and imagination are responding like magic. You're a channel for something which, once you've expressed it, has its own existence. Regardless, however, it's *yours.* It happened with *your* hand. Accept it gratefully.

9. Don't think of imagination as pure daydreaming

Using your imagination in creating art *doesn't* mean trying to capture chaotic daydreams, or conjuring fantastic, non-existent visions. Neither does it necessarily mean originating a new style of art, or some startling new idea. Be satisfied to express a still life or a landscape, for example, with the fresh stamp of your individuality. To combine these familiar elements with your own special feelings is definitely creative and imaginative.

10. Don't judge while creating

It's bad for your morale, because your work will suffer. Judging and creating can't be done at the same time. They're distinctly different acts. Separate them.

Let yourself go completely as you work, say for twenty minutes. Exclude all conscious thinking during this period. When the moment of weariness sets in, stop and rest. Bonnard, the French painter, would

go out for a walk, do something different for an hour, then return to his work refreshed. This is the time when the picture should be judged as a whole, under relaxed conditions. The unconscious is then ready to aid the conscious mind in deciding what the next step should be.

11. Don't be tempted to work directly from objects

Don't be tempted to create directly from nature, a live model, or a still life. Not until the entire creative process, with its alternating unconscious-conscious focus, has become a fixed habit. Otherwise, you'll over-emphasize the conscious approach, as most amateurs do.

This shouldn't prevent you, however, from studying any three-dimensional object, or its parts, in complete detail. In fact, this is frequently essential. Notes or little sketches, for practice or for refreshment of memory, are valuable means of study. However, lay them aside and don't consciously try to remember details during periods of pure expression.

12. Don't make corrections without unconscious deliberation

This is a common problem when the amateur is learning to establish the creative work habit. Let's say the image has emerged with feeling. You've made excellent progress in developing shape and value relationships. In fact, the picture is practically complete. Suddenly, you realize that you've made an error in one area; or perhaps you don't like one part.

In short order, the impulse to change becomes exceedingly strong. You make the correction and the result is worse. Why? Because you've forgotten to let down, to relax mentally, first, to permit the unconscious to encompass the whole. The correction was made *consciously* and lost its relationship to the whole.

René Berger makes this clear: "A work of art can exist only within a certain formal order, i.e., a deliberately constructed system of relationships."

"Touch one part of the canvas," said the famous American portrait painter, Eugene Speicher, "and something immediately happens to some other part."

13. Don't judge your picture at close range

The amateur tends to forget that pictures are usually viewed at a distance of four or five feet. This holds true for the 18 x 24 size I advocate for beginners. A drawing or painting which looks neat, close up, usually appears cramped and far from free, at a dis-

tance. Therefore, step back when judging your picture. There's no other way to see it as a whole.

According to legend, Rembrandt said: "A painting is supposed to be seen, not smelled!"

Also, when working at it, be sure to step back continuously. Blur the outlines of shapes. Avoid too much detail. Get used to irregularities and unfinished lines while you're creating. What may not satisfy your taste close up, very likely will be just right seen over a mantelpiece, over a sofa, or in a gallery.

14. Don't deviate from these principles just yet

Perhaps you'd like to experiment. Maybe you've been toying with the idea of deviating from the instructions given so far in this book. My advice is not to try it, just yet. The procedures and principles given may be safely broken by a master. In fact, some masters have, on occasion, set up almost impossible problems to solve.

Have a little patience. You must be able to understand and apply the basic procedures, first, before you attempt to experiment in other directions.

15. Don't work for camera-like exactness

Free your mind of any preconceived idea that a painting should look like a photograph. A "finished," polished, camera-like picture, as your ideal, will only lead to a static drawing or painting. Even if you spent the necessary years to complete academic training, you'd still have to spend almost as many years to *un*learn the rigidities acquired.

Listen to Robert E. Mueller, who says, "when pressed about technique, many artists argue that it is better that an artist have no technique, that he work in a primitive and stumbling style with little or no craft, and that he create works of art with impact and originality. High craft with mediocre quality is useless and not art."

16. Don't attempt non-objective art until later

Drawings or paintings without subject matter—that is, pure abstract design—shouldn't be attempted until you've understood and applied all the basic principles involved in creating a work of art. Some amateurs, for example, imitate the geometric designs of Mondrian or become disciples of a particular school of abstract art. They're not really capable of following the master because they haven't studied and understood his theories. To use some of the surface ideas of a master isn't enough. In this case, a little knowledge is dangerous.

You must build upon the foundations of art—organization, feeling, and the visible world—first. You certainly don't want a professional artist to judge your work by saying, "This person doesn't know what he's doing; he's painting abstract, non-objective pictures, but . . ." and throw his hands up in disgust.

17. Don't think of art as a sum of techniques

How you think about art is important. Learning a certain number of techniques and formulas will never complete your education in art. It may sound logical to you, but it's an illusion.

The instructions in this book merely serve as guideposts on a road toward the unknown. But what lies ahead for *you* no one knows. For each individual, it's a voyage of self-discovery.

The magic of art, as artist Henry N. Rasmusen states, "cannot be defined with any degree of finality. For after all the explainable principles are judged, there remains much of the infinite, which is both elusive and impenetrable."

My suggestion is to relax, have fun, be alert and receptive. Keep growing and developing, using as much of your innate ability as possible.

Painter Emil Bisttram states, "To be an artist one must remain a student."

18. Don't forget to study the great masters

Let's not forget that a great deal of the professional's experience in evaluating his own work comes from the *constant examination of great works of art*. That's how you sharpen your own visual perception and critical ability.

Summary

Now you should have a much clearer idea of how to improve your drawings. In fact, you should be able to bring them to the point where they'd receive professional commendation.

Naturally, your results would be quite modest in comparison with professional work. But if you've applied the instructions carefully, the professional would be aware immediately of the progress you've made. He'd recognize that you're working intuitively, that your drawings have an interesting quality of mood and feeling. He'd be particularly delighted to find that they're organized rhythmically, as a unified whole.

From an educational viewpoint, you've learned how to integrate free expression with structural organization of the whole. Any educator will recognize that this is no mean accomplishment for an amateur. The key to this teaching method lies in the number (and kind) of factors that have been selected for you to integrate, right from the start. The factors have been purposely limited to only a few, so that you can encompass them without question.

Now, in the coming chapters, the number of factors you'll learn to integrate will be expanded to include color, texture, and line.

9
Materials
and equipment
for painting

COLOR IS a complex subject. Yet, if you can avoid certain pitfalls, you'll make immediate progress. In this chapter, we're going to prepare the way for you to develop *personalized* color.

Let's start with a clear idea of the proper painting tools, why they're chosen for beginners, and how to use them.

Casein and acrylic paints

If you've never painted before, I suggest that you paint in casein or the new acrylics. Casein and acrylic paints are usually prepared by the same companies that make oil paints and are about the same in cost. They contain the same pigments used in oil and are handled in a way similar to oils. That is, you can cover up one color with another.

The difference between them is this. With oil, you require turpentine to wet your brush, to thin the paint, and to move it around. With casein or acrylic, you use water. The big advantage of acrylic and casein is that these water based paints dry rapidly. Therefore overpainting can be done in a few minutes, cleanly and beautifully. With oil, you must wait for days, sometimes, before the pigments will dry.

Casein and acrylic colors dry matte, that is, without shine. An acrylic or casein painting, when hung, has the advantage of no glare. However, should you so desire, it can be varnished and will dry in a few minutes, taking on the luster of oil. When varnished, it's sometimes difficult, even for the professional artist, to distinguish the finished acrylic or casein painting from an oil painting.

Even if you're used to oil painting, I suggest the use of casein or acrylic. You can solve certain basic color problems much more quickly. Later on, after you've learned to control color, you may return to oils. Acrylic and casein colors are as permanent as oils, by the way. They shouldn't be confused with poster paints, which aren't permanent and which cannot be covered easily, color upon color.

Oil paints

Of course, we're all more accustomed to the traditional oil paints. In fact, I've used them, myself, for many years. But I don't use them as much at present because I actually prefer acrylic and casein paint. I repeat, if you've never painted before, I suggest you paint with *them*, rather than with oils.

One of the difficulties with oil paints, especially for beginners, is that colors can become muddy very quickly. To avoid muddy colors requires great care and patience in applying color. On the other hand, the

elastic feeling of oil paints, as you mix them and touch the springy, stretched canvas with loaded brush, can be very thrilling. Thus, despite *my* preference, *you* may prefer oil.

Pigments are either made synthetically or come from vegetable and mineral matter. That's why the drying time of the colors will vary. Some oil paints are so fluid that you'll find little need for a *thinner* (more about this in a moment) to move your brush. But often colors may give you trouble because they're less fluid and require a thinner. So be prepared to experiment and make adjustments to the situation when you use oil paints.

All the projects I've described in this book can be done in oils just as effectively as in casein or acrylic.

Brushes

The bristle brushes recommended in casein and acrylic painting are the same as those used in oil. If you have no brushes, I suggest that you spend a little more money to buy first quality brushes. They almost all look alike when purchased. However, the bristles of poor ones spread apart and lose their shape very quickly. As a result, you've much less control in painting. You may be blaming your results on lack of skill, instead of realizing that you're handicapping yourself with poor tools.

From experience, I've found that the short bristled brushes (called *brights*) are more manageable than the longer haired *flats*. You'll need four brushes: numbers 2, 5, 7, and 11. Whenever you can, paint with the largest brush. It saves time. Also the work looks more professional.

Cleaning brushes is extremely important because acrylic and casein paints dry very quickly. Although oil paint dries more slowly, it should also be removed from the brush when you've finished painting. You must be very careful not to leave a brush around with pigment in it, without protecting it or cleaning it; the paint filled bristles will dry hard as a rock. As you work, keep washing the brushes in water if you work with casein or acrylic, in turpentine if you work in oil. At the end of your painting session, clean the brushes thoroughly with water and Ivory soap, and rinse carefully.

For acrylic and casein, always have two big glass jars of water at hand, one for thinning paint, and one for cleaning brushes. For oil, keep two jars of turpentine handy. Empty coffee jars make excellent receptacles.

If you plan to put aside and reuse a brush that's loaded with acrylic or casein, dip it into water just enough to keep it moistened. Otherwise, clean the brush immediately. Be sure to remove the pigment by stomping the brush thoroughly at the bottom of the water jar.

How wet should a brush be *before* it's dipped into acrylic or casein paint? If it's too wet, it'll drip; even if it doesn't drip, it'll look more like watercolor than oil. On the other hand, if the brush isn't wet enough, the pigment won't cover the surface but will show streaks. My suggestion is to dip the brush fully into clean water, then use a rag to remove the excess water dripping from the brush. A little experimenting will tell you exactly how much water to remove from the soaking brush.

Once you've mixed your colors and the brush is loaded with color, remember how to apply it to the painting surface. Because I've a special sequence for you to follow in learning color, hold the brush almost parallel to the surface. In this way, when you paint, the color will show up flat and solid. Later, I'll explain the reason why you should lay your colors down this way.

Colors to buy

The manufacturers of casein, acrylic, and oil paints make thirty or forty different colors. I've chosen a minimum of fourteen for you to start with. Later on, I'll suggest others to add to your palette.

If you prefer the water based medium, buy either *all* casein colors or *all* acrylics, not both, and buy them in *tubes,* not jars. Whether you paint in acrylic, casein, or oil, don't buy the small set of tube colors advertised at low cost. The tubes are very small and cost much more in relation to the larger *studio size tubes.* Besides, the small tubes won't contain enough color to finish a fair-sized painting. Also, the small tube sets don't include all the colors I consider essential.

Here's a list of the colors to buy:

Large lb. size tube of Titanium White
Viridian
Chrome Oxide or Cadmium Green
Cobalt Blue
Ultramarine Blue
Cadmium Yellow Light
Cadmium Yellow Medium
Cadmium Red Light
Alizarin Crimson
Yellow Ochre
Indian Red
Burnt Umber
Raw Umber
Ivory Black

As a thinner for oil paint, mix double distilled turpentine half-and-half with linseed oil and keep this

FIGURE 157 *Set up your palette in this order.*

Setting the palette

Get into the habit of setting up the colors on your palette properly, in logical order. There are enough frustrations in art without those due to mishandling, indifference, fumbling and confusion.

Here's a tip. A large metal tray—or an enamel butcher tray—makes an excellent palette. If you're allergic to washing up after a session of painting, I suggest you buy a roll of freezer paper (not the aluminum kind). You can get it at any supermarket. Tear off a piece large enough to cover the *back* of the tray and fasten the edges down with masking tape. This way, you'll have an inexpensive, disposable palette. Incidentally, the colors won't be absorbed by the freezer paper. You *can* buy a pad of paper palettes in an art supply shop, but they're made especially for oil and are too absorbent for the water used with casein or acrylic.

Set up your palette in the following order (Fig. 157). Squeeze out some white in the upper left hand corner, black in the lower right. Along the left hand

medium beside your palette in a small jar or tin cup. For acrylics, buy acrylic medium in liquid or gel form; the latter keeps the paint thicker, like oil.

side of your palette, place the cool colors. These start with cobalt blue in the lower left corner, followed by ultramarine blue, viridian, chrome oxide or cadmium green, placed one above the other. Across the top, place the warm colors. Starting with cadmium yellow light, in the upper left corner (after the white). Follow to the right with cadmium yellow medium; cadmium red light; and alizarin crimson. On the right side, in the upper corner, place yellow ochre, followed downward by Indian red, burnt umber, and raw umber; these are the earth colors, practically all on the warm side. As you add more hues to your palette later, be sure to place them properly among the cool, warm, and earth categories.

As you know, warm colors generally seem to advance and cool colors seem to recede. In painting, we'll soon effect a happy balance between them. The earth colors are very important, too, in a muted tone or grayed-down color relationship.

Be sure to place the colors close to the edge of the palette. This will leave plenty of room for mixing colors in the center. By the way, if you're fastidious and wish to retain the purity of colors on your palette, buy an inexpensive palette knife for mixing colors. This eliminates the need for dipping the brush, which may be loaded with one or more colors, into a pure

color. With a palette knife, you can wipe the blade clean each time after transferring a color to the mixing center.

Squeezing a tube of paint is an art. Some colors are slow movers; others are more liquid and move too quickly. To avoid trouble, place the tube of color with the neck touching the palette. Squeeze gently, but firmly, from the bottom of the tube. Don't squeeze out too much color until you're sure you need it. The quantity to be squeezed should equal the size of a dime, a heaping dime. The exception is white. You'll be using a great deal of it; therefore, the quantity should be increased to the equivalent of a heaping quarter.

Painting surface

One of the best painting surfaces is the smooth side of a specially prepared casein gesso Masonite board. These may be purchased ready sprayed (six times) on both sides to give your colors a beautiful luster. The rough side is sprayed to prevent warpage. You can paint on the rough side, too, but I advise against it; it's textured too evenly, it's too absorbent, and it requires more paint to overcome both handicaps.

The casein gesso panels are usually less expensive than stretched linen canvas. However, if you must have the texture of canvas, it can be cut and glued to a Masonite board, using white glue like Sobo or Elmer's Glue. If you like, you may use acrylics or oils on stretched linen canvas, but don't use *casein* on canvas—it usually cracks.

If you have time, you can buy Masonite and have it cut down at the lumber yard. Sandpaper the glossy surface and prime it with gesso, a powdered white pigment, mixed with dry glue. Buy gesso at the art supply store, mix it with water, then brush it onto the Masonite, moving the brush *in one direction*. Allow the gesso to dry over night before covering it with another coat. This time, brush the gesso at right angles to the preceding coat. Thin it to the consistency of cream. If you paint it on too thickly, gesso may dry, showing ridges. These should be sandpapered down before you apply subsequent coats. Don't forget to prime the other side, too, to prevent warpage.

Masonite boards will cost less if you buy them 1/8" thick, rather than 1/4" thick. Buy *un*tempered Masonite. Be sure to use only 18 x 24 boards, at the beginning. This size is neither too large nor too small. For our purposes, they're just right. Whether you buy them or make them, you'll need six or more for the course of study in this book.

Tracing paper

Make a sheet or two of black carbon paper, large enough to cover the 18 by 24 board. Just take a big piece of drawing paper and rub one side with charcoal.

Tracing your drawing on the board—before you start to paint—is a time saving device. It avoids the necessity of working a second time for rhythmically related shapes. To duplicate sensitively spaced shapes is not as simple as you might think. The feeling must be sustained in the spatial relations. So it's best to trace from a successful drawing. The tracing must be done in a certain way to prepare for the particular method of color application I advocate in this book. This will be explained and demonstrated in the next chapter.

10
Prepare for personalized color

You're now ready to begin to work in color. But before you plunge into painting, let's do some thinking about how color *functions*. I don't intend to give you any *rules*, but I do want to call your attention to color *phenomena* which you should bear in mind as you work toward your own personal approach to color in painting.

Three aspects of color

There are three aspects to color: hue, value, and intensity.

When we refer to hue, we're simply using another word for color—blue, red, green, purple, and so forth.

Value refers to the degree of lightness and darkness, as discussed in Chapter 2. Each hue if photographed on black and white film shows up in different degrees of gray values, from light gray to almost black. Take another look at the scale of light and dark values in Fig. 30. For example, yellow photographed on black and white film would show up as very light gray. Ultramarine blue, on the other hand, might look almost black. The experience you've had in balancing light and dark values in your drawings is going to be important when you balance values in color. The process is the same.

Sometimes value is confused with the third aspect of color: intensity. Intensity refers to brilliance, while value refers to the degree of lightness or darkness. For example, when cadmium yellow light is squeezed out of a tube, it's both light and brilliant. If white is added, the yellow still remains light but will lose its brilliance. Therefore, when we refer to a hue at full intensity, we mean full brilliance. Or as it's sometimes said, a hue *fully saturated*.

The color wheel and color mixing

A color wheel is a handy tool for reference. Various color wheels have been constructed, according to different color systems. For beginners, I prefer a simple color wheel which will help you obtain subtlety of color in your paintings (Fig. 158).

As you know, the three primary hues are red, yellow, and blue; by mixing them, you get all the other hues. If you mix red and yellow, you get orange; yellow and blue produce green; red and blue make purple. Place all six colors on a wheel, and they look like this, primaries alternating with secondaries (the mixtures of two primaries).

You can expand a color wheel as much as you like. For example, between orange and yellow, you might easily add two more color combinations. Add some yellow to the orange, and the mixture might be called

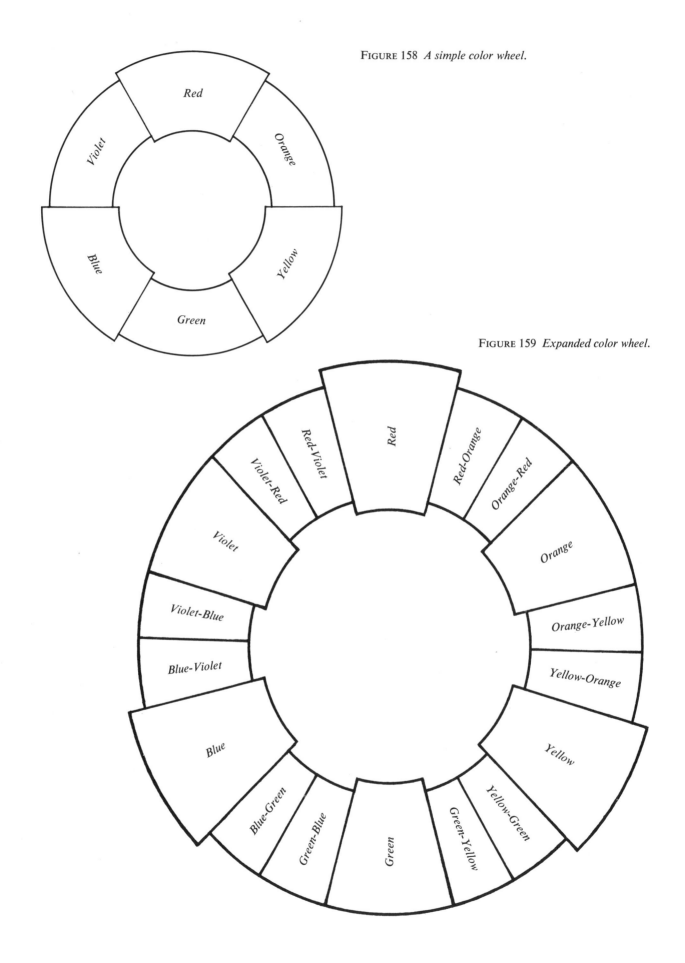

FIGURE 158 *A simple color wheel.*

FIGURE 159 *Expanded color wheel.*

orange-yellow; in the same way, add some orange to the yellow, and the mixture might be called yellow-orange. These names are merely for identification purposes, to help you visualize the process. You could expand a color wheel, all around, in the same way. Don't try to make a huge color wheel, though, because it's not easy and the effort you expend might be more useful in another direction. Here's an expanded color wheel for reference (Fig. 159).

The importance of the color wheel lies in the connecting lines between *opposite colors*. These are called *complementary colors*. You're going to use them a great deal, to get variety of color.

"If you are average," says Dan Smith, Director of the Color Center, Interchemical Corporation, "you can distinguish more than 340,000 colors." Of course, he's referring to the colors in nature, the so-called spectrum, made of light rays. The pigments we *buy* are limited; they're just colored powders, mixed with liquid adhesive. They can't begin to compete with the wide range of light in nature. But with the thirty or forty different pigments available, you should be able to obtain an astounding variety of color, if you approach the task properly. Some experts say that the average person can mix over 200,000 different colors.

How is this possible? Naturally, you can't expect much by painting directly on the board with the six colors mentioned in the diagram a moment ago. Nor will you get much variety from the fourteen minimum colors I've recommended for your palette, if you use each directly from the tube. Even if you were to use all thirty or forty different pigments manufactured—each directly from the tube—they'd still be neither subtle nor original. In fact, this is one sure sign of amateur work: millions of persons painting away, most of them using the same few, raw, harsh colors straight from the tube with no mixing and no understanding of how to balance one color with another.

The fascinating way of getting a great variety of subtle tones is by *mixing any color on the wheel with its complement*. A touch of the complement will reduce the brilliance of any color. If *more* of the complement is added, it'll mute or gray the original color still more.

For example, if you touch blue to orange, the intensity of the brilliant orange will be muted. And because blue is darker in value than orange, the blue will darken the orange at the same time. But suppose you don't want it darker? Then add enough white to keep the orange as light as you like.

There are other ways of increasing your repertoire of colors. Modifying the example just given, you could start by adding a little yellow to the orange or perhaps a little cadmium red. This would modify your orange

to start with. And don't forget the wide range of yellows and reds which you can eventually buy and add to your palette. All these would help you to arrive at a great variety of subtle, muted tones.

As a further extension of the same example, you can mute the orange with cobalt blue *or* ultramarine blue, both on your list of colors. Try each one, or perhaps a *combination* of blues. There are many other blues to buy. This way, you can get a new range of grayed-down colors.

Obviously, if you don't get into the habit of *mixing* your colors, you won't get much variety. Once you start mixing, you'll discover that the possibilities are infinite.

Intensities and muted tone relationships

Study the example of intensities and muted tone relationships in a painting by Henri Matisse (Color Plate 1), probably the greatest modern colorist. It's titled *Shrimps*.

Forget the subject matter for the moment. Block out the shrimps and lemon. It will make you appreciate how important they are to the rest of the painting. The remaining colors are rich. It's the *ensemble* of colors which gives the sense of richness. Note the fewness of colors and how they are massed. Actually, the largest areas surrounding the tablecloth are taken up with subtle, muted browns, reds, and yellows.

Now, take your hand away. Note how the luminosity of the deeper red in the shrimps and the yellow in the lemon is intensified by proximity to the muted tones. Also note that each intense color *occupies only a small area*, in relation to the whole.

The main shape motif? A big rectangle in the center, with smaller ones within it, and others outside of it. Submotif? Ovals.

Let's return again to the relationship of intense colors to muted tones, sometimes called grayed-down colors. Note that the red, and yellow are at full brilliance (or full saturation) of color. Perhaps they were used directly out of a tube, with a touch of another color added. Possibly the cross-hatched yellow was modified by the addition of yellow ochre, a little alizarin, and orange. Maybe a touch of burnt umber. The combined result is a yellow *lowered in value*. Likewise, the table front and upper right corner reveal a bright red, lowered in value. While changes in value offer another way to obtain variety, they're not the same as grayed-down colors, obtained by adding one complementary color to another. Nevertheless, changes in value give you another important form of muted color. Notice that the tablecloth isn't really white. It includes tones of warm and cool gray, prob-

ably mixed by complementaries.

To sum up, Matisse used small areas of red and yellow at full intensity; a yellow and red muted in value; and grays muted by the use of complementaries. (There are a few other colors in the painting which I'm purposely disregarding because the same graying-down process also applies to them.) Altogether, the painting is an excellent example of variety and subtlety in color, obtained mainly by a balance of intense colors to muted tones.

One more point about the use of complementary colors, which should relieve your mind. You don't have to find the *exact opposite* colors before you mix them for muted tones. In fact, any approximate color near the complementary would work out very well.

Except for locating complementaries, the practical value of a color chart, for the beginner, is limited. It's far more important for you to be aware of the possibilities of the almost unlimited number of color combinations. How to experiment, to obtain these combinations, is outlined in the next chapter.

Warm and cool relationships

Note, by the way, that the cool colors on the color wheel are massed side-by-side. You'll see that they stem from the blues, blue-greens, and blue-purples. The rest of the color wheel shows the warm colors: oranges, yellows, reds, and red-purples. As I've mentioned before, warm colors seem to come forward and cool colors appear to recede. In a painting, this gives a forward-backward movement in depth, which has nothing to do with perspective. It's another kind of relationship that makes a painting come alive.

The key to balancing this relationship is in the proportion of cool to warm colors. To find the proper balance, you approach it *intuitively*, as you do for light and dark value distribution. However, there's one important and interesting phenomenon. Generally, we seem to *feel* better when there's *more cool than warm* in a painting. And that's what you'll find in the painting by Matisse called *Interior with Etruscan Vase* (Color Plate 2).

Does this mean that all paintings should have more cool colors than warm? Not necessarily. Judge each painting individually and intuitively.

The masters, on occasion, set themselves the most difficult task of forcing red colors to stay in the background and forcing cool colors to come forward. But don't try it! You've plenty of work ahead to learn the fundamentals of creativity before you experiment with breaking the rules.

11
Work for sensitive color relationships

Everything you've learned so far about creative drawing applies to painting as well. For example, just as there must be a mood expressed in drawing, there must be feeling in color.

Color has its own unique relationships that add further dimensions to a painting. As I mentioned a moment ago, they are warm and cool relationships, and the relationships of intensities to muted tones.

How the professional judges color

Let's follow the professional artist as he looks at a painting on exhibition. First, he may respond to the colors just as deeply as anyone else, probably more so. Then, if the painting appears unusual to him, he may examine it to determine what techniques were used by the artist to obtain certain effects. Next, he would check the ensemble of colors as an integrated whole. He would check this in a number of different ways . . .

He would determine whether the massed two-dimensional color shapes are rhythmically related and integrated; whether the light and dark relationships of the colors are distributed and balanced; whether the warm and cool relationships are in harmony. He would sense if the intense colors are in balance with the muted tones of other colors; if the textural effects in applying paint are varied enough to avoid monotony (more about texture and line later); and if lines of color are applied with sensitivity. Finally, he would scan the painting, looking for the subtle relationship of each color to its neighbors.

In looking at the work of an amateur, the professional spots deficiencies at a glance. The weaknesses are usually glaring. For example, the painting often shows excessive textural effects; the amateur has been attracted to the use of a palette knife. Or perhaps he has concentrated exclusively on making his painting look "real." He's been painting with will and determination, but without the fundamental ingredient of feeling. The results nearly always look labored, hackneyed, forced, or self-conscious. Every amateur wants his painting to be fresh and original, but lacks the visual judgment to recognize where he's gone wrong.

In amateur art, the basic problem of color is lack of sensitivity and personalized feeling. There's no sense in learning many techniques in applying paint until this problem is overcome. A painting which is satisfactorily integrated in color, as a whole, is a painting which shows a sensitive, personalized relationship of each color to its surrounding colors.

Experimenting with color

My method starts with learning to establish the rela-

tionship of one color shape with the color shape right next to it. This approach reduces the problem of color sensitivity to its simplest component parts. You exclude every other consideration but the relationship of one color to the color next to it; you can give color your undivided attention and pour your heart into it. By this method—which I'll explain in a moment—you can experiment until you attain *personalized feeling*.

As you expand the process and continue to give the same degree of attention and emphasis to color relationship, the entire board will be covered and every color shape will relate to the color next to it.

Please note that in establishing a sensitive color to color relationship, you'll be working temporarily in *isolated* fashion on color alone. This may come as a surprise, because up to now I've been hammering away at your integrating everything as you go along. However, there's a very important reason for deviating temporarily. By doing so, you'll be establishing a way of *controlling each succeeding step*.

As you know, a good painting usually takes a number of layers of color upon color. Thus, you'll have the opportunity of adjusting color, not only *next* to its neighbor but *color upon color*. This will be done when you integrate each of the relationships, mentioned a moment ago, to the whole—just as the professional does. At each step, therefore, down to the completion of the painting, your colors will remain sensitive and personal.

Color by itself has no significance

The first principle you must recognize is that a color, by itself, has no significance in art. Therefore, if you've a preference for a particular color, and want to include it in a painting, my suggestion is to forget it.

Why? Because your color preference is a conscious, preconceived idea. Perhaps it's a favorite color in clothing; or perhaps it's a color in the decor of your home. Without being aware of it, you may want to do a painting to match the colors of your walls or drapery. My advice is to let your *unconscious* choose your colors. If the color you favor is truly yours, it'll come out anyway, without trying to force it. But, more important, it'll combine with others (also chosen by your unconscious) in a sensitive way.

Work for sensitive color relationships

Get rid of all fixed ideas. Forget what you've learned in the past about the application of color. *We want mood and feeling*. These must be evoked from your unconscious.

Color has no meaning unless it's related to other colors, unless it's orchestrated with other colors. Even mud can be related. However, you must work for color relationships that you can respond to and like. By *like*, I don't mean the colors that you *know* you like, or colors that you're used to. Go beyond your past experience and find new colors that begin to appeal to you. For example, find a color which, placed next to a muddy color, will make the combination attractive.

However, if you don't like a relationship, change it immediately. You must like every color you place next to another, over the entire painting surface. But remember, you're not expected to like *all* the colors as a whole, not until all relationships have been integrated, one by one.

Your first color experiment

Study the step-by-step demonstration in Color Plates 3 and 4. I've laid out the fourteen casein, acrylic, or oil colors on my palette according to the instructions in the previous chapter. I start with the number 11 bright bristle brush. I dip it into one of the two jars of water and dry the excess water with a rag. Now, I'm ready for fun!

I've no preconceived ideas or thoughts in my mind. I relax inwardly. I look over all the colors *slowly*, beginning with the cobalt blue in the lower left hand corner. After I've seen them all, my eyes are pulled back to some one color, not by previous experience, not by conscious preference or habit, but because my unconscious leads me back.

Perhaps listening to color authority Faber Birren will help. "Color will *do* things to people *whether they like it or not*. Stimulation of the eye will affect what is known as the autonomic nervous system—heart, lungs, glands and all the things that make a person 'tick'."

All right, my brush picks up some cadmium red light. Why, I don't know. (This time, I don't use a palette knife to mix colors; evidently, I don't feel like it.) I bring the color to the center of the palette. It's not thin watercolor, but a thick, buttery substance. I use casein or acrylic pigments as if they're oil paints.

As I look at the red, I feel that I want to modify it. It's too brilliant. I look over all the colors again, slowly, one by one, without consciously thinking. Finally, I add a tiny bit of raw umber, thoroughly mixing the two. Then, without thinking, I add a tiny bit of yellow ochre, a little white, a little alizarin, a touch of permanent green light, a little more raw umber, mixing the batch together each time before adding another color.

Color plates

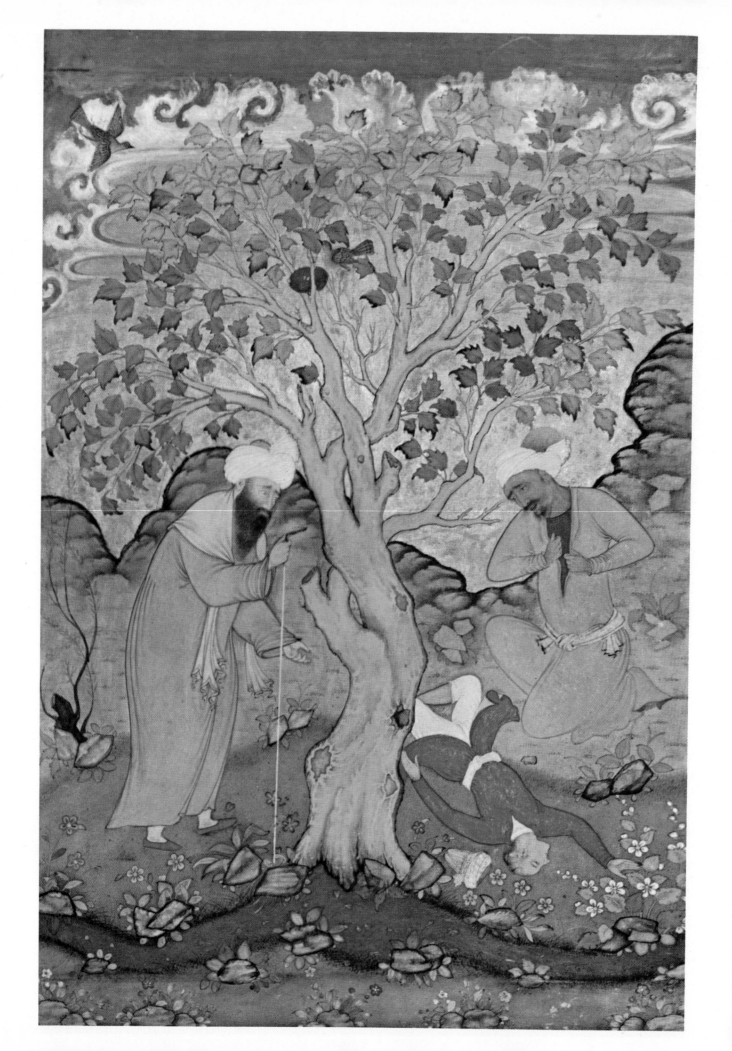

Color plates

COLOR PLATE 1 *Henri Matisse (French, 1869–1954),*
Shrimps, *23¾″ x 28¾″, oil on canvas, Everhart Museum,
Scranton, Pa., This is an excellent example of variety and
subtlety in color, obtained mainly by a balanced relationship
of intense colors to muted tones, sometimes called grayed-
down colors. Forget the subject matter for the moment.
Block out the shrimps and lemon. The large areas sur-
rounding the tablecloth are taken up with subtle, muted
browns, reds, and yellows. Now, take your hand away. Note
how the luminosity of the deeper red in the shrimps and the
yellow in the lemon are intensified by their proximity to the
muted tones. Also note that each intense color occupies only
a small area in relation to the whole. Matisse used small
areas of red and yellow at full brilliance (saturation or
intensity) of color. Perhaps they were squeezed directly out*
of a tube, with a touch of another color added. He muted the
rest of the painting by changing values in some areas and
mixing complementary colors in other areas. Possibly the
cross-hatched yellow was modified by the addition of yellow
ochre, a little alizarin, and orange. Maybe a touch of burnt
umber. The combined result is a yellow, *lowered in value.
Likewise, the table front and upper right hand corner of the
painting reveal a bright red, lowered in value. While changes
in value offer another way to obtain variety, they're not the
same as grayed-down colors, obtained by adding one comple-
mentary color to another. Nevertheless, changes in value
give you another important form of muted color. The table-
cloth, which is not really white, includes tones of warm and
cool grays, probably mixed by complementaries.*

COLOR PLATE 2 *Henri Matisse (French, 1869–1954),
Interior with Etruscan Vase, 29" x 42½", oil on canvas, The
Cleveland Museum of Art, Cleveland, Ohio. Warm colors—
which stem from oranges, yellows, reds and red-purples—
seem to come forward. Cool colors—blues, blue-greens, and
blue-purples—appear to recede. In a painting, this gives a
forward-backward movement in depth, which has nothing to
do with perspective. It's another kind of relationship that
makes a painting come alive. The key to balancing this
relationship is in the proportion of cool to warm colors. To
find the proper balance, you approach it intuitively, as you
do for light and dark distribution. However, there's one
important and interesting phenomenon: generally, we seem
to feel better when there's more cool than warm in a
painting. Does this mean that all paintings should have more
cool colors than warm? Not necessarily. Judge each painting
individually and intuitively.*

COLOR PLATE 3 (A) *Improvise in color, creating random shapes with flat, solid color, and relating each color shape to its neighbors. Find your first color. Relax inwardly. Look over all the colors on your palette* slowly. *After you've seen them all, your eyes are pulled back to some one color; your unconscious leads you back. Here my brush picks up some cadmium red light, though it could have been any color. I feel that I want to modify it; it's too brilliant. I add a tiny bit of raw umber, then tiny bits of yellow ochre, white, alizarin, light green, a little more raw umber, mixing the batch together each time before adding another color. I apply the paint solidly and flat.*

COLOR PLATE 3 (B) *Find your second color and relate it to the first color. Go through the same process again, letting your unconscious pick new colors. Here I find a second color which appeals to me. Before I place it alongside the first color, I test the new hue by holding the paint laden brush in front of the first color.*

COLOR PLATE 3 (C) *Find your third color and relate it to the first two colors. The third color must relate sensitively to* the *first two. Hence, in testing the third color, I place it in front of* each *of the first two colors, to make sure that I feel right about their relationship.*

COLOR PLATE 4 *I continue this procedure until the entire board is covered with color next to color. I can truthfully say that I like every color next to its neighbor. But you'll probably* detest *the ensemble of colors as a* whole *and rightly so. They're not yet adjusted to the various relationships I've described in the text. These adjustments will be made when I go back and tackle this board again (Color Plates 13 to 16).*

COLOR PLATE 5 *Improvise in color, using flat, solid color in shapes traced from a drawing. Introduce color relationships in the shapes you've traced. I follow the same color procedure as I did in Color Plates 3 (a), 3 (b), 3 (c), and 4, with one difference. On the first board, I made shapes as I went along; but now I'm painting within shapes prepared in advance, traced from a drawing. I concentrate exclusively on color to color relationships. At this point, I have absolutely no regard for values, warm and cool, intensities and muted tones, subject matter, or anything else. These will be taken care of in subsequent steps. I'm working for an* under-painting *of the most sensitive, personalized colors, upon which I'll build other colors later.*

COLOR PLATE 6 *I now place color over color to adjust for light and dark. First I decide what areas require adjustment in light and dark to bring the painting into harmonious balance. Second, I find the color to darken (or lighten) an area. Third, I place the new color upon the earlier color, separating the brush strokes, leaving areas of color showing through underneath. This way, I not only adjust the values but* create a textural feeling.

COLOR PLATE 7 *Detail showing color over color (see Color Plate 6). Study this carefully to see what color upon color should look like. By separating your brush strokes, leaving many areas of color showing underneath, you begin to create a textural feeling. You're continuing to create sensitive, personal color relationships. Remember that you must feel right about every color over another.*

COLOR PLATE 8 *I now paint color over color to adjust for warm and cool. First, I find the color to place cool upon warm (or warm upon cool). Second, I apply the color, separating the brush strokes, leaving areas of color showing through underneath. Study Color Plate 7 carefully to see what color upon color should look like. Study Color Plate 2 to see what a painting balanced in warm and cool looks like.*

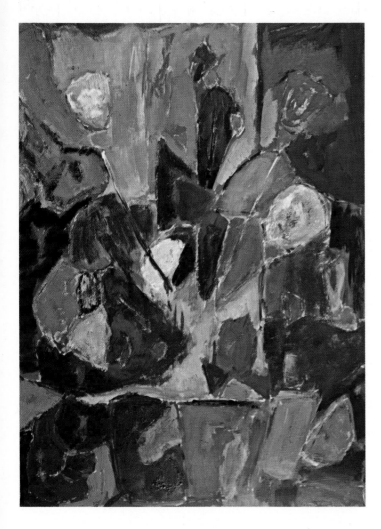 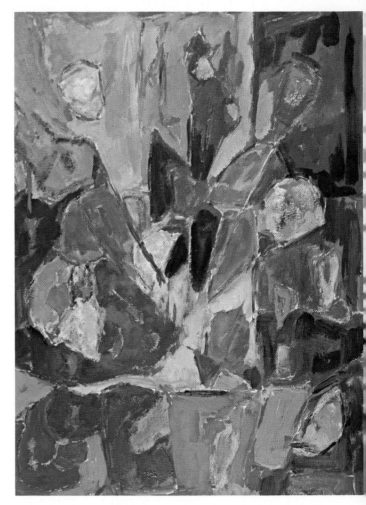

COLOR PLATE 9 *Next, I paint color over color to adjust for intensities and muted tones. Study both this and Color Plate 1 to see what a painting adjusted for intensities and muted tones looks like. Too many brilliant colors—even too large an area of one intense color—may disturb you. If so, use the blocking out test to find out* which one color (*or perhaps two*) among the brilliants you feel *right about keeping. Reduce the intensity of the other brilliant colors by adding a little of the complementary to each new mixture. Color is still applied over color with spaces left between the strokes.*

COLOR PLATE 10 *Now, you're ready to personalize your painting. Let go with full intuitive expression. Make changes wherever you like in any of the four relationships: shape relationships, light and dark, warm and cool, intensities to muted tones. For when you undo a relationship, you're aware that it will be replaced by a better relationship, integrated as a whole. This way your painting is under complete control. There should never be a time when you don't concentrate on finding the most exciting color-to-color, or color over color relationship. This is my painting completed in color over color technique. Compare it with Color Plates 11 and 12, done in another technique.*

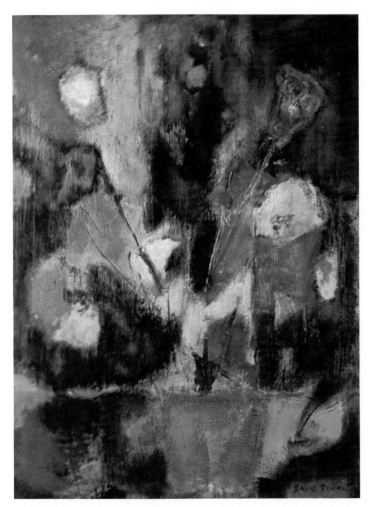

COLOR PLATE 11 *Detail of Color Plate 12, showing color rubbed in to create another form of textural surface. Rub the paint in* forcibly; *don't hold the brush parallel to the board as in the color over color technique, but hold the tip of the brush straight down, at a right angle to the board. You're going to feel more freedom with this technique. You can let yourself go, rubbing in vigorously. In addition, you'll like this method because it leaves many irregularities on the surface, giving a lively, spontaneous feeling.*

COLOR PLATE 12 Abstract Flowers, *collection Mr. and Mrs. Samuel Miller, New York. Improvise in color, using the rubbing-in technique. Paint within shapes traced from a drawing and relate each rubbed-in shape to its neighbors. Here's the rubbing-in technique applied to the completed painting (Color Plate 10). When you rub in forcibly, don't be surprised to find that the color has changed! In the process of rubbing-in, the new color has* intermingled *with the color underneath. For example, the* value *of the color rubbed in has been modified. It may not be as dark as you want. You gauge how much* more *value adjustment you need by squinting at the painting as a whole. Continue in the same way to make all other adjustments.*

COLOR PLATE 13 *Now combine a drawing with a color board of random shapes; each color shape is related to its neighbors in flat, solid color. Here I choose one of my completed drawings (Fig. 11) and trace it on a color board I'd prepared previously (Color Plate 4). At first, the board may appear chaotic, because I'm not used to the combined charcoal and color areas. But I think of it, more or less, as a doodle. You'll notice that the traced lines have divided most of the color areas; the lines have run right through them. Some colors must obviously be eliminated—covered up—to reduce this chaos. Other colors must be kept and even extended. I must decide whether to stick to the colors* within *the landscape or* outside *it. I decide to retain the colors within, as my subconscious dictates. The job ahead, then, is to cover up the color outside.*

COLOR PLATE 14 *I survey my palette and find a color, as I did before. I check it against the color to be covered, as well as against all neighboring colors. I'm not yet concerned with value and other relationships. One by one, I make decisions about all the areas where the tracing has divided the color shapes: which colors stay and which must go? As I change all the colors—inside and out, using the color over color technique—the subject matter gradually emerges. However, there may still be arbitrarily colored shapes within the shape of a mountain, for instance, which seem to destroy the forms. These shapes may now be combined to give the forms more solidity. In this case, you adjust the adjacent colors to unify the forms. These colors need not be accurate. Nor should you cover up all the colors underneath. Cover them just enough to unify the forms and, at the same time, maintain variety of color.*

COLOR PLATE 15 *From this point on, I use* both *color over color and rubbing-in techniques, changing them according to my mood. I check the painting as a whole for value relationships. Then I adjust for warm and cool relationships.*

COLOR PLATE 16 *In the final stage, I continue to use the techniques as in Color Plate 15. I adjust for intensities and muted tones. Finally, I personalize the painting. This, you'll recall, means that I let go and vitalize any area which still bothers me. First, I relax inwardly to make sure the decision is confirmed from within, intuitively. If and when I've made changes, I check the painting as a whole (in all relationships) once more.*

COLOR PLATE 17 *Improvise in color, creating random shapes with rubbed-in colors; relate each color shape to its neighbors, until the board is covered. Start with a fresh gesso board. Find your first color as usual. This time however, don't apply it flat and solid. Instead, start immediately to use the rubbing-in technique demonstrated in Color Plates 11 and 12, and make any shape you like. Continue to relate color to color in the same way as before, making various kinds of shapes as you go along. Continue until the board is covered. This is another method of obtaining originality and freshness of color.*

COLOR PLATE 18 *Using the rubbing-in technique, adjust the color board for all relationships. Since the board is in balance, it can remain as it is, if you like. Such a painting would be termed non-objective, that is, without subject matter. You and your friends might react strongly against it until you became used to the idea of a painting with no subject. Look at it this way: your painting has an expressive mood and an integrated structure, the qualities of a good painting. Why not (as Kandinsky said) let your eyes be enchanted by the purely physical effect of color, like a gourmet savoring a delicacy. If the painting is in harmony, you don't need a subject. The painting can have an independent spiritual quality without it. In time, you'll learn to appreciate this kind of purely visual experience. But if you want a subject, there are three ready alternatives discussed on the next page.*

COLOR PLATE 19 *Add newly found colors until a satisfactory subject is discovered. The first method of finding a subject to your liking is to turn the board four ways. Be sure to let down—relax completely—as you turn the board, to permit your imagination to function. If no subject appears in your mind as you study the board, the second alternative would be to trace a drawing on top of the color and continue as described in Chapter 15. I used a third alternative in this instance. I introduced newly found colors at random and related them in the usual way. I turned the board each time to see whether the change suggested a subject. I continued this process until I found a satisfactory subject. The final stage is Color Plate 20.*

COLOR PLATE 20 *The final painting:* Spanish Village. *Once houses began to appear and the subject appealed to me, I checked and adjusted all relationships: shape motifs, values, warm and cool, intensities and muted tones. Finally, I personalized the color. After making minor changes—my intuition suggested— I checked all relationships once again.*

COLOR PLATE 21 *Detail of Color Plate 22, showing the use of acrylic paste as a textural device. It dries and hardens rapidly. It can be built up and modeled to give a sculptured, three-dimensional effect. Smear the paste thickly or thinly over the area you wish to build up texturally. When the paste is partially dry, you may shape it any way you like. You may rub a brush over the paste, smooth part of it with a palette knife, or even incise it with a nail. Then paint the area in the usual way when the paste is dry.*

146

COLOR PLATE 22 The Spanish Temper, *12¼″ x 8¾″,
acrylic paste and acrylic paint on gesso board. I include it
mainly as an example of line, as well as texture in color;
also, the non-objective style may appeal to the more
advanced student. A painting doesn't always need a "subject."
The process of applying color can be a pleasure in itself,
provided that all relationships are kept in balance, just as if
you're painting a landscape or a still life.*

COLOR PLATE 23 *Modeling a face and half figure. I begin by tracing the drawing (Fig. 41). I then start with flat, solid colors, relating them to neighboring colors (see Color Plate 5). Following that, I balance the painting in value relationships, warm and cool relationships, and intensities to muted tones. I use both color over color and rubbing-in techniques. In the next step, I begin to model the face and work for a dynamic personal quality. This personalizing process isn't restricted to the face. It applies to the figure and to the entire painting.*

COLOR PLATE 24 *I place a deep, dark, cadmium red over the violet face. Now, I'm ready to model the face by using a lighter color. I use a lighter red, but a distinctly different shade than the dark one. I start rubbing it in, working for value relationships. As I keep modeling, I add touches of other colors, such as yellow ochre, light yellow green, and cobalt or ultramarine blue. I work for mood, so I let myself go. I've no idea what mood will emerge. I don't try to remember the mood in the drawing. I don't try to model in detail. Even the eyes are indicated generally. Everything is subordinated to the mood of the whole painting.*

COLOR PLATE 25 *Stage 3. I rub in white with a touch of blue. I feel the need to tone down the strong facial color. Yet, I want to retain a glow. I add greens and blues for value contrasts. Notice that I've begun to model the scarf. Here you may need to study how a scarf folds. Get someone to pose for you with a scarf and draw the folds a few times until you're satisfied—then paint freely.*

COLOR PLATE 26 Figure, *collection, Mr. and Mrs. Samuel Miller, New York. I continue the process. Wherever I've unbalanced relationships in order to personalize and vitalize the painting, I make sure to check them afterward, as a whole. In this case, I work on every part of the painting. Notice that I've modified the background and clothing, as well as the face and hair. If the result isn't satisfactory, I don't hesitate to go over the face a number of times, until I evoke the mood which appeals to me. It can even be an ugly mood, as long as it's vital.*

COLOR PLATE 27 *Paul Cézanne (French, 1839–1906), Still Life with Apples, 27" x 36½", oil on canvas, The Museum of Modern Art, New York. Cézanne used the principle of overlapping planes in a new approach to color. The form of each object was built up by a myriad of tiny planes of different colors. For instance, look at the large grapefruit and two apples in the lower right. They weren't painted in the academic manner: a red apple wasn't blended with different tones of white to achieve brightness and roundness; neither was the shadow side of a red apple painted in red of a darker shade. Instead, Cézanne used tiny planes of warm color in the light areas. He charged each little brush stroke with another related hue as he worked from warm to cool colors in the dark shadow (study the enlargement in Color Plate 28). This was not a formula. Cézanne saw nature in a unique way. Color, lines, shapes, and space were completely integrated as one to create three-dimensional volume.*

COLOR PLATE 28 *Enlargement of the grapefruit and apples in the lower right of Cézanne's Still Life with Apples. Study the grapefruit first. Use a magnifying glass, if necessary. Notice the tiny planes of warm color in the light areas. Then observe how Cézanne worked his way from warm to cool colors in the dark shadow. Each plane of color is distinctly different, and carefully related to its neighbor. This is the foundation of the procedures I advocate in relating color to color.* ▶

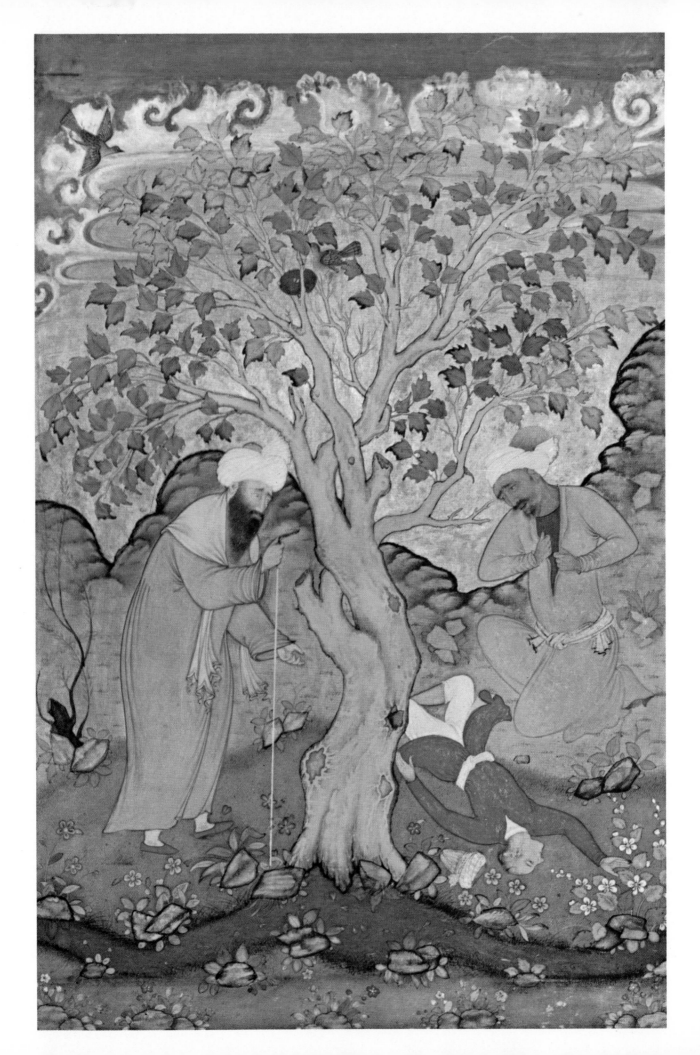

Applying your first color area

The combination appeals to me and I'm ready to apply a patch of color to the gesso Masonite board (Color Plate 3A). Please note that I move the brush almost parallel to the surface. This way, the paint is applied solidly and flat. It looks like paint on a wall, smooth with no texture; I'm purposely avoiding texture for the moment. I'm concentrating on the search for color relationships. Texture has its own exciting quality, and I don't want it to interfere just yet. Amateurs have a habit of substituting texture for color. Texture will be added at a later stage.

Notice that it doesn't make any difference where you start to paint on the board. I've placed my first color area at random. Eventually, the entire surface will be filled with colors. And what we'll do with the resulting color arrangement will be explained in Chapter 15 (Color Plates 13–16). This is *not* an exercise. It's creative expression, working for sensitive, personal color relationships. And, as you'll see, it will end up in a most unexpected painting!

Please note also that the shape I make with the brush on the board has no particular significance at the moment. It can be large or small, and preferably irregular to avoid possible monotony.

The color appealed to me on the palette and I placed it on the gesso board. If the color mixture hadn't appealed to me before I painted it on the board, I would have had two alternatives. I could have transferred a little of the color to an empty space on the palette, then added other colors until I liked the combination. Or I could have discarded the mixture and started all over again. Suppose the color appealed to me on the palette, but I disliked it *after* it was painted on the board? I'd go through the process of *finding* another color mixture unknown to me beforehand. And when I responded to it favorably, I'd then *cover up* the previous color painted on the board.

The idea, therefore, is not to go beyond the first color unless you're absolutely sure you respond inwardly to it. Don't be tempted to shortcut this discipline. Relax with it. Don't say to yourself, "Let me get through with this stage quickly. I'll improve it later." You're *creating now!* The final painting reflects the

expressive drive of *every step* you take on the way, right from the very beginning. The painting will fool no professional. Your personality, your mood, your feelings, your sincerity—all show through in your painting. But so do the weaknesses: indifference, lack of assurance, uneven application, lack of sensitivity, intellectual interference with the unconscious processes, and every other faltering step.

Adding your second color

Now then, I've put the first color on the board and it appeals to me. I go through the same process again, looking over all the colors slowly and letting my unconscious pick new colors for me. The only thing to do *consciously* is to give the order to let yourself go and experiment with colors you'd never ordinarily accept. For example, start with a burnt umber, raw umber, or some other somber color, even black, which doesn't appeal to you offhand. Then add, let's say, plenty of white and a brilliant color or two. You'll be surprised what subtle, muted colors will result from such experimentation.

Occasionally, paint an intense color right from the tube, but remember to keep the shape small in relation to the whole. Above all, let the colors come intuitively.

I've finally found a second color—I mixed it on the palette—which appeals to me. Before I place it alongside the first color, I test the new hue by holding the paint laden brush in front of the first color. There's no point in putting it on the board unless I really like the new color next to the first. If you don't like it or you're only lukewarm toward it, be ruthless; *change it* until you do like it.

When my second color is satisfactory to me, I place it next to the first color (Color Plate 3B). I place the second color right along one edge of the first color shape. I then paint outward from this edge, making a new shape with the second color until there's no more pigment left.

Completing the painting

The process is continued. However, the *third* color must relate sensitively to the *first two*. Hence, in testing the third color, I place it in front of each of the first two colors, to make sure that I feel right about their relationship. This increases the difficulty. But, by persistence, I intuitively find a new combination that (I feel) relates nicely to the first two (Color Plate 3C).

Now then, I place the third color so that it touches the edges of the *two* preceding colors. I brush the new color outward from the edge, making a third new shape. From now on, I continue the process, adding

new colors and checking every new color against *any* two preceding colors, until I decide where it should be placed on the board.

When I've continued this procedure until the entire board is covered, I can truthfully say that I like every color next to its neighbor (Color Plate 4). If there was any color that I didn't like, I would have changed it immediately. This procedure takes discipline, but it pays big rewards. You're actually creating sensitive, personal color relationships—your *own* expressive color.

But now you'll probably detest the ensemble of colors as a *whole* and rightly so. They're not yet adjusted to the various relationships I mentioned in earlier chapters. These adjustments will be made when I go back and tackle this board again in Chapter 15 (see Color Plates 13-16).

Your assignment is to do a board of your own, following the creative process as I've just demonstrated. Be sure, however, to work for your own personal color relationships. Let go and work intuitively.

Tips from classroom experience

Keep away from the use of brilliant yellows, except to use them for mixing with other colors. If you must use yellow, modify it until the tone is muted, then apply it sparingly. For that matter, this advice applies to all brilliant colors, straight from a tube. Always use brilliant colors with extreme caution to avoid harshness and gaudiness.

Don't *think* about colors. *Feel* them.

In using casein or acrylic paints, don't be fooled by tints of watercolor on your palette and brush. There must be a thick paste of color, just as in oil painting.

Use plenty of white. That's why we buy a much larger tube of white than of other colors. It increases the range of colors and thus gives you great variety.

Under no circumstances should you consciously study the colors on the board before you start to mix new colors. If you do, you'll be using your knowledge of color combinations, your experience of the past, or what you *think* will go well together. This negates all intuitive searching for colors.

You may find good color to color relationships, but decide to adjust and integrate the over-all color arrangement on the board *as you go along*. My advice is to postpone this, because you don't know what's ahead. Have patience.

Keep the colors flat and solid. Don't be tempted to texture them. Again, have patience.

In fact, don't be tempted to alter any of the procedures. They're given for a purpose. When you work through all the steps outlined, you'll begin to produce the kind of painting approved by professionals. It can't fail because you're working like the professional —except in slow motion.

After you've finished this assignment, put the board away until you reach Chapter 15. You're now ready for your first real painting.

12
Start your first creative painting

Y OUR ASSIGNMENT IS to choose any drawing, completed previously, which you'd like to paint. The first step is to trace it on a gesso painting board. See the demonstration in Color Plates 5-12.

Trace a drawing on a gesso board

Here's how to proceed. Place the tracing paper, with charcoal side down, on the Masonite board. Place the drawing on top, face up. Fasten both tracing paper and drawing to the four corners of the board with clothes pins or clips.

You want to trace all of the two-dimensional shapes in the drawing as accurately as possible. Compare the drawing which I completed earlier (Fig. 56) with the tracing of it in the demonstration (Fig. 160). In the latter, I use a sharp, pointed nail to trace the contour of each shape in a *continuous* line. When I finish tracing, every shape (including each negative shape) becomes an individually enclosed area.

To be sure that I don't overlook any areas, I unfasten two clothes pins and carefully pick up both the drawing and tracing paper from *one end* of the board. If I've overlooked a line or an area, I refasten the paper and I complete the tracing. Then I check the drawing at the other end of the board in the same way.

Don't try to carry over the sensitive light and dark values of your drawing. It can't be done. A drawing in black and white retains its own special sensitivity; it reflects the texture of the charcoal. Each medium has its own unique character and can't be duplicated in another medium.

Perhaps, having attained a certain quality of light and dark in the drawing, you're concerned whether the light and dark of the painting will give you as much pleasure. It may give you even more pleasure, but it'll be a different kind of pleasure and a different work of art.

Why, then, did you work so hard for the light and dark mood if you're not going to use it in the painting? Trust your intuition. It'll take sustenance and inspiration from the feeling and mood in the drawing. In some mysterious way, your unconscious will feed on these to produce an entirely new and exciting mood in color.

Introduce color relationships in traced shapes

If you've traced your drawing carefully, you've automatically accounted for the first important relationship in color. You have variety of two-dimensional shapes, rhythmically related.

You're now ready for the second step: to introduce color into these shapes. Follow the same color pro-

155

FIGURE 160 *Trace a drawing on a gesso board. Choose any drawing, completed previously, which you'd like to paint. Place the tracing paper with black side down on the Masonite board. Place the drawing on top, face up. Fasten both tracing paper and drawing to the four corners of the board with clothes pins. Trace all of the two dimensional shapes in the drawing as accurately as possible. Compare the drawing which I completed earlier (Fig. 56) with the tracing of it here. Here I've used a sharp pointed nail to trace the contour of each shape in a* continuous *line. When I've finished tracing, every shape (including each negative shape) becomes an individually enclosed area.*

cedure as you did in the previous chapter. What you want is to obtain sensitive, personalized color-to-color relationships throughout this new board, as you did on the first board. The only difference is this: on the first board, you made shapes as you proceeded; in *this* case, the shapes have been prepared in advance.

Start with any shape and find your first satisfactory color. Fill it in flat and solid, no texture. Then relate a color next to it. *Expand in no other way.* For example, don't decide suddenly to paint a shape on another part of the board. And under no circumstances think of a color consciously in relation to the subject matter. Turn your board sideways or upside down, if necessary, to get your mind off the subject matter. *Concentrate exclusively on color to color relationships.* At this

point, have absolutely no regard for values, warm and cool, intensities, muted tones, subject matter or anything else. These will be taken care of in subsequent steps.

In effect you're working for an *underpainting* of the most sensitive, personalized colors, upon which you're going to build other colors later.

In Color Plate 5, you'll see the color-to-color relationships I made from the board I traced. This will give you an idea of how far removed the painting is from the original drawing in Fig. 56. I haven't attempted to pour my feelings over the entire area, as I did in the drawing. Instead, I worked for the finest quality I could muster for *each* color-to-color relationship. I excluded every other thought.

You're now ready for the next step.

Adjust for light and dark

Your next step is to adjust your painting for light and dark value relationships. If you've followed instructions, your painting at this point should bear no resemblance to the values in your original drawing.

You've now two options. You can adjust the values in the painting to those of the drawing. Or you can decide whether the values—provided by the color-to-color procedure—if balanced as a whole, would give you a more dynamic or more unique set of values. Here's the possible opportunity for the "controlled accident" to provide a vital, original painting. Here's where intuition and imagination begin to offer large returns in creativity.

Of course, in harmonizing values in color, you need to let down—to relax inwardly—as in drawing, to view your painting quietly and serenely, permitting your unconscious to function. However, checking over-all light and dark value relationships in *color* may be confusing for the beginner. Color can be overpowering at times. Brilliantly intense colors like yellow, for example, may intrude on your vision and throw off your judgment.

My suggestion is to think of the colors as if they were photographed in black and white. For it's this relationship of light and dark that you need to balance.

Sometimes, too, the subject matter intrudes and interferes with the judging of values. In such a case, try looking at your painting out of focus. You can also turn your painting upside down or sideways.

Finally, if you're still in doubt about the distribution of values, apply more darks than lights, as a whole. In suggesting this, I don't mean that the darks need to be way down to number 8 or 9 in the value scale illustrated in Fig. 30. This is a common error. If you use plenty of white with your colors generally, you'll find

that the values are usually somewhere between numbers 4 and 5. You could, therefore, darken the value to number 6. There's no firm rule; but the point is that you don't need to get values too dark, unless that's what you want.

Color over color to adjust values

Whichever choice you make, proceed to cover color *upon c*olor to adjust values (Color Plates 6-7). For example, in order to balance light and dark values, you feel that a certain area needs to be darkened. You look over all the colors on your palette one by one, slowly, as before, to allow your unconscious to choose a color to start with. Your conscious mind has already given the order to choose colors with dark values. Hence, you automatically disregard light colors. You may, nevertheless, add a touch of light color into the mass of dark color you choose.

You're now ready to proceed with the mixed color of your choice. The next step is to check for isolated color relationship. The brush is loaded with the color you've just mixed. You place it in front of the color to be covered and in front of all adjacent colors to make sure that the relationship is subtle, just right.

If it isn't, again go through the process of *finding* a new color. *Don't look at your painting while you're seeking a color.* Otherwise the quality of color relationship will suffer. The painting will lose its originality and freshness. This is a difficult habit to form, but it's a *must*. Colors should be arrived at intuitively, not consciously.

All right, you've the right color and you're ready to darken the area. Don't rush. *How* you place color upon color is extremely important. You want to accomplish two things at the same time: first, to darken the area; second, to begin to *create a textural feeling*. You attain texture by not covering the entire area. In fact, you *separate* your brush strokes, leaving many areas showing underneath. Study the demonstration closely to see what color upon color should look like.

Don't forget to step back after each brush stroke. Otherwise, you'll inadvertently cover up too much. If you do, I warn you that it will be difficult to correct it sensitively, Also, what looks right close up, usually doesn't at the viewing distance of four feet. Therefore, cover less and check more.

One more thought. At this point, *consciously* let the brush strokes follow the form of the object within the area you're covering. If you're doing a vase, let the brush stroke take the shape of the vase, following the roundness of the form. If you're doing the side of a mountain, let the strokes take the jagged form of the mountain. Now study the demonstration painting, adjusted for light and dark.

Color over color to adjust for warm and cool

Up to now, you've made two adjustments on your painting as a whole. The first adjustment was for shape relationships. The tracing of shapes previously adjusted on the drawing took care of that. The second adjustment was for light and dark value relationships. Now you're ready for the third adjustment: warm and cool relationships (Color Plate 8). Take this next step on your painting as I've done in the demonstration.

You'll remember that the cool colors are based on blue; the warm colors, on orange, red, and yellow. Green and purple are borderline colors. If enough blue is added to them, they become blue-green or blue-purple. On the other hand, if enough yellow is added to green, or enough red is added to purple, they're considered warm colors.

When in doubt, apply more cool colors than warm. Let's assume, for example, that you've spotted the area or areas that are too warm. This time, your conscious mind gives the command to concentrate on cool colors. You begin, once again, to search intuitively for a cool color mixture. There are very few cool colors to choose from on your palette. Therefore, you'll need to depend more than ever on adding touches of other colors. There's always white—and even black—to use with other colors. As usual, *disregard the subject matter* and the colors on your painting in arriving at the new cool color to be used.

The actual technique of applying color over color to adjust warm and cool is the same as I described a moment ago.

By relaxing, you'll find that your intuition will function without difficulty in making this color adjustment. Perhaps you'll find it easier because, by now, you've had some experience in placing color over color, and you're now more confident.

Study the demonstration painting, now adjusted for warm and cool.

Color over color to adjust for intensities and muted tones

Now you're ready for the fourth adjustment: intensities to muted tones (Color Plate 9). Make this adjustment on your painting.

If any colors in your painting still disturb you, chances are that there are too many brilliant colors in relation to the whole. Use the blocking out test to find out. Place your finger or fingers over all the intense colors, except one, and note the relationship of this one to the rest of the painting. Do the same with each of the brilliant colors; then decide *which one color,* among the brilliants, you *feel* right about.

Proceed to reduce the intensity of the other brilliant

colors—the too-brilliant ones—by adding a little of the complementary to each new mixture. Test the painting as a whole, once again. You'll probably feel better about the painting now.

Color is still applied over color as in the previous adjustments.

Personalize your painting

In following the instructions in this chapter, you've done exactly what the professional does. He sensitizes his colors, one to another. At the same time, he makes the four adjustments you've made.

The only difference is that the professional, through long experience, is able to jump from one adjustment to another, without taking them in the systematic order you've followed. Or he may return to any part of the painting, at any time, for further adjustment. My suggestion is not to deviate from the procedures I've given. That way, you're assured of color control.

Of course, if you're impatient by nature, withholding your expressive feelings at times, in order to make adjustments, may be disturbing. But the alternative is to lose control of your painting. This, again, is one of the problems of the amateur, who flounders in confusion and has no idea where he's headed when painting.

Having made all necessary adjustments, your final step is to *personalize* your painting, that is, if you feel there's something still to be done. For example, in relaxing with your painting, you might find that in applying color over color, you inadvertently lost the form of an object. Very gently, correct it without losing the shape relationships, values, warm and cool relationships, or intensities and muted tone relationships (Color Plate 10).

This may puzzle you. How can you possibly make a correction by using practically the same color? You can't, if the color you put on top is the same as the one underneath; the correction wouldn't be visible. What then? Now that the painting is under full control, you can purposely change the value of an area temporarily. For example, make the correction with a lighter value first. Then go over it a second time with the original value. To make sure that you remember the original value and color, don't cover it all up. Leave a generous portion of it uncovered in your painting while you cover it with the lighter value.

If you're not satisfied with the correction of the form you lost, go over the same procedure again.

Modify the color and value. Be careful, however, to check color-to-color relationships as you go along. That is, hold a brush up to the color to be covered. It must feel right before you make any correction.

Another point. When you check your painting as a whole, you may find that some of the dark colors have become dull. For example, let's say that in adjusting to darker values you introduced a blue, mixed with other tones. It looked good at the time. Now, you find that it's lost its luster. What to do? Take a blue of the same value, *almost directly from a tube,* and apply it on top, here and there. If necessary, add a pinch of white, which usually brings out the intensity of low keyed colors. Will this destroy the relationship of intensities to muted tones? Not if done carefully. That is, start to add a little, to see how it affects the whole. Keep adding some more in small doses, each time checking the painting as a whole, until the time arrives when the painting feels right.

You may also have something of the same problem with muted tones. After graying them down, you may find that they're too dull in relation to their neighbors. Lighten and brighten them a *tiny bit.* For example, you may have an Indian red, grayed down. Touch a *little* cadmium red or alizarin (plus white) over the color.

To sum up, personalizing a painting means to let go with full intuitive expression, knowing that the painting is under complete control. Make changes wherever you like, in any of the four relationships. For when you undo a relationship, you're doing it with full awareness that it will be replaced by a better relationship, integrated as a whole.

There should never be a time when you don't concentrate on finding the most exciting color-to-color, or color over color relationship. Finding colors and color relationships is a challenging habit of search and joyous discovery, one of the deepest satisfactions in the life of an artist.

Study my completed demonstration painting, personalized. Note how different it is from the drawing (Fig. 56), in value relationship. Please note, too, that it has a distinctly different mood than in the drawing. In fact, we might say that the painting, while a relative of the drawing, has a life of its own. It was first created from the imagination in black and white. Then, step by step, it's developed intuitively and unconsciously, until it's unified, in all relationships, as one felt, unified whole—a completed painting in personalized color. ized color.

13
Variety of texture

NOW THAT YOU'VE EXPERIENCED the creative art process from beginning to end, you're ready to build upon this foundation. In this chapter, I'm going to discuss two ways to improve your paintings by means of texture.

Textural quality refers to the *surface* of things. Do you remember how you felt, for example, when you touched the irregular surface of an old weather-beaten door? Or when you held a fur coat next to your skin? Or when you ran the loose weave of burlap through your fingers? In each case, you received a different sensation of texture. As we know, not only children, but grownups as well, love to caress the surface of sculpture with their hands.

These feelings, based upon touch, are very strong within us. And they carry over to a large extent, when we *see* the textural surface of a drawing or painting. The roughness of a charcoal drawing may remind us of the surface of an old wall or a rocky ledge, thus creating a special emotional response. The textural quality of paint, through the use of a palette knife, has been experienced by many amateurs.

Your assignment

Unfortunately, the urge for texture is so strong that unless used with discretion it can ruin your sensitivity for delicate color relationships. Texture must never be used as a substitute for color relationships, the key to a successful painting. That's why I've insisted upon your first using flat, solid color, to be sure that you arrive at sensitive, personalized color. Only afterward, by superimposing color upon color and leaving plenty of the colors underneath to show through, will you create a textural quality without sacrificing color relationships.

Your first job is to choose two drawings, completed previously, for painting. Trace them on *two* gesso Masonite boards. Work for isolated color to color relationship, as before. But don't integrate them for value, warm and cool, intensity to muted tones relationships. These will be adjusted when you apply two new textural techniques.

Rubbing-in: your first textural technique

In the first of the two new procedures, you're going to use the *rubbing-in* technique to create another form of textural surface (Color Plates 11-12).

Once again, you've traced your drawing and covered the board with a color in each area, sensitively related to its neighbor. You've made your decision as to which value relationship to adjust, the one in the drawing or the newly found "accidental" one.

The first change in the new technique is to have much less water on your brush, working with casein or acrylic, or color undiluted with turpentine if you're painting in oil. (Instead of merely shaking out the excess water, in this case use your *rag* to remove a good deal of the water. Otherwise, the pressure of the brush, rubbing the color in, will cause the water to drip.)

You've found the first color which you want to superimpose upon the color in the area to be adjusted. You've checked the new color by holding up the loaded brush in front of the color to be adjusted in value. Now, the new technique.

Rub the paint in *forcibly,* not with the brush parallel to the board as in the first technique, but with the tip of the brush held directly against the board. In other words, you're holding the brush at a *right angle* to the board. Don't be surprised to find that the color has changed! In the process of rubbing-in, the new color has *intermingled* with the color underneath.

You'll notice two things. First, when you rub in the color, the pigment doesn't extend as far as it did in the previous procedure. Rubbing-in exhausts the quantity of color rather quickly. This means that you'll need to dip into the color on your palette more often to complete the adjustment of the color area you want to change. Secondly, you'll find that the *value* of the color rubbed in has been modified. For example, it may not be as dark as you want. What to do?

Further adjustments

The first step is to gauge how much *more* of a value adjustment you need by squinting at the painting as a whole. Next, lighten or darken the color on your palette, accordingly. Here's how I suggest that you do it. Take some of the same color left on your palette and transfer it to another clean area. Then add color to change it to the value you want. At the same time, *change the color slightly.* Thus, when you rub it into the board, you'll get still *more variety* of color. Now, take some more of the original color on your palette and transfer it to still another clean area. Again, adjust for value and another slight change in color. Rub it into the board.

Continue this process until the area is all rubbed in. The color area should have delicate variations of color—of the same value—throughout.

Continue in the same way to make warm and cool adjustments; also adjust your intensities and muted tones. Then, finally, personalize the painting as I described in the preceding chapter.

You're going to feel more freedom with this technique than in the first technique you tried. You can let yourself go, rubbing in vigorously. In addition, you'll like it because it leaves many irregularities on the surface, which give you a lively, spontaneous feeling.

Finally, you can vary the application of color during the personalizing process. For example, if you don't like an area, rub in a brilliant color as it comes from a tube, unmixed, directly into the board. Don't rub it in too hard or the color underneath may modify it too much. Use plenty of white in the same way. What it amounts to is really this: now you'll be doing your mixing on the *board,* not on the palette. This final variation should not be used until all relationships are in balance. Thus, in undoing a relationship, you'll still have a strong sense of control.

In Color Plates 11 and 12, you'll see a demonstration of what the rubbing-in technique looks like.

Simulating texture: your second textural technique

The other textural technique, which I'm about to describe, should be used on the second of the two boards you prepared for this chapter's work.

FIGURE 161 *Imitation or simulation of the characteristics of texture. Markings like these, and others, have been used in art throughout the centuries. They remind us of some of the characteristics of texture. If we photograph and magnify the woven strands of cloth, the pores of skin, the bark of trees, or the surface of seashells, we notice a variety of markings.*

FIGURE 162 *Persian 16th Century Miniature (by unknown artist),* Alexander Consulting the Seven Wise Men, *manuscript of the Khamsah of Nizami, (1509–1510), The Metropolitan Museum of Art, New York. When markings like these dominate a painting, we say that its outstanding structural element is variety of texture.* ▶

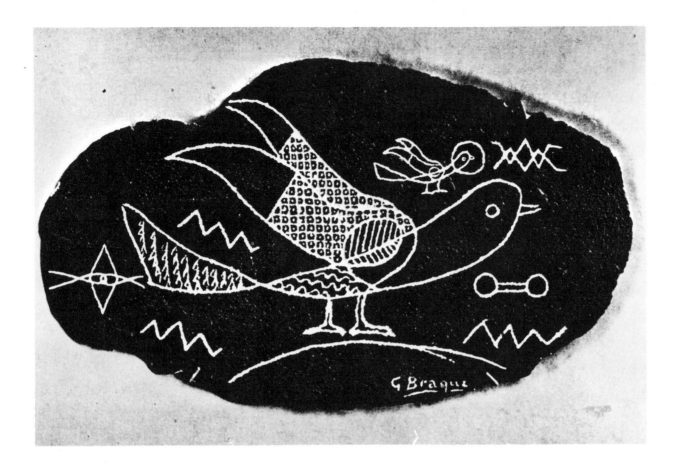

FIGURE 163 *Georges Braque (French, 1881–1963)*, Bird.
*Modern artists use simulated textures, sometimes rather
arbitrarily, as in this instance. Notice the distinctly individual
markings that bear no relationship to reality. The feathers in
Braque's bird are not an imitation of feathers.*

The procedure is based upon a distinctly different kind of pattern, which has been used throughout the centuries as texture in art. I refer to the *imitation* or simulation of the characteristics of texture. For example, if we photograph and magnify the woven streaks of cloth, the pores of skin, the bark of trees, or the surface of seashells, we notice a variety of markings. In Fig. 161, you'll see what some of them may appear to look like.

When markings like these dominate a painting, we say that its outstanding structural element is variety of texture. Look at the Persian miniature of the sixteenth century in Fig. 162. We respond to it immediately.

Modern artists have also used simulated textures, sometimes rather arbitrarily, as in the case of Braque (Fig. 163).

Therefore, in making the value adjustments and other adjustments on the second board, *add markings of color,* instead of rubbing in or superimposing solid, flat color over color. Use your own markings as the spirit moves you. Don't consciously try to remember what an object's textural qualities look like. Be guided solely by your feelings. Introduce markings of any kind which appeal to you. For example, the feathers in Braque's bird are entirely arbitrary markings, not an imitation of feathers.

As an example of how color is used in texture, study the Matisse painting in Color Plate 2. The textural design retains a free-flowing look about it, despite the fact that it was changed many times before the artist was satisfied with it.

One more thought. You may, if you like, combine the painting method used in the previous chapter with either (or both) of the textural techniques discussed in this chapter.

14
Variety of line

LINE, as you probably know, doesn't exist in nature. It's merely a theoretical term indicating one dimension—length.

In a drawing or a painting, line is used to describe contours and edges. But strictly speaking, what we refer to as a line is, in reality, a *shape*. No matter how thin a line appears, it has a certain degree of width. Of course, no one has come up with a satisfactory answer to the question, "How much width must a line have to be called a shape?" However, we won't quibble. For our purposes, we'll continue to use the term, *line,* in its conventional sense, as something that defines a contour or edge.

The problem of line

There are a number of reasons why I've delayed consideration of line until now. Many of us have been conditioned to draw with an even, monotonous line. This habit, carried forward from preschool and early school training, is not easy to break. We were encouraged, in those days, to draw rigid designs and patterns and to learn mechanical drawing, all with even outlines. This conditioning is still going on today. Children are being desensitized to the expressiveness of line by the horrible coloring books which are being sold in chain stores throughout the country. Practically all the illustrations in coloring books are outlined in monotonous, even lines. These lines are vapid. They create no mood at all.

Our emotional response to line comes from *variety* in the way strokes are made in drawing lines. This can easily be proven. Compare the lines in *Madame Cézanne in the Conservatory* by Cézanne (Figs. 164 and 165) with a *tracing* of the same painting in even, continuous lines. You'll agree that the tracing falls flat by comparison. We get no emotional uplift from the monotonous outlines.

If you require more proof, look at the tracing of my drawing (Fig. 170), which I prepared for painting. It's a continuous line with no variety. It isn't meant to be expressive. It's merely an intermediate step to save time and energy. To feel the difference, compare the tracing with the finished drawing (Fig. 11) or the finished painting (Color Plate 16). Both of the finished works include variety of line, arrived at intuitively.

The importance of variety

When line is understood and applied properly, it can be one of the most expressive structural elements in a drawing or painting. Line can evoke an emotional response second to none. The key element is variety.

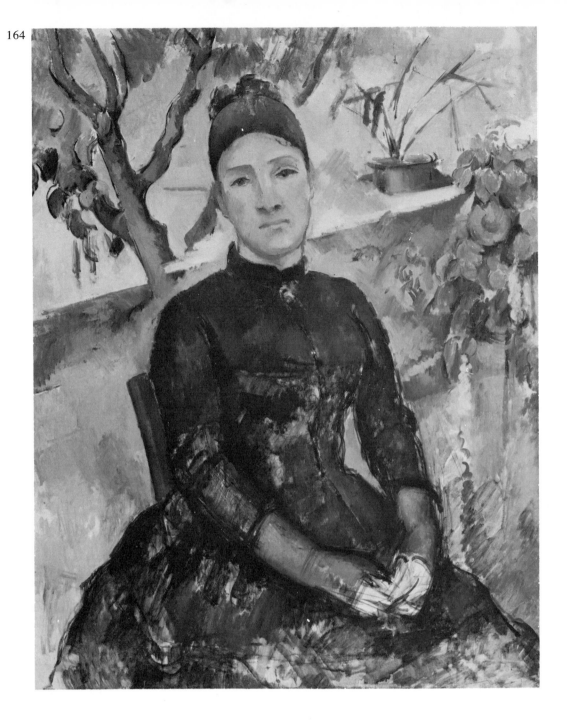

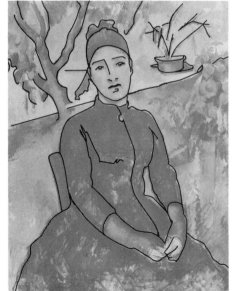

FIGURE 164 *Paul Cézanne (French, 1839–1906), Mme. Cézanne in the Conservatory, 36¼" x 28¾", oil on canvas, The Metropolitan Museum of Art, New York. Our emotional response to line comes from the variety in the way the strokes are made. We react with pleasure to the contrast of sharp lines to blurred lines, thick lines to thin lines, long lines to short lines, continuous lines to broken lines, staccato lines to sinuous lines, harsh lines to smooth lines. Compare the lines in this painting with the lifeless* tracing *of the same painting in even, continuous lines (Fig. 165).*

FIGURE 165 *Tracing in even, continuous line of Cézanne's painting, Mme. Cézanne (Fig. 164). Compare this tracing with the painting itself. The tracing falls flat by comparison. You'll agree that we get no emotional uplift from the monotonous outlines here.*

We react with pleasure to the contrast of sharp lines to blurred lines, thick lines to thin lines, long lines to short lines, continuous lines to broken lines, staccato lines to sinuous lines, harsh lines to smooth lines.

One of the reasons we respond emotionally to Cézanne's painting of Mme. Cézanne is the quality and variety of his line. I suggest that you study every line in this painting; study every edge carefully, using a magnifying glass, if necessary. Cézanne's lines are expressive because of their great variety. Yet, as you look at the painting as a whole, you're hardly aware of the impact of line.

Of course, there are many other things which add to the expressive power of the painting. Not the least is the texture of the dress, notwithstanding its "unfinished" look.

Your first assignment in line

To be effective, Robert Henri says, "You should draw not a line, but an *inspired* line . . . It should be an expression of your spiritual sight."

Your next assignment, therefore, is to be daring and let yourself go in a rich variety of line. Let your intuition function, not your reasoning mind. However, in one drawing or painting, you don't need *all* of the various kinds of line mentioned a moment ago. As a start, look over all your paintings and eliminate continuous, even lines. Use a #2 bright bristle brush to create fresh, spontaneous lines. *Twist* the brush, once in a while, to vary the line.

Now for your next assignment. Trace another drawing on a gesso board. Find and relate isolated color to color relationships over the entire surface. But, in adjusting the values, create *more light areas than dark*. In fact, many areas might all have the *same* light values. To do so, you'll need to use more white than ever with your colors. Then adjust for warm and cool, as usual. Do the same for intensities and muted tones.

At this point, you're ready to emphasize the *contours* of shapes with variety of line. Use black or any darker color than the values in your painting. This isn't easy to do delicately. If you're not careful, the painting will turn out to be a poster. If you feel that a line is too rigid and needs more variety, break up the line by running the color on either side into the line just a little—but do it spontaneously. This creates an uneven line effect. If it's not successful the first time, add more dark line and repeat the process until you feel right about it.

Step back with each brush stroke to feel the line's relationship to the whole. The blacks or other dark colors mustn't be permitted to jump out of the picture.

It's the integration of the *whole* that matters, above all else.

Before you start, study my abstract painting (Color Plates 21-22), particularly where I broke into the lines with adjacent colors.

I suggest that you complete this assignment before you continue with the rest of the chapter.

Oriental approach to space

There's another outstanding reason why I've delayed consideration of line until now: the most dynamic spatial and value relationships of line, borrowed from the Orient, often follow laws just the *opposite* of what I've discussed so far. Oriental paintings often contain large and small open areas which look like unrelated negative space, as in Fig. 95. These areas *are* related. But these relationships have nothing to do with the two-dimensional shapes we've discussed. To understand this, it's better to disregard (for the moment) any two-dimensional shapes which appear in the picture.

Visualize, if you will, what takes place when you make a *direct statement* in line. When you draw in charcoal, which is dark, or paint with a dark line, you do so on a comparatively light background. We therefore distinguish variety in line by the contrast between dark and light. Variety of line, then, functions effectively where there's a *minimum of dark and a maximum of light*.

The *quantity and quality* of darks placed in relation to large, light, open areas, is the key to Oriental space. Look at the darks which appear in the Early Ming Chinese painting, called *Guest House by Mountain Lake* (Fig. 166). The darks appear to operate on the principle of a fulcrum or seesaw. The weight of the area of dark—in the lower left corner—balances the large expanse of light and space in the rest of the picture. It's an equilibrium of weights and forces, like the contrast of a small piece of lead versus a large bag of feathers on a pair of scales. The tension is created because we normally expect the large bag to outweigh the small piece. To our surprise, the weight and downward pressure of the small piece are greater. Consequently, we feel the tension.

As another example, think of a scene at the circus. Way high up, there's a taut line. On it, a slim shape is teetering with a long, thin pole. Study the space between the taut lines—rope, figure, and pole—and the ground, away below. It's this space which creates the tension. If the taut rope were just three feet off the ground, there would be no tension. In the same way, in a picture, the *space between* must be stretched daringly, until it's felt.

FIGURE 166 *Early Ming Chinese Painting,* Guest House by
Mountain Lake, *9¾″ x 10½″, Fogg Art Museum, Harvard
University, Cambridge, Mass. The darks appear to operate
on the principle of a fulcrum or seesaw. The weight of the
area of dark—in the lower left corner—balances the large
expanse of light and space in the rest of the picture.*

The Orientals are masters at such tension-creating space. Look at the Japanese screen in Fig. 167. Note the spatial relationship between the flowers and the bird in the upper right. The large space in between is far from empty. It's the bold stretching of "empty" space that holds the whole thing in balance. Any less space in between would loosen the tension and the relationship would collapse.

FIGURE 167 *Attributed to Kano Motonobu* (*Japanese, Ashikaga Period, 1334–1573*), A Willow Tree, Camellias, Doves, Robins, *six-panel screen, The Metropolitan Museum of Art, New York. The* space between *shapes and lines must be stretched daringly until it's felt. The Orientals are masters at such tension-creating space. Note the spatial relationship between the flowers and the bird in the upper right, for instance. The large space between is far from "empty". It's the bold stretching of "empty" space that holds the whole thing in balance. Any less space between would loosen the tension; the relationship would collapse.*

Another assignment in line

A *direct* statement in line is either a success or a failure. If it fails, it can't be corrected. It must be started over again. It's a success if it's done with subtlety and meaningful nuances. These qualities can be felt at once. It's a failure if the line is artificially rigid, indicating that the reasoning mind has interfered with intuition.

So, once again, the problem is to overcome the intellect and to express ourselves with complete detachment. This applies even more so when a direct statement in line is involved. For the pulsations and vibrations of line lay bare our weaknesses, anxieties, inhibitions, and past habits in no uncertain terms. In addition, learning to express ourselves intuitively requires time—time and patience to get the brush or charcoal to respond to our command.

If direct line appeals to you, I suggest you try to do three line drawings in charcoal. Before you start, look at Fig. 16 again; this is where I made my first shape in charcoal. Notice that the shape includes a number of lines which predominate. Start off with some such shape and work for variety of line with no particular subject in mind. Keep enlarging this area with more line. At the same time, maintain a relationship between the dark area and the large, open area. You may, if you like, add some lines far from the large area of lines, to create a tension pull. Try to feel the weight of the large area of lines balanced against the large open area and the rest of the drawing. Continue this process until the whole suggests a subject which interests you; then complete the drawing as a landscape, a still life, or a figure. But the subject must be subordinated to variety of line and spatial tensions.

There are many other ways of handling line and

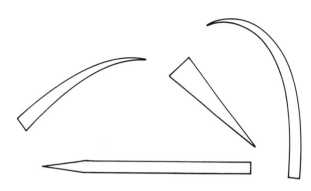

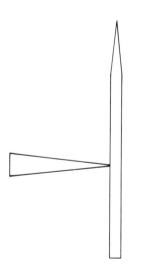

FIGURE 168 *Schematic diagrams illustrating one-way movements of various directional arrows. Movement flows in* either *direction along the length of a line, depending upon the artist's control of his line.* To control movement in one direction, the professional uses the idea of the directional arrow. The shape doesn't matter as long as it's narrow at one end, something like an arrowhead.

FIGURE 169 *Schematic diagram illustrating the stoppage of movement of a directional arrow. The artist might place another line (or shape) at right angles to the directional arrow, thus blocking further movement. The second shape (or line), also an arrow, directs its own movement. Look at Tintoretto's* Christ at the Sea of Galilee (*Fig. 206). The sea, a large directional arrow, moves to the right, stopped by the tree—another directional arrow—which in turn moves up to the sky area.*

balancing the whole. Look at my painting in Color Plate 22, which is an abstraction in line. If this approach interests you, try to work the same way, more or less. The drawing may end as an abstract charcoal or a picture with a subject, according to your desire.

The directional arrow

Finally, there's another form of movement in line (or in a shape) which you should know about. I don't mean the movement suggested by wriggly or agitated lines, which act strongly on the nervous system. I refer to the movement along the *length* of a line. In fact, movement flows in *either* direction along its length, depending upon the artist's control of his line.

To control movement in *one* direction, the professional uses the idea of the directional arrow. In Figs. 168 and 169, you'll find schematic diagrams to illustrate what I mean. The shape doesn't matter as long as it's narrow at one end, something like an arrowhead. For example, in Mantegna's painting of *St. Jerome* (Fig. 96), the tree on the right is like an arrow bent by the artist to point the way he wishes the viewer to follow. In this case, Mantegna wanted the tree to move as part of a larger oval motif. But, if the artist wanted to *stop* the movement of the directional arrow, he might place another line (or shape) at the narrow end of the arrow, at a right angle (Fig. 169). The second shape, also an arrow, directs its own movement.

I suggest that you keep this in mind when analyzing paintings. You'll find that the directional arrow shows up frequently. A word of caution: don't try to introduce this movement consciously in your drawings or paintings. Now that you know about it, let your unconscious use it as it sees fit.

Summary

By this time, you've begun the struggle of creating in color. You've also begun to integrate texture and line, as a whole.

From now on, the road upward becomes more hazardous, requiring more patience and perseverance than ever. And progress will move more slowly, all because you know so much more and your standards are higher. You'll refuse to settle for *less* than your best.

In the final chapters, you'll begin to approach more complex art problems. In fact, some of the concepts in this present chapter have already begun to move from the simple to the complex.

15
More originality
in color

YOUR NEXT ASSIGNMENT is to follow through on the color board you prepared for Chapter 11. This time, you're going to trace a drawing *on top of the colors,* which, as you may remember, were not yet adjusted for the various relationships to the whole.

Combining a drawing and color board

Using the color board I prepared previously (Color Plate 4), let me show you how I go about it. First, I choose one of my completed drawings (Fig. 11) and trace it on the color board. Fig. 170 shows how. I'm particularly careful to check the tracing because some of the colors may be dark and may not show the tracing easily. I also check to be sure that all shapes traced on the board are enclosed by lines. The only exceptions are lines purposely extended into an open space. Can you find such lines in the mountain area to the right? See how the lines become shapes in Color Plate 16.

Now we're ready for an adventure. I sit down quietly and relax as I look at the result of the tracing on the color board (Color Plate 13). At first, the board may appear chaotic, because I'm not used to the combined charcoal and colored areas. But I think of it, more or less, as a doodle. I examine the board four ways (right side up, upside down, sideways, etc.) to determine whether the combined tracing and colors suggest a more dynamic and original subject. If not, I can always return to the subject matter in the drawing I originally traced. In either case, whether you accept a possible "accidental" subject or the original one, the procedure which follows is the same. I chose the original still life which I traced.

You'll notice that the tracing has divided most of the color shapes; the lines have run right through them. For example, the colors inside and outside the landscape are the same. To give the subject matter more definite form, my first step is to cover up some of the color shapes. There are a number of divided color areas. You can start with any area. Now the decision must be made whether to retain the color *within* the landscape or *outside* it. I decide to retain the color within, as my subconscious dictates. The job, then, is to cover up the color outside.

I survey my palette and find a color in the usual manner. I check it against the color to be covered, as well as against all neighboring colors. At this point, I'm not yet concerned with value and other relationships. One by one, I make decisions about all the areas where the tracing has divided the color shapes. As I change all the colors, inside and out, using the color over color technique, the subject matter gradually emerges.

FIGURE 170 *How to trace a completed drawing on a color board. Using the color board I prepared previously (Color Plate 4), I trace the drawing (Fig. 11) on it (see Color Plate 13). I check to be sure that all shapes are enclosed by line. The only exceptions are those lines purposely extended directly into an open space. Find such lines in the mountain area to the right. The lines become shapes in Color Plate 16.*

FIGURE 171 *Robert Motherwell (American, 1915–),* Pancho Villa, Dead and Alive, *28″ x 35⅞″, gouache and oil with collage on cardboard, The Museum of Modern Art, New York. A collage is made by pasting pieces of paper or other material onto the painting surface, then painting on top of them or alongside. Before you glue them down, move the pieces around until you achieve the greatest spatial tension. Keep in mind that the pieces are shapes first; you must feel right about their spacing. After color is added, check the whole thing out for all relationships. Regardless of the materials you use, you still have the task of creating a mood and an integrated structure.*

However, there may still be arbitrary colored shapes *within* the shape of a mountain, for example, which seem to destroy the forms. These shapes may now be combined to give the forms more solidity. In this case, you adjust the *adjacent* colors to unify the forms. These colors need not be accurate. Nor should you cover up all the colors underneath, just enough to unify the forms and, at the same time, maintain variety of color (see Color Plate 14).

From this point on, I use *both* color over color and rubbing-in techniques, changing them according to my mood. Following the usual procedure, I check the painting as a whole for value relationships. Then I adjust for warm and cool relationships (see Color Plate 15). Next, I adjust for intensities and muted tones. Finally, I personalize the painting. You'll recall that this means that I let go and vitalize any area that still bothers me. When I've made changes, I check the painting as a whole—in all relationships—once more. Color Plate 16 shows the final painting.

Note that the colors in my finished painting are ones I would probably never have chosen ordinarily. They've come about by accident, by putting together a drawing and a color board that started out unrelated to one another. Furthermore, had I discovered another unexpected subject, the painting might have become even more original.

Rubbing-in technique on a fresh board

Another method of obtaining originality and freshness in color is to start with a fresh gesso Masonite board. Find your first color as usual. This time, however, don't apply it flat and solid. Instead, start immediately to use the rubbing-in technique demonstrated in Color Plates 11 and 12, and make any shape you like. Continue to relate color to color in the same way as before, making various kinds of shapes as you go along. As soon as the board is covered, adjust for light and dark relationships, then warm and cool, and finally intensities to muted tones.

Now, you're ready to consider subject matter. Turn the board four ways. Determine which way, if any, suggests a subject to your liking. Be sure to let down and relax completely as you turn the board, to permit your imagination to function.

If no subject appears in your mind as you study the board, there are a number of alternatives. Since the board is in balance, it can remain as it is, if you like. Such a painting would be termed non-objective: that is, without subject matter. You and your friends

might react strongly against it until you become used to the idea of a painting with no subject. But as Wassily Kandinsky wrote, "This art creates alongside the real world a new world which has nothing to do *externally* with reality." Kandinsky was a pioneer in completely detaching painting from the objects we see around us. He worked from within, guided by his intuition.

But look at it this way. You've expressed yourself with all the feeling you could muster, relating color to color throughout the board. With intuitive sensitivity, you've adjusted light and dark relationships. You've done the same with warm and cool relationships, as well as intensities to muted tones. The painting therefore has an expressive mood and an integrated structure—the qualities of a good painting. Let yourself go; as Kandinsky said, let your eye itself be enchanted by the beauty of color, the purely physical effect of color. Experience the satisfaction and delight of the painting as a handsome *object,* like a gourmet savoring a delicacy. If the painting is in harmony, you don't need a subject. The painting can have an independent spiritual quality without it. In time, you'll learn to appreciate this kind of purely *visual* experience.

But if you *want* a subject and none comes to mind, the second alternative would be to trace a drawing on top of the color and continue as in the method I described earlier in this chapter.

A third alternative would be to unbalance the board by introducing additional, newly found colors. Turn the board around each time you add a color, to see whether the change suggests a subject. Continue this process until a satisfactory subject is found. Then check and adjust for values and all other relationships.

A demonstration of this method is illustrated in Color Plates 17-20. In the first stage (Color Plate 17), I covered the board with rubbed-in color-to-color. In the second stage (Color Plate 18), I made all adjustments; now it's a non-objective painting. In the third stage (Color Plate 19), I unbalanced the board to find a subject. In the fourth and final stage (Color Plate 20), the subject takes its completed form and becomes a *Spanish Village.*

The palette knife as a textural scraping tool

Still another way to obtain originality and vitality in color is the judicious use of a palette knife. This time, unbalance the board by *scraping* an area. Please note that this technique won't work with acrylic paints;

they'll peel if you attempt to scrape them. However, results can be exciting if you scrape either oil or casein.

In scraping, place the edge of the palette knife almost parallel to the board. Scrape a small area at a time. Do it gently.

Next, turn the board four ways to study how the scraping has affected the whole. Also see whether the board now suggests a subject. Keep scraping and checking until a subject is evoked. Then readjust for all color relationships, as before. Try the rubbing-in technique in adjusting color relationships. The scraped areas should be touched up with extreme care. That is, don't rub in color all over, but rather blend in gently. The idea is to retain the subtle colors uncovered in scraping and keep them consistent in their relationships to the whole.

If the rubbed-in adjustments are unsatisfactory, there's no harm in scraping down the area again, as often as necessary. The effect will vary each time because, in scraping, not only does the pressure on the palette knife vary, but some colors dry more quickly than others. Thus, some colors will scrape off while others won't, resulting in unexpected color combinations not obtained in any other way.

Examine Color Plate 11. The palette knife was used to scrape a light area in the center, above the small, vertical, dark lines. You'll recognize the area by its textured appearance, showing a variety of tiny, subtle colors, uncovered in scraping. This technique should be used sparingly.

A nail as a textural tool

A sharp nail or stylus may be used on occasion, here and there, as a textural tool to enliven a painting with variety of line. This tool is particularly useful if you've been too precise and over-exacting in painting your subject matter. Incise some of the edges with a few swift strokes. Don't be afraid of spoiling your painting. The scratches will probably stray from the edges of the shapes, creating double lines here and there. This procedure may sound reckless, but it isn't. Actually, it will loosen up your painting and give it some life. Here again, what may look exaggerated when seen up close, will usually be just right at the correct viewing distance, that is, the distance where you can see the painting as a whole.

A demonstration of this procedure appears in some of the stems in Color Plate 12.

Collage in painting

A collage is made by pasting pieces of textured wall-paper, newspaper, or other material onto the painting surface, then painting on top of them or alongside. Before you glue them down with white glue (like Elmer's Glue or Sobo) or acrylic painting medium, move the pieces around until you achieve the greatest degree of spatial tension. Keep in mind that the pieces are *shapes* first. Therefore, you must *feel* right about their spacing. Another point: don't cut them with scissors, but tear them spontaneously to create rough edges. After color is added, check the whole thing out for all relationships.

Sometimes pieces of photos are combined to give a bizarre effect. This is called a photo montage.

Remember: regardless of the materials used, you still have the task of creating a mood and an integrated structure in such paintings.

Fig. 171 is an example of a collage by the contemporary American artist, Robert Motherwell.

Acrylic paste as a textural tool

Acrylic paste is a valuable adjunct to obtain a variety of textural effects. It's a white plastic resin emulsion, compounded with ground marble to a slightly granular, clay-like consistency. It dries and hardens rapidly. If you like, it can even be built up and modeled to give a sculptured, three-dimensional effect. It'll probably appeal to you if you find the gesso Masonite board too smooth for your taste, or if the rubbing-in technique doesn't give you the degree of textural roughness you desire.

Let's say you want the rough effect of a stone wall or a rocky mountainside in your painting. Pick up a quantity of acrylic paste with your palette knife (closing the lid of the can immediately to prevent drying). Smear the paste thickly or thinly over the area you wish to build up texturally. When partially dry you may shape it any way you like. You may rub a brush over the paste, smooth part of it with a palette knife, or even incise it with a nail. Then paint the area in the usual way, when the paste is dry. See Color Plates 21-22 for the use of acrylic modeling paste as a textural device.

Other textural devices with acrylic paste

A variety of textured surfaces can be constructed with wire mesh, lace, fibrous rice paper, pebbles, sand, string—to name only a few materials. Any one of these, or a combination, may be imbedded in the wet acrylic compound. Some of them will give a three dimensional effect, depending upon their height above the layer of compound. Most will adhere without glue. If not, use white glue or acrylic medium.

On the other hand, when the acrylic paste is partly dry, you may press wire mesh or some other solid substance into it to act as a mold. When the material is removed (the paste is still wet), a sculptured design will appear in relief. This design will appear above or below the surface of the compound depending upon the shape and form of the material used.

In either case the paste will dry in a few minutes. Should the surface crack during shrinkage don't hesitate to touch it up with a little more acrylic paste. Once the crack is covered it won't deteriorate or crack again.

The next step is to add color. An interesting effect is obtained if you don't color all of the indented or raised shapes. Leave a suggestion of white showing.

If for any reason the result is unsatisfactory, scrape the paste down with a palette knife. But don't wait a week to do it, because you'll need a chisel by then. However, even when hardened, acrylic paste can be turned to advantage. You may find enjoyment in the use of carving tools; the modeling paste can be cut, sawed, and grooved out to form a low relief design which will stand out slightly from the background. It'll cut smoothly without breakage. Acrylic paste, when dry, has remarkable strength to resist chipping and breakage.

In trying out these technical suggestions, please remember that sensitivity in selecting, combining, and spacing material is the key to a good painting of this type. Furthermore, the textural effects must be integrated with color relationships as one unified whole.

Textural demonstration

Fig. 172 is an example of a painting in which I combined a number of textural techniques. I started by covering the entire Masonite board with acrylic modeling paste. I brushed the upper part and the sides to give it the rough textural effect. In the lower part, along the edges, I added some sand and leveled it with a ruler; compare the difference in texture with the center. In the center, I used the back of an old spoon to create a number of vertical ridges. I didn't add sand here. Instead, using a small reed basket that I bought at a white elephant sale, I pressed it into the acrylic compound with no particular thought in mind. I liked the impression it made, so I repeated the process in one or two other areas nearby. For contrast, I took the top from a tube of paint and made a number of impressions.

At the time, I had no idea of subject matter. Eventually, however, I decided to do a still life with flowers, directly over all of the textured surface. The straw vase was no doubt, suggested by the reed indentations.

I adjusted the shapes and colors at least twenty times during the next six months. Each time, after an interval, I examined the painting as a whole and felt the lack of cohesion. Either the relationship of the parts to the whole didn't satisfy me; or I was critical of the relationships of the shapes to each other; or the color relationships didn't feel right.

In the meantime, I had found a cardboard game picturing an old timepiece with its inner workings. The illustrations were round and of various sizes. I decided to add collage material to the still life. So I deleted the different flowers and substituted the various illustrations. The surface of the Masonite board had been built up fairly high with acrylic paste; I therefore used a chisel and hammer to take out the flowers. I was able to remove two of the flower areas intact. These fascinated me. I began to move them around in the lower part of the painting until the spatial relations felt right, then I glued them down. To me, they suggested flowers in bas-relief.

More months elapsed before the painting was completed. The symbolism of time instead of flowers appealed to me. But the collage threw the painting out of relationship in light and dark. The illustrations were too light but I was afraid to darken them because I feared the symbolism might disappear. One day, after a long interval of time, I had a strong urge to work on it. At the top I reduced some of the wider leaf shapes to thin lines. I turned the painting upside down and slashed into the vase area, rounding it rhythmically to the ovals and circles of the flowers. I squinted as I dashed color over collage illustrations to reduce the values, paying no attention to the symbolism. When I turned the painting right side up, it was complete. It had taken one hour.

When I placed the painting in a frame and stepped back to viewing distance, I was surprised to see a suggestion of a face in the clock and a tiny skull in another. A few weeks later, I titled it, *Tribute to Jean Liberte*, a very fine artist, an excellent teacher and a dear friend. I later learned that he had died on the day I finished the painting.

Model a face

I'm assuming that you've applied the principles and procedures outlined so far. If so, you're now able to evoke an image and create a mood and a structure to support it in an integrated way. You have the basics of creativity firmly established. Yet, in paintings containing a figure, the face may give you trouble.

For example, you may carry through a painting properly, except for one thing. You may suddenly decide to give the face a realistic look. You work with

vigor and enthusiasm, but in the end you're unhappy with the painting. It looks inept. What's happened?

First, you've concentrated on a part instead of the whole painting. In addition, you've tried to do a head in detail without knowledge of anatomy.

What's the answer? It depends on your objective. You may even need to make a major decision at this point. If portraits are what you want to do more than anything else, this is the time to study portrait drawing and painting in the traditional manner. As a start I recommend *Drawing the Human Head* by Burne Hogarth. It won't be easy and will take a long period of training to develop skill. And after you've got the skill at your command, you'll need to *unlearn* the very habit of detailed seeing which helped develop your skill—in order to establish a mood in your painting. As Degas said, "At last, I've forgotten how to draw."

Is there any alternative to long academic training, if you merely wish to do a face on occasion? Yes, there are two ways to handle a face.

You may adjust the features of the face by means of line, especially if the rest of the painting has considerable variety of line, and particularly if there's a preponderance of two-dimensional flat color shapes, as in Matisse's painting (Color Plate 2). It may look easy, but the difficulty is in making it *feel* right in relation to the whole.

However, if the painting is fairly well textured, you may *model* the face to give it a dynamic, unique expression. In such case, I suggest that you balance and adjust all relationships, leaving the modeling of the face until you personalize the painting at the end. Then you *unbalance* the facial area to model the face. Here's how it's done.

Demonstration: face and half figure

You'll find a demonstration starting with Color Plate 23. First, the drawing in Fig. 41 is traced and the

◀ FIGURE 172 *A painting combining a number of textural techniques. I started by covering the entire Masonite board with acrylic modeling paste. I brushed the upper part and the sides for the rough textural effect. In the lower part, along the edges, I added some sand and leveled it with a ruler. In the center, I used the back of an old spoon to create vertical ridges. I also pressed a small reed basket into the acrylic compound and repeated the process in other areas nearby. For contrast, I took the top from a tube of paint and made a number of impressions. At that time, I had no idea of subject matter. Eventually, I decided to do a still life with flowers, directly over the textured surface. Months later, I decided to add collage material; I substituted illustrations of an old timepiece for the flowers.*

colors related. I'm now ready to personalize the painting. Using a gentle rubbing-in technique, I apply a color over practically the entire facial area. The color depends first on what's underneath. If the colors underneath are mostly warm and light, I find a color that's cool and dark. If the colors are mostly cool and dark, I work for a color that's warm and light on top. In either case, the color on top must relate to the neighboring colors.

Continuing with this demonstration (Color Plate 24), I place a deep, dark cadmium red over the violet face. Now I'm ready to model the face by using a lighter color, in this case a lighter red, but distinctly different in tone from the dark. I start rubbing it in, working for value relationships, perhaps as I did in the drawing, though not necessarily. As I keep modeling, I add touches of other color, such as yellow ochre, light yellow-green, and blue.

I'm now working for mood, so I let myself go fearlessly. I've no idea what mood will emerge. I don't try to remember the mood in the drawing. I couldn't, even if I wanted to. I don't try to model in detail. Even the eyes are indicated generally. Everything is subordinated to the mood of the whole painting.

When I obtain a mood in the face which attracts me, I use a small brush to add more variety of color. For example, if the main color rubbed in is warm, I touch it up with small areas of cool color. The important point is not to change the values in the *dominant* color; otherwise the mood may be lost.

In the third stage (Color Plate 25), I rub in white with a touch of blue. This tones down the strong facial color, yet retains a glow. I add greens and blues for value contrasts. Note that I've begun to model the scarf. (Here you may need to study how a scarf folds; get someone to pose with a scarf and draw it a few times until you're satisfied—then paint it freely.)

The final stage (Color Plate 26) merely reflects a continuation of the same process. Notice that every part of the painting has been modeled, including the background and clothing, as well as the face and hair.

If the result isn't satisfactory, I don't hesitate to repeat the procedure until I obtain an exciting mood. One more thought: in applying the rubbing-in technique, I use paint *sparingly*. Ordinarily, I want to leave the facial area fairly smooth with a minimum of textural ridges, especially since I usually go over the face a number of times before I evoke the mood which appeals to me. It can even be an ugly mood, as long as it's vital.

Expand your palette

Because there are so few cool pigments available in

comparison with the warm colors, I suggest you take full advantage of the range of pigments manufactured. From an economic viewpoint it's no more costly to use a little of many pigments purchased, than a great deal of a few pigments. The advantage, of course, in expanding your palette, is the greater variety of color possible.

I suggest you add the following cool colors to your palette: phthalo blue, phthalo green, phthalo turquoise, cerulean blue.

Since muted colors play such an important part in painting, I suggest you buy a range of casein grays, which you can blend with casein or acrylics. These may be used in addition to—or in conjunction with—the methods of graying down colors mentioned earlier. You simply mix them with the color you wish to tone down. Oils or acrylics don't normally come in grays.

For example, you may use a 25% gray with a light color of about the same value, a 50% gray with a somewhat darker color, and a 75% gray with a much darker color. You may combine different grays for values in between.

One manufacturer has developed a series of casein paints based on artist Ben Stahl's range, numbered from 1 to 5. Whichever set of grays you buy, you'll expand your range of muted tones if you use them regularly.

Other colors which you may add to your palette are: lemon yellow, cadmium red medium, cadmium red deep, cobalt violet.

I suggest that you also add the following earth colors: burnt sienna, raw sienna, terra rosa.

All of these will be helpful in obtaining more variety of color, particularly in painting your first layer of color relationships. Once you've gotten used to the expanded palette, I suggest that you restrict your palette on the *second* layer, when you adjust relationships.

For example, remove the yellows from the palette. You'll then be forced to depend upon the remaining colors to find a combination to your liking. Later on, in other paintings, try eliminating two basic colors. When you reach the personalizing stage, then use any color or colors you've omitted, if you feel the need.

Another approach, in the second and later adjustments, is to use all of the various pigments manufactured under the general heading of one color. For example, yellow. Remove all colors from your palette except cadmium yellow light, cadmium yellow medium, yellow ochre, raw sienna, and for contrast, keep cobalt blue, ultramarine blue, phthalo blue, turquoise, cerulean blue. Also keep white, 25% gray, 50% gray, and black. Limit yourself to these colors for the adjustment of light and dark, warm and cool, intensities and muted tones. Here again, in the personalizing stage, use any other colors from your expanded palette.

Many other variations will occur to you from time to time. You're now ready to experiment. Don't hesitate to follow through with new ideas. And if you run out of them, remember to return to the full, expanded palette and start again with flat, solid color to color relationships. They are like bread and butter —the staff of life in painting.

16

Use perspective creatively

As I've suggested earlier, professional artists agree that a painting or drawing which doesn't succeed in two dimensions can rarely, if ever, be a good painting in three dimensions.

Working on this premise, I haven't discussed problems of the third dimension until you've established your perception firmly in two dimensions. This you've done, if you've applied the instructions. You've been analyzing your drawings and paintings by observing various relationships to the whole; you've been watching the interplay of values, color, texture, line, etc., on the *two-dimensional* surface of your drawing paper or gesso board. By training yourself to see in wholes, you've assured yourself of success. Your paintings and drawings are integrated in feeling and structure.

The third dimension—the illusion of depth—is very important. Just because we haven't discussed it, however, doesn't mean that you haven't included it in your paintings and drawings. It's been there all the time. In most of the pictures you've produced, you've created the third dimension automatically through overlapping planes and perspective. Now you're ready to improve the quality of the third dimension in your pictures. First, we'll discuss perspective; then, overlapping planes.

How perspective works

This isn't a treatise on perspective. It's meant to clear up some of the confusions surrounding the subject and to show you how to obtain accurate perspective. Further on, I'll discuss some of the limitations of perspective and how the masters overcame these limitations.

The key to perspective is the vanishing point. Wherever you look, all lines—rooftops, roads, telephone wires—seem to converge at a given point. In a drawing or painting, you've the option of fixing the given point anywhere you wish. All lines in your picture are then made to converge to that point.

For example, consider the horizontal line in Fig. 173 as you look toward the horizon. I've marked a dot where I choose to place the vanishing point. Now, I stick a thumbtack on the dot and attach a thin cord to it (Fig. 174). By resting the cord tautly against the drawing paper, I can use the cord as a guide to accurate perspective.

I swing the cord—still attached to the tack—completely around in a circle. Using the cord as a ruler, I draw lines, all of which are in perspective to the vanishing point I've chosen (Fig. 175).

Suppose I want to draw clouds above the horizon, in relationship to the vanishing point. By sketching

FIGURE 173 *Schematic diagram illustrating a chosen vanishing point. The key to perspective is the vanishing point. Wherever you look, all lines—rooftops, roads, telephone wires—seem to converge at a given point. In a drawing or painting, you've the option of fixing the point anywhere you wish. All lines in your picture are then made to converge to that point. I've marked a dot where I chose to place the vanishing point.*

FIGURE 174 *Schematic diagram illustrating the use of a cord as a guide to accurate perspective. I stuck a thumbtack on the dot where I chose to place the vanishing point. I attached a thin cord to the tack. By resting the cord tautly against the drawing paper, I used the cord as a guide to accurate perspective.*

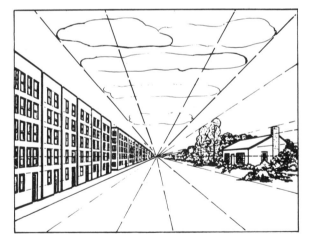

FIGURE 175 *Schematic diagram illustrating lines in perspective to a given vanishing point. I swung the cord—still attached to the tack—completely around in a circle. Using the cord as a ruler, I drew lines, all in perspective, to the vanishing point I'd chosen.*

FIGURE 176 *Schematic diagram illustrating clouds, buildings, roof lines, windows in perspective. The clouds become smaller as they near the horizon. Suppose I decide to add buildings; note how the roof lines, window lines, and ground lines all converge toward the vanishing point.*

FIGURE 177 *Schematic diagram illustrating a second vanishing point on the same horizon line. Here's a common problem: you may wish to show the side of a building which faces in a different direction from your vanishing point. In that case, you simply add a second vanishing point on the same horizon and converge the lines from the side. You may even extend the horizon line* beyond *the frame of the picture and choose a vanishing point anywhere on this imaginary line.*

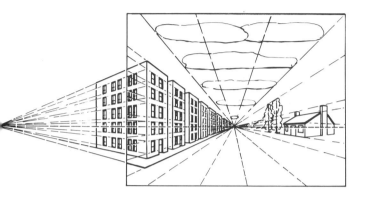

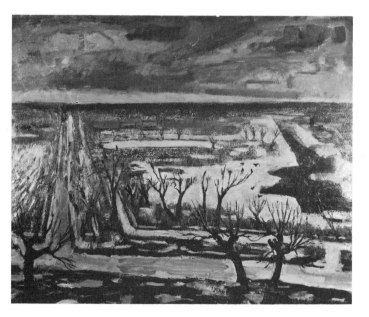

FIGURE 178 *Gerrit Hondius (American, 1891–), Dutch Winter Landscape, 24″ x 30″, oil on Masonite, collection of Mr. and Mrs. Gerrit Hondius. We know that the terrain in Holland is flat and low. But Hondius, nevertheless, painted it as if he were looking from above, not at sea level. Most artists paint as if they're fairly high up.*

them *in between* the dotted lines, I'll place them in correct perspective. Note, also, how the clouds become smaller as they near the horizon. Now, suppose I decide to add buildings; note how the roof lines, window lines, and ground lines all converge toward the vanishing point (Fig. 176).

But here's a common problem. You may wish to show the side of a building which faces in a different direction from your vanishing point. In that case, you simply add a second vanishing point on the same horizon and converge the lines from the side. You may even extend the horizon line *beyond* the frame of your picture and choose a vanishing point anywhere on this imaginary line (Fig. 177).

You may wonder about the horizon line itself. How do you know where to place it? Near the top of the drawing paper, near the bottom, or where? That would depend. If you're lying on your back on a beach at sea level and looking straight out toward the water, the horizon line would be practically on the bottom edge of the sheet; you'd see mostly sky, very little sand or water. If you're standing on the beach, the horizon line would be a little above the bottom edge; you see a bit more beach and water, a bit less sky. From the roof of a two story building on the beach, you'll see lots of sand and water as you look straight out; thus, the horizon line might be about one third up from the bottom of the sheet. If you're overlooking the building and watching the horizon from the top of a hill, the line would be even closer to the top of the sheet.

Fig. 178 is a Dutch landscape by Gerrit Hondius. We know that the terrain in Holland is flat and the horizon low. But Hondius, nevertheless, painted it as if he were looking from above and not at sea level. Most artists do this. They paint as if they're fairly high up.

Look at Cikovsky's painting again in Fig. 36, and examine the photograph of the scene (Fig. 35). In raising the horizon line, he was able to paint less sky and a greater expanse of field in which he spaced the trees at delightful intervals.

Limitations of perspective

We mustn't forget that perspective is merely an illusion. Objects only *seem* to diminish in size as they recede into the distance. Actually, we know that they don't change in size. The appearance of things diminishing is merely an optical illusion.

Since things aren't what they seem anyway, you have the artistic license to use perspective or not. If you paint in a primitive, naive manner, you shouldn't

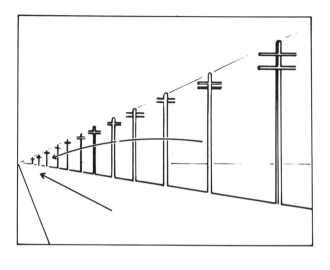

try to use perspective adjustments of any kind. Otherwise, you'll lose that unique, original quality in your work.

You may be strongly tempted to try to paint a row of buildings, let's say, in exact perspective. You might as well face it: you'll fail unless your painting meets the tests outlined in preceding chapters. Even if you're able to paint a naturalistic picture in complete detail, with the light of the moment and in correct perspective, you may only be exhibiting good craftsmanship. You may have a skillful copy of things seen in the optical illusion of perspective, but no originality, no inner expression of feeling, no rhythmic distribution of structural elements in relationship to the whole. Therefore, no movement, no life.

Then, why you may ask, is perspective so popular? Simply because perspective is important. Architects, for example, couldn't do without it. It's also vital if you want to do precise renderings of the visible world, particularly landscapes that contain architecture. But don't *overestimate* its importance!

Perspective follows mechanical optical laws discovered in the fifteenth century, when modern science was coming into its own. For a short time, perspective became a fad among artists who thought optical illusion was the whole story. (Luckily, the greatest masters of painting thought otherwise.) The impact of scientific investigation has had a continuing effect on art for centuries. With the advent of the camera, in the nineteenth century, optical imitation became more popular than ever.

In fact, to the average person, art *still* means skillful imitation. He believes that the more skillful the copy of nature, including the optical illusion of perspective, the better the painting and the greater the artist. The unsophisticated viewer finds early Egyptian, Byzantine, Oriental and primitive artists—with their distortions and their systems of rendering space by other methods than optical perspective—ignorant and unskilled.

But there's a mighty accumulation of evidence to show that they weren't ignorant. Many ancient civilizations were extremely advanced, scientifically. They just painted differently. They painted with their minds, not their eyes. And they painted just as well as we do. Instead, *we* are the ignorant ones when we jump to a hasty conclusion that perspective is the *only* way. Fortunately, the fixed idea that all pictures should be painted in a naturalistic style and in accurate optical perspective, is subsiding among educated persons, who value imagination above photographic imitation.

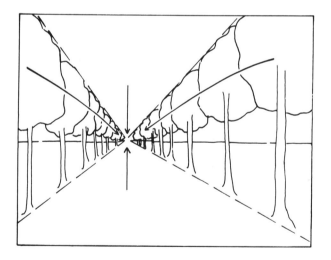

FIGURE 180 *Schematic diagram illustrating the dead spot of naturalistic perspective. Detach your mind from the scene and examine it for shape relationships. There are four triangular shapes, four arrows, really. All point to the center and get stuck there. There's no relief. Unless something is done to modify the perspective, the picture remains static. It needs a submotif in contrast to the repeated, dominant geometric triangle—needs a strong movement to force your eye away from the dead spot.*

How the masters control perspective

What do the masters do? They *modify* the natural appearance of perspective. They discard the particular light of the moment or subordinate it to values related to the whole. They also minimize the details of what they see in order to avoid merely copying the appearance of things. Instead, they're interested in expressing a *mood*. Finally, they modify the naturalistic vision of perspective because, if not controlled, it may run out of the picture (Fig. 179). Or the movement of perspective lines may end in a dead spot. Thus, painted in rigid perspective, the picture may lack variety of two-dimensional shapes, rhythmically related as a whole.

Let's look, once again, at the schematic illustration of naturalistic perspective (Fig. 180). Detach your mind from the scene and examine it analytically for shape relationships. There are four triangular shapes, four arrows, really. All point to the center and get stuck there. There's no relief. Unless something is done to modify the perspective, the picture remains static. There's need of a submotif in contrast to the repeated, dominant geometric triangle. There's need of a strong movement to force your eye away from the dead spot.

Study the painting by Gerrit Hondius, *Pier in Provincetown* (Fig. 181). Hondius forces your attention to the foreground. The pole with flying flags, plus all the people up front, carry your eye away from the dead spot where the perspective lines might lead you. Please note that the pier in perspective doesn't end as a dead spot in the distance. Hondius introduced a vertical motif up front—actually a pole with flags flying—to direct your vision forward, after your eye has wandered to the rest of the painting.

Incidentally, he's created a tension pull by placing a figure in the lower left. Test whether it's needed. Block it out and look at the rest of the painting. You'll find that you *do* need it. To add to the pull, psychologically, Hondius introduced the figure walking to the *left*, in opposition to the directional force of perspective.

Study the painting by Lamar Dodd, called *Factor's Walk* (Fig. 182). Compare it with a photograph of the actual place (Fig. 183). You have the feeling of perspective in the painting, yet the lower right part isn't in perspective at all. The artist has flattened out the angle of the building. He's accentuated this line by carrying a horizontal right across. By doing so, he's eliminated the forward perspective thrust of the roadway, as it appears in the naturalistic illusion of the photograph. Note how this horizontal relates to the horizontals of the bridges in the photo. We might

say, then, that Dodd created an original painting by modifying perspective.

Fig. 184 is a lithograph by Edvard Munch, the Norwegian master: *The Shriek*. Note how he modified perspective. He stopped it from running out of the picture by simply placing two figures at the end of the thrust. This created a dead spot. Then, by introducing a figure in the foreground, he pulled the action up front.

In Fig. 185, Cézanne modified the thrust of perspective in a different way. He created a strong, upright, rectangular motif of the trees and fence in the center of the picture. In this way, after viewing the chateau at the end of the road, your eye is directed to the foreground.

Applying perspective

The question is this: how can you apply this information to your own work? It would be a mistake to concentrate on perspective while you're in the process of creating and developing an image. A good picture

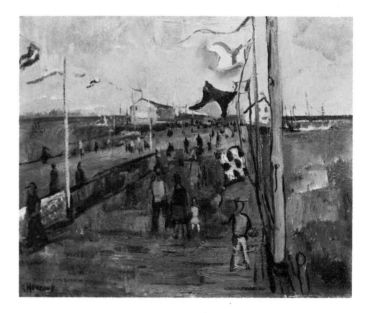

FIGURE 181 *Gerrit Hondius (American, 1891–)*, Pier in Provincetown, *16" x 20", oil on Masonite, collection of Mr. and Mrs. Bertram J. Adams, New York. Hondius forces your attention to the foreground. The pole with flying flags, plus all the people up front, carry your eye away from the dead spot where the perspective lines might lead you. Note that the pier in perspective doesn't end as a dead spot in the distance. Hondius introduced a vertical motif up front—a pole with flags flying—to direct your vision forward* after *your eye has wandered to the rest of the painting. He's also created a tension pull by placing a figure in the lower left, facing out of the picture, in opposition to the directional force of perspective.*

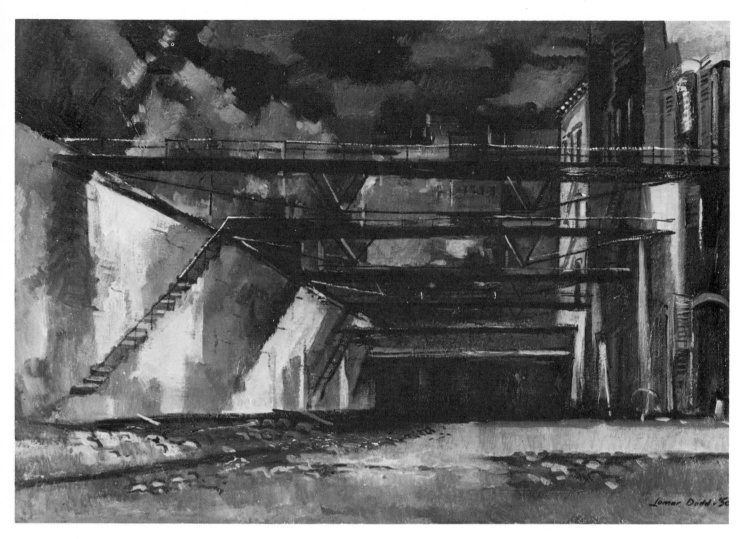

FIGURE 182 *Lamar Dodd (American, 1909–),* Factor's Walk, *courtesy, Lamar Dodd and W. W. Norton Co. Inc., New York. Compare this painting with a photograph of the actual place (Fig. 183). You have the feeling of perspective in the painting, yet the lower right part isn't in perspective at all. The artist has flattened out the angle of the building. He's accentuated this line by carrying a horizontal right across. By doing so, he's eliminated the forward perspective thrust of the roadway, as it appears in the photograph. Note how this horizontal relates to the horizontals of the bridges in the photo. We might say that Dodd created an original painting by modifying perspective.*

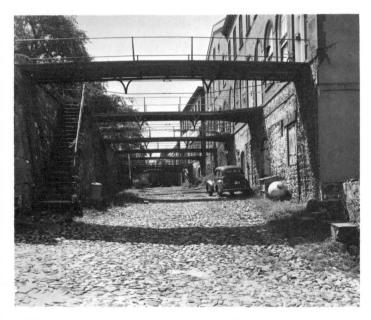

FIGURE 183 *Photograph of Factor's Walk, courtesy of Lamar Dodd and W. W. Norton Co. Inc., New York. Compare this photograph with the painting by Lamar Dodd (Fig. 182). In the painting, he's eliminated the forward thrust of the roadway, yet you have the feeling of perspective.*

FIGURE 184. *Edvard Munch (Norwegian, 1863–1944),* The Shriek, *$20^{11}/_{16}$" x $15^{13}/_{16}$", lithograph, Museum of Modern Art, New York. Note how Munch modified perspective. He stopped it from running out of the picture by simply placing two figures at the end of the thrust. This created a dead spot. By introducing a figure in the foreground, he pulled the action forward.*

▶

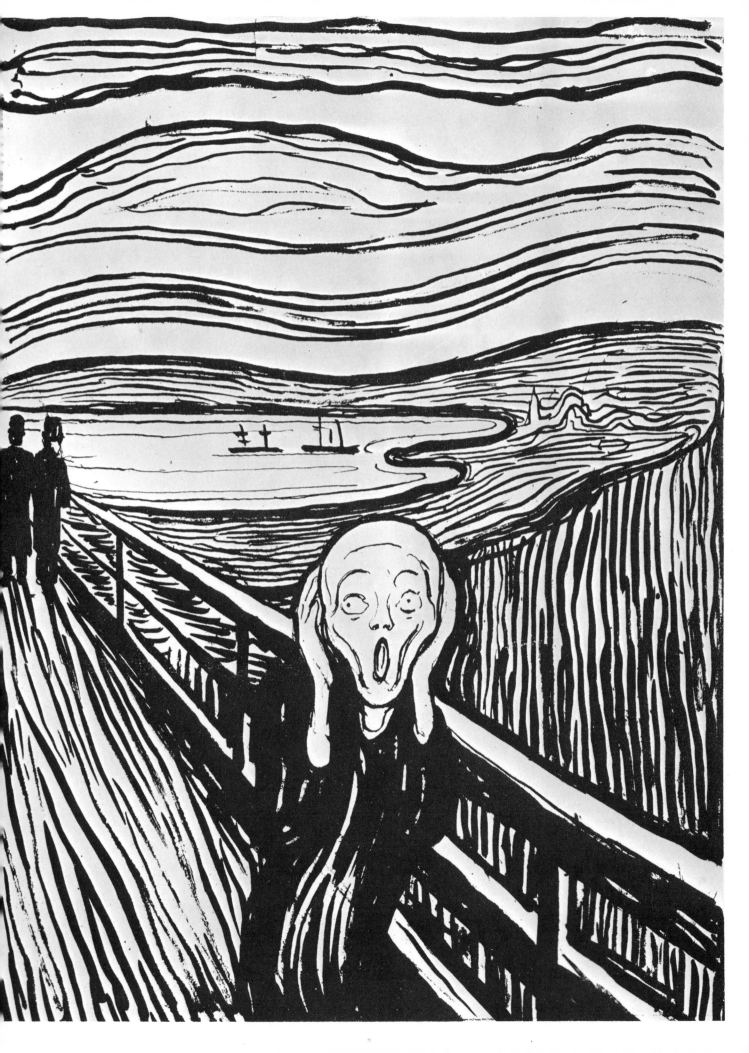

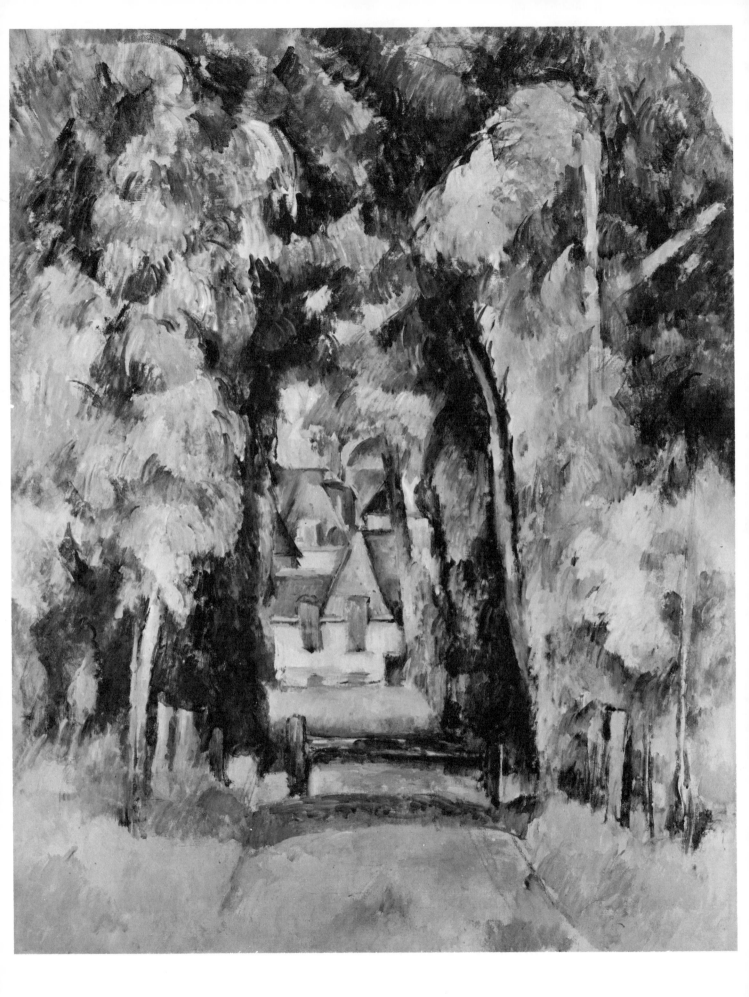

is the expression of a mood. While working to evoke an image, the feeling within you must be allowed to have full sway. Nothing should be allowed to interfere with its liberation. Later on, however, after the main geometric shape-motif and submotif have been established, and value relationships have been adjusted as a whole you may then consider any obvious perspective problem.

Even then, the adjustment lines should be made with a minimum of disturbance to the feeling of the drawing or the painting as a whole. The deviations or distortions from naturalistic appearance—which give the picture its character and uniqueness—should not be corrected by sharp lines as in the schematic illustrations of perspective. Nor need all lines be 100% accurate in perspective. But if the slope of a roof is in perspective, while the line of a window underneath is slanting in the opposite direction, then the window should be changed delicately, without disturbing the textural and value sensitivity of the whole.

Any gross ineptitude in perspective, then, *should* be corrected; but concentration on complete accuracy should be *avoided* in order not to ruin the mood of a picture. For example, suppose that the center of interest in your drawing is an old building. Use the roof line to establish the vanishing point on the horizon. Place the tack on that point. Run a cord to the lines of the windows and the road, to find if they need adjustment. If there are other buildings in the drawing, continue the cord in their direction for possible adjustments to roof, window, and other angled lines.

For your assignment, look over all your drawings. Pick out two or three in which you've introduced buildings or similar objects in perspective. Note how you might improve them. Don't make the changes on the drawings until you've tested them. Instead, merely trace the contours of shapes as you normally would on a gesso board, but this time trace on another sheet. Make the changes on the new drawing. Then refer back to the original drawings and correct them sensitively, without disturbing the mood of the whole. Wherever all perspective lines direct the eye to a dead spot, be sure to break this up by some counter movement in another direction.

FIGURE 185 *Paul Cézanne (French, 1839–1906)*, The Avenue at Chantilly, *32″ x 25½″, oil on canvas, The Toledo Museum of Art, Toledo, Ohio. In this case, Cézanne modified the thrust of perspective in a different way. He created a strong, upright, rectangular motif of the trees and fence in the center of the picture. In this way, after viewing the chateau at the end of the road, your eye is directed to the foreground.*

17
Create depth through overlapping planes

WITHOUT BEING AWARE of it, the chances are you've been creating space or depth in some of your drawings through overlapping planes.

You'll recognize a plane as a flat, two-dimensional shape, like the side of a building (Fig. 186). By placing one plane partially behind another—the way buildings are stacked one behind the other in a large city—you create the illusion of depth (Fig. 187). This has nothing to do with diminishing size. The planes can be of any size.

Overlapping of planes is one of the spatial principles in modern art. If you've been baffled by modern art, you'll be relieved to know that the *principles* of modern art aren't modern at all. The same basic principles in the fifteenth century Persian miniature in Fig. 188 will be found, for example, in a Cézanne, as you'll discover shortly.

In Fig. 188, notice how the figures at the left and right overlap, creating the illusion of depth. These shapes are, in reality, overlapping planes. Even the roof and the top of the tree are planes overlapping the frame, which, in turn, is also a plane that establishes the two-dimensional quality of the entire picture. Not only that, but the figures are so placed as to become a part of the two-dimensional rectangular shape motif. The contrasting submotif is the rhomboid, a rectangle with slanting sides. You can see the rhomboid in the shape of the gate, in the upper right, and also in various parts of the building.

Perspective then—even modified perspective—isn't required to create the illusion of depth.

This Persian painting may appear crude to those who are accustomed to perspective; nevertheless, it meets the standards of a first rate work of art. The basic artistic requirements of both two and three dimensions are fully taken care of. The mood is felt and integrated with all the structural relationships as a whole.

However, there's more going on that needs to be explained in detail. For the moment, I wish to fix in your consciousness this thought: you can create space in depth through overlapping planes, as well as through perspective.

Imagine your picture happens on a stage

In considering deep space, think of the action of your picture as something that happens on a stage, on which movement takes place in all directions (Fig. 189).

What do I mean by *movement*? Exactly what moves? Well, let's take color as an example. We know that warm colors usually come forward and that cool colors recede. So then, think of them moving forward and backward on a stage. At other times, intense,

FIGURE 186 *Schematic diagram of a plane. You'll recognize a plane as a flat, two-dimensional shape, like the side of a building.*

FIGURE 187 *Schematic diagram of overlapping planes. By placing one plane partially behind another—the way buildings are stacked one behind the other—you create the illusion of depth. This has nothing to do with diminishing size. The planes can be of any size.*

brilliant colors seem to be focal points around which muted tones appear to revolve in a rhythmic dance. The same holds true for light and dark values. Sometimes light areas appear to come forward as darker areas recede. At other times, dark areas seem to come forward as lighter areas move backward. Finally, movement may be identified visually through *planes* and their *position* in space.

Movement may take place in all directions: up and down, in and out, side to side. Solid walls of color may even become transparent to permit movement through them. With these movements, a certain amount of exertion may be felt; there may be stresses and strains, tensions pulling between areas, gravitational pressures of weight, thrusts, squeezing pressures.

Movements of planes

To help you visualize specific movements of planes, let's start first with the surface upon which you draw or paint. Besides being a two-dimensional shape, it's also a plane. When your picture is hanging on the wall, the paper or gesso panel is a plane parallel to the wall, which is also a plane. From the front, the picture on the wall would look something like Fig. 190. We recognize that the picture is parallel to the wall because the four sides of the picture are parallel to the four sides of the wall in the illustration. If the same picture is leaning against the wall, on top of a cabinet, we identify its position in space by the angle of the plane. From the front, the picture would look something like Fig. 191. The top and bottom of the picture are parallel to the top and bottom of the wall. But the sides of the picture aren't parallel to the sides of the wall. They're angled.

The next two schematic drawings (Figs. 192 and 193) will help to clarify these relationships. In both drawings, we're looking at the picture, wall, and cabinet from the *side*. The longer vertical is the wall, which is perpendicular to the horizontal of the floor. The rectangle is the cabinet resting on the horizontal floor. In Fig. 192 the picture is represented by the little vertical in front of the wall. Wall and picture are parallel. In Fig. 193, the picture is on the cabinet, leaning against the wall. Again, you can identify the picture's position in space by the angle next to the vertical wall.

The actual movement of any angle is a *thrust* into space. This will be illustrated in a moment.

Picture surface

The first and nearest plane you see when you look at your picture is on the surface of the picture itself

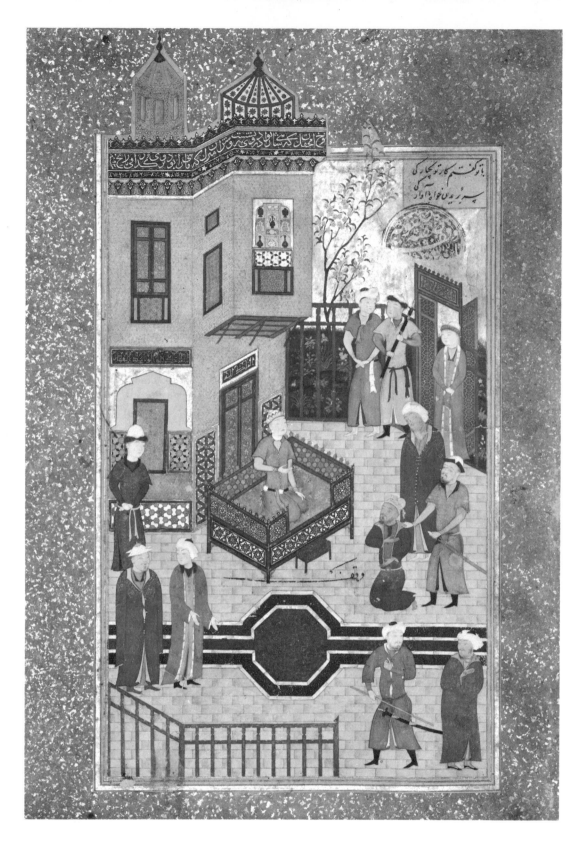

FIGURE 188 *Persian 15th Century Miniature, probably by Mirak,* The Beggar who Professed his Love for a Prince, Brought Before Him, *8⅜″ x 4½″, The Metropolitan Museum of Art, New York. Notice how the figures on the left and right overlap, creating the illusion of depth. These shapes are, in reality, overlapping planes. Even the roof and the top of the tree are planes overlapping the frame, which, in turn, is also a plane that establishes the two-dimensional* quality of the entire picture. The figures are placed to become part of the two-dimensional rectangular shape motif. The contrasting submotif is a rhomboid, a rectangle with slanting sides. You can see it in the gate, in the upper right hand, and in various parts of the building. Perspective then—even modified perspective—isn't required to create the illusion of depth.

FIGURE 189 *Schematic diagram of the "stage". In considering deep space, think of the action of your picture as something that happens on a stage, on which movement takes place in all directions.*

FIGURE 190 *Schematic diagram identifying the position of a plane in space, parallel to another plane. To help you visualize specific movements of planes, let's start with the surface upon which you draw. Besides being a two-dimensional shape, it's also a plane. When your picture is hanging on the wall, the paper is a plane parallel to the wall, which is also a plane. From the front, the picture on the wall would look something like this. We recognize that the picture is parallel to the wall because the four sides of the picture are parallel to the four sides of the wall. Compare this diagram with Fig. 191.*

FIGURE 191 *Schematic diagram identifying the position of a plane in space,* not *parallel to another plane. If the picture, as in Fig. 190, is* leaning *against the wall, on top of a cabinet, we identify the picture's position in space by the angle of the plane. From the front, the picture would look something like this. The top and bottom of the picture are parallel to the top and bottom of the wall. But the sides of the picture are angled—not parallel to the sides of the wall.*

FIGURES 192 AND 193 *Schematic diagrams identifying the positions of a plane in space—side view. In both diagrams, we're looking at the picture, wall, and cabinet from the side. The longer vertical is the wall, perpendicular to the horizontal floor. The rectangle is the cabinet resting on the horizontal floor. In the left hand diagram, the picture is represented by the little vertical in front of the wall; wall and picture are parallel. In the right hand diagram, the picture is on the cabinet, leaning against the wall; you can identify the picture's position in space by the angle next to the vertical wall.*

FIGURE 194 *Schematic diagram illustrating a surface plane.
The first and nearest plane you see when you look at your
picture is the surface of the picture itself. It's called a surface
plane or a picture plane. However, when you think of your
picture as a* stage, *the picture plane is often referred to as a
frontal plane, because it's in front of all other planes on the
stage. All planes on the stage establish their position and
distance in space by their relationship to the frontal plane.*

FIGURE 195 *Schematic diagram illustrating two-dimensional
shapes of a painting as jigsaw pieces of the frontal plane.
The two-dimensional shapes of tone and color (which make
up the subject of your drawing or painting) are also planes.
We've been analyzing them, up to now, as if they existed
only on the frontal plane—that is, as if the frontal plane were
composed of shaped pieces of a jigsaw puzzle. When the
frontal plane is separated into individual shapes, these planes
are easily identified as being on the surface.*

FIGURE 196 *Schematic diagram illustrating the same two-
dimensional shapes as seen on a stage in three dimensions.
When the same shapes, illustrated in Fig. 195, are united
and seen on a stage in three dimensions, they look like this.
The movement into space is achieved by overlapping planes.
In this case, the overlapping planes are perpendicular and
parallel to the frontal plane.*

FIGURE 197 *Schematic diagram illustrating overlapping
planes as seen from the wings of the stage.*

FIGURE 198 *Schematic diagram showing the addition of two more overlapping planes to Fig. 196. Using the example in Fig. 196, let's add some more movement through overlapping planes. We start with plane 1 at the front; now planes 2 and 3 take you to the back of the stage at plane 4. Now, to return the movement to the front again, I add planes 5 and 6. They bring us to the frontal plane where we started.*

FIGURE 199 *Schematic diagram illustrating movements on a more realistic stage. The movements into space and back may start from a number of points: from the lower left hand figure in an arc through the four figures; from the planes on the extreme left to the extreme right via the backdrop. Not shown are movements from the lower right hand figure through the figure above, continued in space to the backdrop and returning through the planes on the left. There are other movements in space through overlapping planes. Can you find them?*

(Fig. 194). It's called a surface plane or a picture plane. However, when you think of your picture as a stage, it's often referred to as a frontal plane, because it's in front of all other planes on the stage. More important, all planes on the stage establish their position and distance in space by their relationship to the frontal plane.

The two-dimensional shapes of tone and color—which make up the subject of your drawing or painting—are also planes. We've been analyzing them, up to now, as if they existed only on the frontal plane—that is, as if the frontal plane were composed of shaped pieces of a jigsaw puzzle (Fig. 195). When the frontal plane is separated into individual shapes, these planes are easily identified as being on the surface. They look like this to us. But when united, and seen as on a stage in three dimensions, they look like Fig. 196. The movement into space is achieved by overlapping planes. In this case, the overlapping planes are perpendicular and parallel. That is, they're all in the same relative position as the frontal plane, which is, of course, also perpendicular and parallel to the others. From the wings of the stage, they might look like Fig. 197.

Three-dimensional movement on a stage

The imaginary stage can be of any size you like. However, in order to obtain a good sense of movement into depth, you need to think of yourself up in the balcony, looking at the stage from the side. This position does two things for you. It raises the horizon line to give you more space to adjust your planes. It also angles your planes to give the movements more vitality.

Using the same example you saw a moment ago, let's add some more movement through overlapping planes (Fig. 198). We start with plane 1 at the front; now planes 2 and 3 take you to the back of the stage at plane 4. Now, to return the movement to the front again, I add planes 5 and 6. They bring us to the frontal plane where we started. Planes 5 and 6 are also parallel and perpendicular to the frontal plane. Actually, planes 1 and 6 are *on* the frontal plane.

In the following example (Fig. 199), the stage appears a little more realistic, with schematic figures of performers. The movement into space and back may start from a number of points: from the lower left hand figure (or the lower right hand figure) in an arc through the four figures (in either direction); from the planes on the extreme left to the extreme right via the backdrop (and vice versa); from the lower right hand figure through the figure above, continued in space to the backdrop and returning through the planes on the

FIGURE 200 *Schematic diagram illustrating the thrust of the angled plane. You get more of a* thrust *into space with a plane that's angled in relation to the frontal plane. The left side of the empty stage shows this thrust as it moves to meet the back plane of the stage.*

left. There are other movements in space through overlapping planes. Can you find them?

Thrust of angled plane

So far, I've been discussing planes parallel to the frontal plane. But you get more of a *thrust* into space with a plane that's *angled* in relation to the frontal plane. The left side of the empty stage shows this thrust as it moves to meet the back plane of the stage (Fig. 200). The perspective plane, angled as it is, has an overpowering directional thrust. That's one of the reasons its movement needs to be controlled. But angled planes don't have to be in accurate perspective to move into space. In the painting by Stuart Davis, *Place Pasdeloup* (Fig. 201), you'll find many deviations from perspective, yet the planes move in comparatively shallow space, as if on a stage.

Here's an interesting coincidence. Although the perspective plane is angled, the thrust of the angled plane into space has nothing particularly to do with accurate perspective. I use the empty stage to demonstrate this.

In the first example (Fig. 202), angled planes 1 and 2 are in perspective because the dotted lines, added above the stage, were arranged to bring the stage into perspective. However, on the same empty stage, the same planes (1 and 2) are not in perspective when the dotted lines aren't in perspective (Fig. 203).

Spatial movement relates to frontal plane

The position and movement of a plane in space is identified by its relationship to the frontal plane.

For example, plane 1, the left side of the stage, moves into space. We recognize the direction of this

movement by the position of the angled line. This line is angled in relation to the lower horizontal of the frontal plane. We also recognize that plane 1 is perpendicular, because its sides are vertical in relation to the verticals of the frontal plane. Also, one vertical is common to both.

Plane 2, the floor of the stage, moves into space because it's angled on its left side, again in relation to the frontal horizontal. Plane 3, the rear of the stage, is parallel to the frontal plane. It takes its position in space by the relation of its lower horizontal to the lower horizontal of the frontal plane.

In Fig. 204, planes 4 and 5 have been added to reinforce these movements visually. Plane 5 is in the same relative position as plane 1. Plane 4 is another floor plane in relation to plane 2. Both of these planes move into space, but plane 5 has more of a thrust than plane 4.

The next example (Fig. 205) is very important because there's more action in it. Planes 1, 2, 3, and 4 are in the same position as in the previous illustration. But plane 5 not only shows a thrust into space, but also *tilts* to the left toward plane 1. Planes 6 and 7 have been added. Plane 6 tilts backward toward plane 3. Plane 7 tilts to the right, but, in addition, it's angled into space.

How the masters adjusted planes

Now, we're ready to see how the masters adjusted planes and what effects they created in three-dimensional space.

Let's start with this painting, *Christ at the Sea of Galilee* (Fig. 206) by the sixteenth century Italian painter, Tintoretto.

There's dynamic movement in this masterpiece. Many planes overlap, particularly in the strong sea. To help you grasp the main movement, I've simplified the planes in the schematic diagram (Fig. 207). Plane 1 is an angled vertical, resting on plane 2. Plane 2 is equivalent to the floor plane of the stage; it surges toward the tree, plane 3. In turn, plane 3 moves upward to meet the clouds (equivalent to planes at the back of the stage). The clouds—planes 4, 5, and 6—overlap as they rush from the right of the back stage to the left, and finally overlap the far hills, plane 7. Plane 8 brings the movement forward again to plane 1.

FIGURE 201 *Stuart Davis (American, 1894–1964),* Place Pasdeloup, *36¼″ x 28¾″, oil on canvas, The Whitney Museum of American Art, New York. Angled planes don't have to be in perspective to move into space. You'll find many deviations from perspective in this painting. Yet the planes move in comparatively shallow space, as if on a stage.* ▶

FIGURE 202 *Schematic diagram illustrating angled planes on stage in perspective. Angled planes 1 and 2 are in perspective because the dotted lines above the stage were arranged to bring the stage into perspective. The thrusts of the angled planes, however, have nothing particularly to do with accurate perspective. Compare this diagram with Fig. 203.*

FIGURE 203 *Schematic diagram illustrating the same angled planes on stage* not *in perspective. This time, the same angled planes 1 and 2 are* not *in perspective, as you can see by the dotted lines above the stage. This proves that the thrust of an angled plane functions whether the plane is in perspective or not.*

FIGURE 204 *Schematic diagram showing planes 4 and 5 added to reinforce movements. The previous diagram (Fig. 203) shows the empty stage with planes 1, 2, and 3. In this diagram, plane 5 is in the same relative position as plane 1. Plane 4 is another floor plane in relation to plane 2. Both of these planes move into space, but plane 5 has more of a thrust than plane 4.*

FIGURE 205 *Schematic diagram showing planes 5, 6, and 7 tilted. This example is very important because there's more action. Planes 1, 2, 3, and 4 are in the same position as in the previous diagram; plane 5 not only shows a thrust into space, but also* tilts *to the left toward plane 1. Planes 6 and 7 have been added. Plane 6 tilts backward toward plane 3. Plane 7 tilts to the right, but in addition, it's angled into space.*

Here's another example by the famous El Greco: *The Purification of the Temple* (Fig. 208). It illustrates the tension, excitement, and movement of angled planes in space. Some of the figures are not only angled, but are also tilted from vertical to diagonal. To appreciate their vitality compare them with the schematic diagram of angled and tilted planes (Fig. 205). In the painting, you feel the vigor of the figures as they twist and turn. In addition, they overlap as planes from the left foreground, for example, to one of the buildings in the rear, and then come forward again to the right foreground of the frontal plane. This, again, is action on a narrow stage. Incidentally, let's not overlook the exciting light and dark relationship, the variety of two-dimensional shape relationships, and the vitality due to distortion and elongation of the figures.

Cezanne's approach

Let's continue with another example from the work of the modern master Cézanne. He'd studied the spatial relations of Tintoretto very carefully. He was even more affected by the work of Poussin, the late seventeenth century French painter who had studied in Italy and who knew the work of Tintoretto and others intimately. This example of Cézanne's work in Fig. 209—a watercolor—is excellent for our purpose, because it demonstrates his creative procedure. It's called *The Bridge at Gardanne.*

Here, Cézanne distorted nature and paid no attention to perspective. He composed his painting in the narrow space of a stage as if he were looking at the church and bridge from above, with a pair of field glasses. The trees on the left were treated as planes. He created leafy masses, not individual leaves, as planes. Between the background and the foreground, each plane is related to the others and to the whole. He calculated the intervals *between* the planes with extreme sensitivity.

Compare the painting with the photograph of the scene (Fig. 210). Note how Cézanne not only raised the church, but made it larger. He did the same with the bridge. In this way he brought them closer to the foreground. The schematic diagram (Fig. 211) shows how the planes march from the lower left up to the church, then come forward to the foreground, to the right.

Please note, too, how the two-dimensional, geometric shape motif of the rectangle stands out so strongly. It's rhythmically related to the smaller rectangles in and around the church. The submotif of the geometric arch, under the bridge, is repeated

delicately in the arcs of the foliage, and in the curve of the ground at the lower right.

Cézanne was a master in compressing space. He made the planes larger in the distance, not smaller as in perspective. In his landscapes, mountains were not permitted to fade out in the distant atmosphere but were stated clearly. This had the effect, too, of bringing them nearer the foreground. On the other hand, he pushed the foreground outward, heightening the tension between the planes in space.

Cézanne used the principle of overlapping planes in a new approach to color. The form of each object was built up by a myriad of tiny planes of different colors. Study Cézanne's *Still Life with Apples* (Color Plate 27). It was *not* painted in the academic manner. By that I mean, a red apple wasn't blended with different tones of white to achieve brightness and roundness; neither was the shadow side of a red apple painted in red of a darker shade. Instead, Cézanne used tiny planes of warm colors in the light areas. (You can see this very clearly in the enlargement Color Plate 28.) He charged each little brush stroke with another related hue as he worked his way from warm to cool colors in the dark shadow.

This was not a formula. Cézanne saw nature in a unique way. Color, line, shapes, and space were completely integrated as one, to create three-dimensional volume. He saw forms in nature as geometric volumes. Napkins and tablecloth, bunched in his still lifes, were no different to him than mountains; they all had the volume of pyramids. Similarly, tree trunks or bottles were cylinders. Houses were cubes. Apples and oranges were spheres. He felt the space in and around them.

All of this may not touch you immediately. One reason, perhaps, is because, at first glance, you may not find his paintings especially attractive. They don't exude the charm of Renoir's *Madame Charpentier and Her Children* (Fig. 14). Nevertheless, Cézanne is acknowledged by professionals as the most important and most profound artist of modern times. His paintings need to be studied patiently to appreciate their great simplicity, to realize how he discarded everything that was non-essential. He didn't hesitate to overthrow the shapes of naturalistic objects and resort to distortion. By comparing his paintings with photographs of the places where they were painted, you'll begin to understand how he created monumental paintings out of simple, commonplace landscapes.

Your first rapport with Cézanne may come when you begin to feel the tension in the intervals between planes. In Chapter 3, I called your attention to the way we respond inwardly when we space furniture in the home. The intervals of objects in space affect

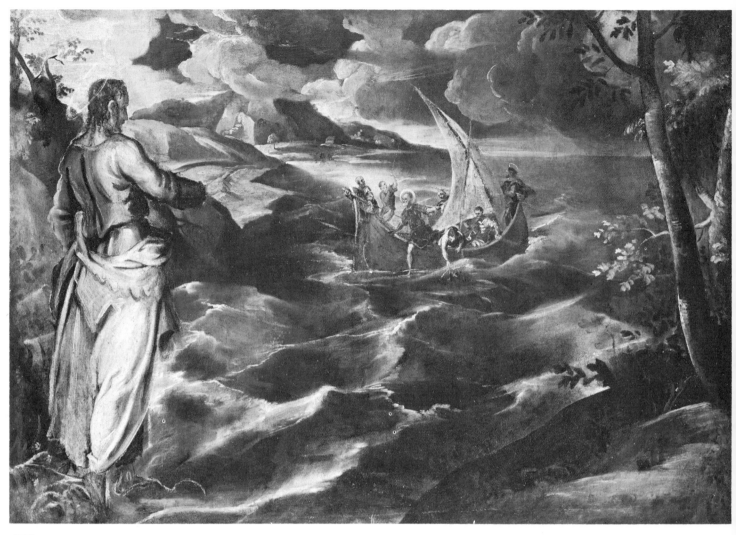

206

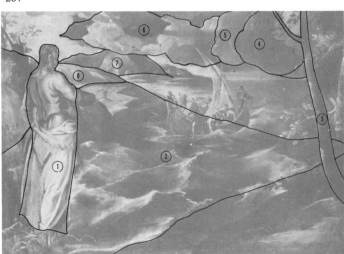

207

▲ FIGURE 206 *Jacopo Tintoretto (Venetian, 1518–1594),* Christ at the Sea of Galilee, *46" x 66¼", oil on canvas, National Gallery of Art, Washington, D. C. There's dynamic movement in this masterpiece; many planes overlap, particularly in the strong sea. To help you grasp the main movement, I've simplified the planes in the schematic diagram (Fig. 207). Plane 1 is an angled vertical, resting on plane 2. Plane 2 is equivalent to the floor plane of the stage; it surges toward the tree plane (plane 3). In turn, plane 3 moves up to meet the clouds (equivalent to planes at the back of the stage). The clouds (planes 4, 5, and 6) overlap as they rush from right to left, and finally overlap the far hills, plane 7. Plane 8 brings the movement forward again to plane 1.*

FIGURE 207 *Schematic diagram of Tintoretto's* Christ at the Sea of Galilee, *illustrating three-dimensional movement on a stage, through overlapping planes. Notice how plane 3 moves up from the foreground to meet the clouds. The clouds—planes 4, 5, and 6—are equivalent to planes at the back of the stage. Thus, at the right, planes overlap from foreground to background. Planes 7 and 8 return the movement from the background to foreground plane 1, at the left.*

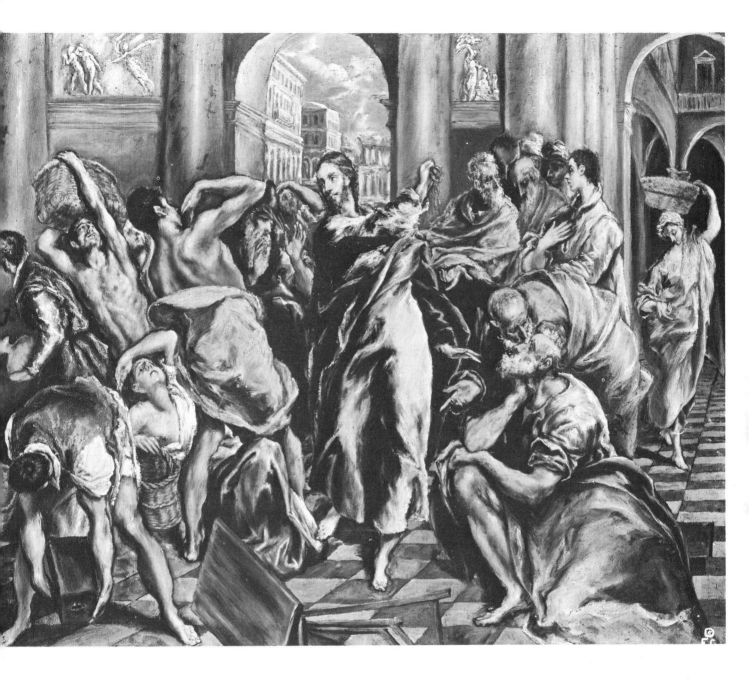

FIGURE 208 *El Greco* (*Spanish, 1541–1614*), Purification of the Temple, *16½″ x 20⅝″, oil on canvas, The Frick Collection, New York. This painting illustrates the tension, excitement, and movement of angled planes in space. Some of the figures are not only angled, but are also tilted from vertical to diagonal. To appreciate their vitality, compare them with the diagram of angled and tilted planes (Fig. 205). In the painting, you feel the vigor of the figures as they twist and turn. In addition, they overlap as planes from the left foreground, for example, to one of the buildings in the rear, then come forward again to the right foreground of the frontal plane. This, again, is action on a narrow stage. Incidentally, let's not overlook the exciting value relationships, the variety of two dimensional shape relationships, and the vitality due to distortion and elongation of the figures.*

FIGURE 210 *Photograph of the bridge at Gardanne, courtesy of Erle Loran and W. W. Norton Company Inc., New York. Compare this photograph with Cézanne's painting (Fig. 209).*

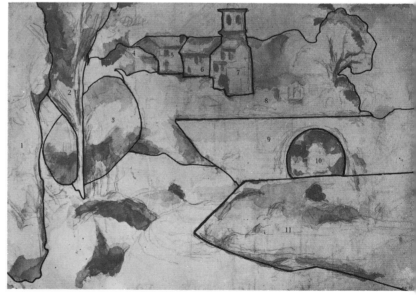

FIGURE 211 *Schematic diagram showing the movement in overlapping planes in Cézanne's* The Bridge at Gardanne. *The planes march from the lower left up to the church, then come forward to the foreground, to the right.*

◀FIGURE 209 *Paul Cézanne (French, 1839–1906),* The Bridge at Gardanne, *8⅛" x 12¼", watercolor, The Museum of Modern Art, New York. Cézanne distorted nature and paid no attention to perspective. He composed his painting in the narrow space of a stage as if he were looking at the church and bridge from above, with a pair of field glasses. The trees on the left were treated as planes. Each plane is related to the others and to the whole. He calculated the intervals between the planes with extreme sensitivity. Compare the painting with the photo of the scene (Fig. 210). Cézanne not only raised the church, but made it larger. He did the same with the bridge. In this way, he brought them closer to the foreground. The schematic diagram (Fig. 211) shows how the planes march from the lower left up to the church, then come forward to the foreground, to the right. A master in compressing space, Cézanne made the planes larger in the distance, not smaller as in perspective. Mountains were not permitted to fade in the distant atmosphere, but were stated clearly. This had the effect of bringing them nearer the foreground. On the other hand, he pushed the foreground outward, heightening the tension between the planes. Thus, he created monumental paintings out of simple, commonplace landscapes.*

FIGURE 212 *Schematic diagram showing the movements and directions of some tension pressures in Cézanne's* Still Life with Apples (*Color Plate 27*). *The front edge of the table, overlapped by the tablecloth, creates another form of movement and tension. It doesn't look distorted, but it is. Test it by placing a ruler along the left edge. You'll find it's not straight. It only looks so to the eye. Actually, in the painting there are two lines across the right, each one on a slightly different level. Breaking up the continuity of line is called the* shifting *of line.*

us physically and emotionally, according to our inner sense of order. Allen Leepa, author of *The Challenge of Modern Art,* describes this emotion-tension in another way. "When we press our hands together, we experience a muscular tension. Can you visualize an emotional intensity of a somewhat similar nature which you feel deeply within yourself, viscerally, muscularly through your body, one which has many of the characteristics of other emotional intensities, yet is not exactly like any other, but is visually stimulated?"

Cézanne distorted to create tension in his paintings by his placement of planes in space. Distortion implies pressure and force. We're affected *internally* by the visual appearance of any change in the shape of an object from its normal shape. We're even more affected by an object's *displacement in space* as it's distorted; this creates within us an opposing feeling of pressure, as if we're wrestling to force the distortion back into equilibrium, as if we're trying to press it back into the so-called normal position and shape we're used to. Once our eye travels all over a painting containing these distortions and displacements of space, and we permit ourselves to get used to them, we finally learn to accept and appreciate them. We accept them because we sense a *balance* of tension pulls and pressures, an equalization of opposing forces in the painting as a whole.

You can experience this feeling in Cézanne's *Still Life with Apples.* Look at the jug. It's tilted toward the dish of fruit. We feel this pressure. As a result, we experience a desire to press it back, to straighten it out.

Now look at the ellipse of the fruit dish. It's distorted, out of perspective. Based on the angle of the table and the position of the dish, you couldn't possibly see such a narrow ellipse. Also, the front is flattened, giving the effect of squeezed pressure, narrowing the dish. By distorting these planes, Cézanne pressed the dish not only inward but upward. Here again, we want to press the dish downward to its normal position. The squeezing pressure and displacement of space, caused by the distortion of jug and dish, create a muscular tension within us. We sense the forces—the pulls and pushes—in our urge to oppose distortion. There are other distortions. See if you can find them. For example, the handle of the jug is distorted.

All of this is in addition to the overlapping fruit and tablecloth planes which move in different directions, backward and forward, over the narrow stage on which the action takes place.

Shifting of line

One more subtle distortion is important. It creates

another form of movement and tension. I refer to the front edge of the table, which is overlapped by the tablecloth. It doesn't look distorted, but it is. Test it by placing a ruler along the left edge. You'll find it's not straight. It only looks so to the eye. Actually, there are two lines across the right, each one on a slightly different level. The schematic drawing (Fig. 212) shows the two lines.

Breaking up the continuity of line is called the *shifting* of line. It creates other surface movements, spatial displacements, and tension pressures. The arrows in the schematic diagram show the movements and directions of some of the tension pressures.

There's something interesting about the fact that the table edge, bisected by the tablecloth, looks like one continuous line, but isn't. The painting was created between 1895 and 1898. Cézanne was born in 1839. Had Cézanne ever heard of the German physicist, J. C. Poggendorff, who lived during his time? Dr. Poggendorff was interested in optics, among other scientific subjects, and developed what is known as the Poggendorff Illusion.

It's illustrated here (Fig. 213), as improved by S. Tolansky, Professor of Physics, London University, who wrote: "How devastatingly false can be our visual estimates of such quantities as length, area, angle, curvature etc. . . . This has an obvious bearing on the activities of both the scientist and the artist."

Despite appearances to the contrary, line A is not continuous with line B. Nor is line C continuous with line D. Line D is a prolongation of line A.

The illusion of a shifting line takes place when the line is intersected by an oblique plane. In this case, the tablecloth is the oblique plane. In other still lifes, Cézanne introduced other objects as the oblique plane to bisect the line of the table in front or in the rear. Invariably, he shifted the line to compensate for our vision.

As art teacher and writer, Aaron Berkman says: "Cézanne was the first painter to look into hitherto unexplored realms of optics and discover areas of perception beyond the boundaries of the perspective theory."

Two more principles

So far, we've discussed movement in space and depth through overlapping planes, tilted planes, compressed and displaced distortions, and shifting lines. There are many other movements in space, but two more will give you a good basic knowledge upon which to build.

The first of these is really psychological and optical. It's based on the principle that a small shape or plane,

FIGURE 213 *The Poggendorff Illusion, as improved by S. Tolansky, Professor of Physics, London University. There's something interesting about the fact that in Cézanne's* Still Life with Apples (Color Plate 27), *the table edge, bisected by the tablecloth, looks like one continuous line, but isn't. In the Poggendorff Illusion, despite appearances to the contrary, line A is not continuous with line B. Nor is line C continuous with line D. Only line D is a prolongation of line A. The illusion of a shifting line takes place when the line is intersected by an oblique plane. In Cézanne's painting, the tablecloth is the oblique plane. Apparently he shifted the table edge to compensate for our vision.*

FIGURE 214 *El Greco (Spanish, 1541–1614),* The Adoration of the Shepherds, *43½" x 25⅝", oil on canvas, The Metropolitan Museum of Art, New York. The lower left hand figure tilts and twists. The small plane of the head, on top of a large, elongated plane of the body, creates a stretching tension; a small shape or plane, placed near a large shape, helps to make the large shape appear still larger.*

FIGURE 215 *Schematic diagram illustrating the stretching tension in El Greco's* The Adoration of the Shepherds. *Note the arrows. They seem to stretch the body, one downward in space, and the other upward. A small shape or plane, placed near a large shape, gives a painting a monumental effect.*

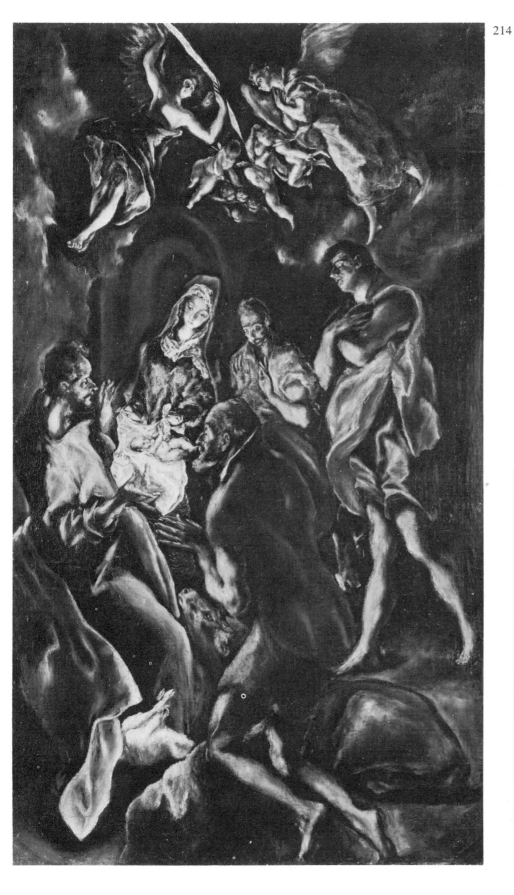

214

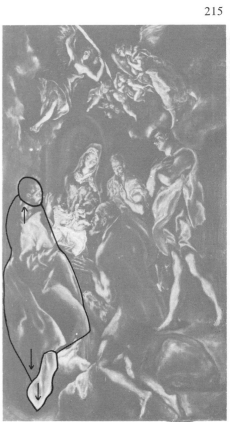

215

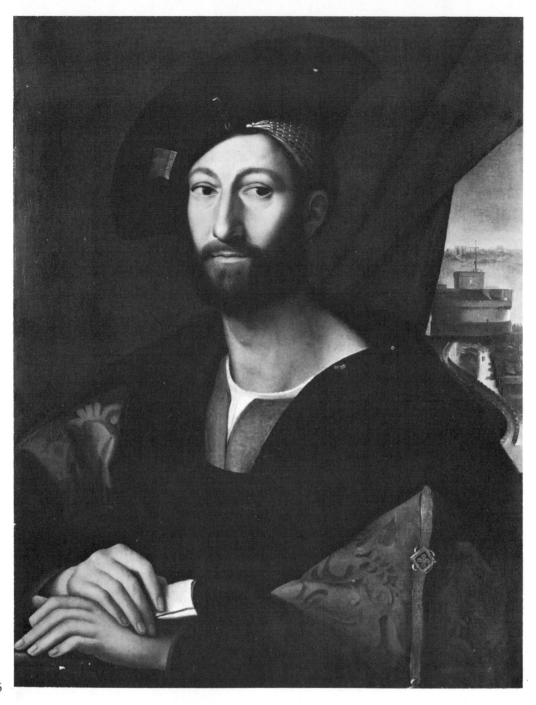

216

217

FIGURE 216 *Raphael Sanzio* (*Umbrian, 1483–1520*),
Giuliano de' Medici, Duke of Nemours, *32¾" x 26",
tempera and oil on canvas. The Metropolitan Museum of
Art, New York. This painting illustrates the principle of
interlocking relationships. Note how the rampart interlocks
with the cape, giving the effect of one continuous plane. Yet
we know that the plane of the cape is in front of the rampart
plane; therefore we see it that way. One moment we see the
rampart plane back in space, where it belongs. The next
moment it seems to move forward as one continuous plane,
joining the cape. This gives it a forward-backward movement
in depth, as on a stage.*

FIGURE 217 *Schematic diagram illustrating the principle of
interlocking relationships (see Fig. 216).*

placed near a large shape helps to make the large shape appear still larger.

In El Greco's *The Adoration of the Shepherds* (Fig. 214), the lower left hand figure tilts and twists. In addition, the small plane of the head, on top of a large, elongated plane of the body creates a stretching tension. Note the arrows in the schematic diagram (Fig. 215). They seem to stretch the body, one downward in space, and the other upward. When applied, the principle of the small against the large gives a painting a monumental effect.

The second is the principle of interlocking relationship. This principle will be seen in many works of art. Please refer to Tintoretto's *Christ at the Sea of Galilee* (Fig. 206). Note how the line of the hill, which forms the upper part of the large triangle, continues right down into the sea. It interlocks hill and sea as one. Examine another example from the work of the sixteenth century Italian painter, Raphael: *Giuliano de Medici, Duke of Nemours* (Figs. 216-217). Note how the rampart interlocks with the cape, giving the effect of one continuous plane. Yet we know that the plane of the cape is in front of the rampart plane; therefore we see it that way. But not always. One moment we see the rampart plane back in space, where it belongs. The next moment it seems to move forward as one continuous plane, joining the cape. This gives it a forward-backward movement in depth, as on a stage.

In Titian's *Madonna and Child* (Fig. 218), the interlocking is more pronounced. The schematic diagram (Fig. 219), shows how the left tree is interlocked with the Madonna's robe at the lower right. At one moment, tree and robe are seen together as one plane. At another moment, the Madonna's robe overlaps the tree in three-dimensional depth.

In the final example, Cézanne's *Boy in Red Waistcoat* (Fig. 220), we can see how the modern artist utilized the principle of interlocking. The schematic diagram (Fig. 221), illustrates the interlocking of background drape and the boy's trousers on one plane.

We can sum it up as follows: the principle of interlocking is an important means of unifying your painting into an organic whole. It provides continuous movement in space. It creates in-and-out spatial tension by uniting near and far planes; the next moment, they're separated in space.

How to apply this chapter

This won't be easy. For we're now considering the basic complexities of a work of art, in three, as well as two dimensions. But, if you'll take the time and have the patience to analyze paintings, you'll be rewarded with tremendous satisfaction.

First look at any painting, including your own, in the usual two-dimensional relationships to the whole. Be especially careful about the spacing of two-dimensional shapes. They're the steel girders of your structure. If you're in doubt about any shape being out of relationship with any other shape or with the whole, block out the questionable shape with your thumb or your index finger. Then see how the rest of the shapes look as a whole. When you take your finger away, you'll know whether your doubt has any substance to it or not. I must warn you to *disregard subject matter* at this point. Turn your drawing or painting upside down and look for two-dimensional shape relationships.

Watch particularly for the *negative* shapes next to the four edges. Do they offer just the right amount of space from the edge? This, too, can be checked. Suppose your background has been broken up into a series of vertical areas. Place a ruler, or better yet, the edge of one of your blank sheets of drawing paper, on the right edge of your drawing or painting. Now move it very slowly toward the first vertical line. Watch as the area diminishes in width. Stop when the width feels right. That's generally how far your line should be from the edge. If you're not sure, repeat the procedure. This time, however, place the edge of the sheet on the *line* and move slowly toward the edge. By stopping when it feels right, you'll know how much to broaden or narrow that area. Do the same with the left edge.

Checking three-dimensional relationships

Only after you've checked all relationships in *two* dimensions are you ready to analyze in *three* dimensions. Look to see how the planes overlap and move in space. If a plane appears to stop in the distance and you want it further forward, try to add another plane to bring it forward again.

Check for distortions. Feel the tension pulls and the pressures. Make sure there are always opposing tensions and pressures.

When you've made changes, as far as you can, in three dimensions, check once again to see their effect on two dimensions; in the final analysis, both dimensions must be integrated. In the case of Cézanne, it's practically impossible, in his later work, to improve a line, space, shape or color. They're so well adjusted and integrated.

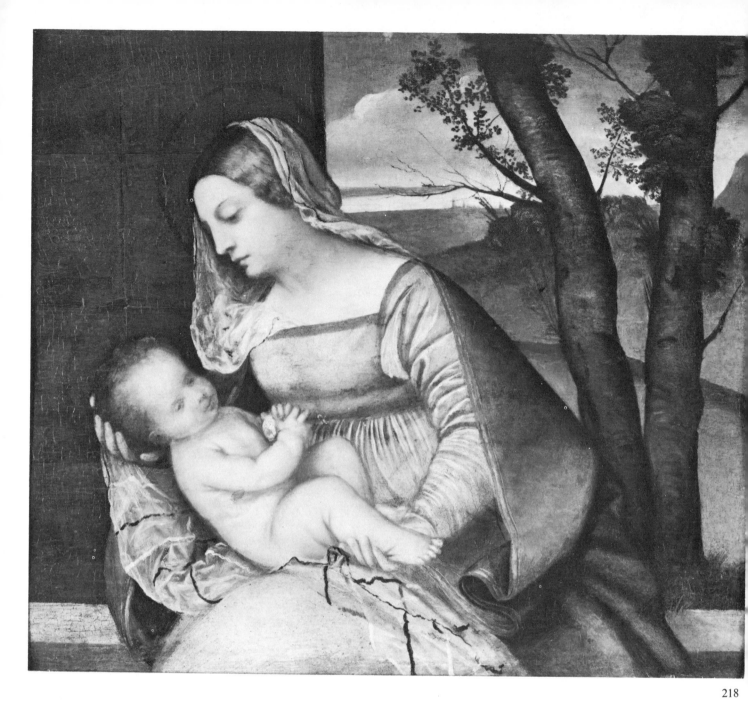

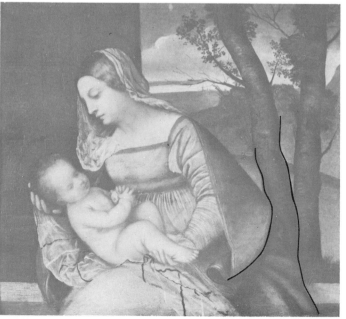

FIGURE 218 Titian (*Venetian, c.1477–1576*), Madonna and Child, *18″ x 22″, oil on wood, The Metropolitan Museum of Art, New York. In this painting, the interlocking is more pronounced. Note how the left tree is interlocked with the Madonna's robe at the lower right. At one moment, tree and robe are seen together as one plane. Then, at another moment, the Madonna's robe overlaps the tree in three-dimensional depth.*

FIGURE 219 *Schematic diagram showing interlocking of tree and robe as one plane,* in Titian's Madonna and Child *(Fig. 218).*

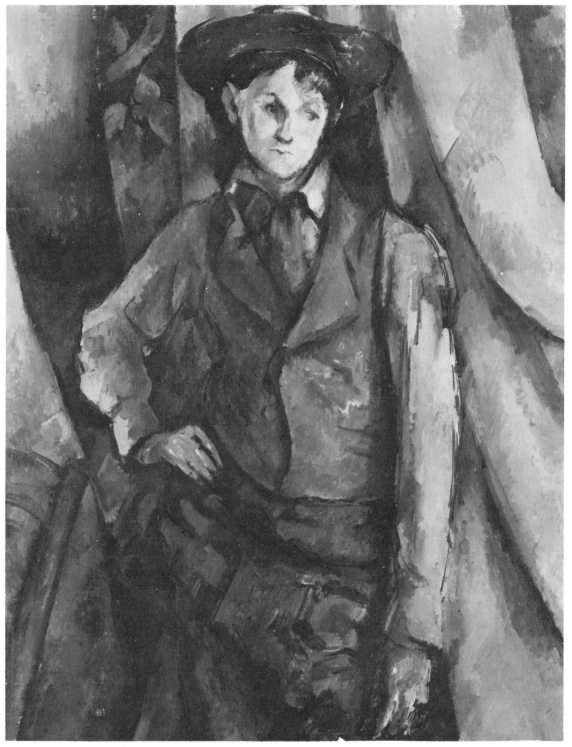

220

221

FIGURE 220 *Paul Cézanne (French, 1839–1906), Boy in Red Waistcoat, 36" x 29", oil on canvas, Collection of Mr. and Mrs. Paul Mellon, Washington, D.C. In this painting, we can see how the modern artist utilized the principle of interlocking. Fig. 221 diagrams the interlocking of the background drape and the boy's trousers on one plane. The principle of interlocking is an important means of unifying a painting into an organic whole, providing continuous movement in space, creating in-and-out spatial tension by uniting near and far planes, which are actually separated in space.*

FIGURE 221 *Schematic diagram showing interlocking of background drape and boy's trousers.*

In making changes don't be afraid to let yourself go with variety of line. The results are visual proof that you've been expressing yourself with vitality. Amateurs, even those doing fairly good work, are generally too timid in expressing themselves. Once your subconscious has revealed the area to be improved, you've nothing to lose by approaching it with vigor. This has nothing to do with whether you approach your work with delicate sensitivity or with dynamic fury. In either case, the result must show the stamp of complete involvement—the inner fire of your whole personality.

How should you apply Cézanne's approach to color? Don't try to follow it literally. You don't need to change color with every brush stroke. But the principle of color to color relationship is essential if you wish your painting to look fresh and alive. Look at the example of a Mughal Indian painting of the early seventeenth century (Color Plate 29). Note how the colors are clearly defined and sensitively related to neighboring colors.

To grasp what I mean, study the way the great modern masters used color. To choose a few, Matisse, Braque, Bonnard, Rouault, Van Gogh, Gauguin, Modigliani, Soutine, Klee, and Picasso. Each was greatly influenced by Cézanne, yet each approached color in his own way. Rouault was influenced by the individual colors of stained glass windows in cathedrals. Matisse and others were affected by the colors in Islamic and Japanese paintings.

If you've applied the instructions on color, there's one other check. To make sure that you haven't overlooked anything, begin to scan your painting through a "keyhole." Make a circle by closing thumb and forefinger. Start at any corner of the painting and look slowly at every part of the painting; you're searching for areas of color to color relationship that may need improvement.

You may find that, in the heat of applying a color texturally, you don't pay enough attention to color relationships. Look particularly at the area where two or three colors meet. By looking at them through the keyhole, you isolate color to color relationships, once again, to make absolutely sure that you can't improve them. If you *do* find areas which need improving (and they'll usually be small ones), change them, but be careful to keep the same value relationships (and other relationships) constant.

Heightening your awareness

There's one more thing you can do. Try to understand and apply Cézanne's attitude toward nature.

Amateurs have the habit of looking at an orange or an apple in terms of how to paint it. When they look at an apple, for example, they see the contour of a circle. They concentrate on the question of painting it in three dimensions by grading values from light to dark. That way, they arrive at the illusion of a sphere. Then they go on to solve some other technical problem.

But before Cézanne painted, he studied the objects of a still life before him at great length. He saw napkins, bunched up, as having space inside. He felt the roominess of space. Apples or oranges had bulk. When he painted an orange, he saw it as having volume all the way through to the other side. He just didn't assume this. He felt it. He felt it occupying space. He felt it surrounded by space. He felt the downward pressure of gravity. He felt the weight of it, its strength and solidity.

These things you, too, can do. You can intensify your feeling for the subject you paint. How? By heightening your awareness of things usually taken for granted. You can't *see* the air around you, but try breathing where there's no oxygen and you'll *feel* it quickly. You can't walk or perform any kind of activity without being subject to the downward pressure of gravity. You can't even stand still without two sets of antagonistic muscles operating against each other to keep the body in equilibrium, against gravity. You can't *see* these forces, but they're there.

If so, give yourself a chance to *feel* them. *Feel* the weight of things, the strength of things. If you're drawing mountains, feel the resistance of the hard rock. If a mountain isn't handy, try to push the walls in your room. We don't walk on air; *feel* the solidity of the ground under your foot. If you're painting the sea, *feel* its vastness, its force. Remember how you bucked the surf when bathing. Think of the vast, living world in the ocean underneath.

Don't take nature for granted. Look at everything with fresh eyes. Become personally involved. Permit yourself to be stirred up. Then proceed to spread your emotions, to encompass *all* space in a painting, not only the focal point of your interest. Like Cézanne, aim for sensitively proportioned intervals of space between objects, to permit rhythmic relationships to move freely in your drawings and paintings.

18
Reinforce your creative development

WITH THE END OF THE BOOK in sight, I'm sure you realize that I've merely opened the door to creative painting. A vast amount of knowledge and experience awaits you. In this last chapter, I'm going to suggest ways to reinforce ycur creative development.

Many levels of creativity and originality

You probably suspect that there are many levels of creativity and originality. And, what's more, there are many degrees of quality in art. To explore all these would require another book at least. But you don't have to wait for it. When you've accepted the basic concepts of creativity presented in this book, and you've mastered the disciplines I've outlined, you'll be ready for the next upward step in creative development. You don't have to be a genius to explore new avenues boldly. You can, of course, learn from the giants of art . . .

For example, Braque and Picasso were strongly influenced by Cézanne's work and they explored ways of going beyond his discoveries. They produced what was later called Cubism: seeing an object in overlapping (and sometimes transparent) planes, from all sides simultaneously. Earlier, in his Blue Period, Picasso was influenced by seeing the hungry and the downtrodden. He moved through many periods, such as his Classical Period, influenced by ancient Greek art. But his strongest influence, which still appears in his late work, comes from the impact of African sculpture.

The stained glass windows in cathedrals had their influence on Rouault. The inner dream world was used by the Surrealist painters (like Dali and Magritte) to juxtapose objects in incongruous relattionships. In the world of fantasy, Paul Klee used line and color in a poetic and lyrical way. The fascination of space inspired Mondrian to eliminate subject matter altogether. Both he and Kandinsky explored different roads to non-objective art.

Such were some of the influences that opened new vistas and led artists to reach higher degrees of originality and quality. What significance does all this have for you? If a new idea comes to mind, no matter how ridiculous it may sound, try it. Don't try to *reason* out new ideas. I mean, don't say, "Now, I'm going to try to think of a new idea." If you approach the job this way, the chances are that your ideas will be superficial. Instead, allow *your whole being* to be receptive to new influences.

Why our creative mood changes

You may not be concerned with the next higher step,

at least not yet. Quite the contrary, you may still be struggling with a more immediate and fundamental problem. You may say, "I don't have the same drive or ambition I had two weeks ago. I suppose I haven't got what it takes. I've run out of ideas. I'm afraid I'm no good and I'll never amount to anything."

Of course, spouting negatives is destructive. Such statements are usually pure nonsense. What you really need to know is *why* a creative mood cannot be sustained; why a mood changes and what you can do about it.

In creative work, there's a period of intake and a period of outgo. You needn't worry if, suddenly, you're listless or can't produce ideas. Your body is like a battery. It needs recharging. Just as we need sleep to renew ourselves, we need periodic rest from art. Creating isn't based on a lucky chance. After periods of rest, short or long, we come back stronger than ever. Contrary to common belief, once you've established certain creative habits, nothing much is lost during the break.

If you've done something good once, you can do it again. Yes, even better. It's a matter of *recognizing* that your mood is low and keeping busy during the non-creative period. Will you have sense enough to *know* that you're in a non-creative mood? You'll have no trouble on that score; you'll probably feel depressed, exhausted, weary, listless. Don't fight it. Let down as best you can and turn your attention to some form of routine work. Put a bureau drawer in order, for example. The idea is to *organize* something, whether it's your tools, private papers, books, or the attic.

Every professional artist has these non-creative periods. The best advice I can give you is to be prepared for them in advance.

We can never tell beforehand what will stir us up to create. I've found it useful to keep a list of experiences which recall some strong emotional feelings. These may come from events in childhood, for example: places visited in travels, books read, or plays seen. If you make such a list and find that it has stimulated you, test yourself by trying to create. If you have difficulty and find yourself tense, take a longer period away from creativity. Here are a few suggestions that may lift you out of the doldrums.

Your art reference library

This may be a good time for you to read about art. Most good public libraries will have a variety of art books. Or, if you wish, build up your own art library. Here are a number of books well worth including.

Painting and Painters, Lionello Venturi, Scribner,

New York. Developing artistic sensibility is a lifetime job of looking at pictures. This book will help.

Discovery of Painting, René Berger, Viking Press, New York. This book will also help to develop artistic sensibility. It's a more recent and more elaborate book. It will require deeper concentration and reflection to get the most out of it.

Art Has Many Faces, Katherine Kuh, Harper and Row, New York. *Laymen's Guide to Modern Art,* Rathbun and Hayes, Oxford University Press, New York. Both books have been written simply. They are packed with visual examples that help to remove some of the baffling confusions of modern art.

The Mind and Work of Paul Klee, Werner Haftmann, Faber and Faber, London. This book helps to reveal the creative process by which a highly sensitive artist makes his inner world clearly visible in his art.

Cézanne's Composition, Erle Loran, University of California Press, Berkeley, California. The many diagrams of overlapping planes help to analyze Cézanne's paintings. Photographs of motifs—the actual landscapes he chose as subjects — provide insight into Cézanne's way of distorting nature to create sensitive spatial relationships.

The Challenge of Modern Art, Allen Leepa, A. S. Barnes, New York. This is a more advanced book to show how the artist struggles to organize his deepest feelings to create meaningful art.

How Paintings Happen, Ray Bethers, Norton, New York. By juxtaposing photographs of the actual scene with the artist's painting of the scene, this book helps the reader to understand that art is interpretation, not a copy of nature.

Art Through the Ages, Helen Gardner, Harcourt, Brace and World, New York. This book gives a world panorama and history of art.

The Story of Modern Art, Sheldon Cheney, Viking Press, New York. This book gives a narrative account of the development of modern art to the mid-twentieth century.

Sight and Insight, Richard Guggenheimer, Harper and Row, New York. *Art and Experience,* John Dewey, Putnam, New York. These are two good books on the philosophy of art.

The Materials of the Artist, Max Doerner, Harcourt, Brace and World, New York. *The Artist's Handbook,* Ralph Mayer, Viking Press, New York. These provide technical information on pigments, binding media, etc. Doerner also describes the techniques of the old masters.

Short art courses to develop skills

If you've made good progress in developing the cre-

ative habit, you may consider, during a non-creative period, taking up a short art course. If you've had a nagging urge in the back of your mind to take a course to develop skill in some detail of art, this is the time to do it.

It may come as a surprise that I suggest such action. It really shouldn't. Nothing that I've advocated in this book denies the need for skill and craftsmanship. There's a time for everything. You can develop your skill in small or large doses.

Whatever *craftsmanship* you've developed as a result of the program in this book has come in small doses. First, you've concentrated on learning by wholes. You developed skill only after you'd adjusted all rhythmic relationships as a whole; skill came as a last step when you personalized your drawing or painting at the end. At this final stage, you worked to improve some small part which disturbed you psychologically. If the handle of a jug or the ear of a cup didn't look right to you in your drawing, you looked up a model to study it. You then made your correction, being sure not to disturb the relationships as a whole.

In taking a typical art course, you must take into consideration that you'll probably concentrate completely on developing skill and craftsmanship. You'll be studying *parts* in great detail. There will be very little opportunity to consider relationships as a whole, because the very nature of the training and discipline requires complete concentration on details to master them. *You,* therefore, must judge whether you're ready to do this. Are you sufficiently grounded in creative procedures to accept the *risk* of concentrating on a large dose of detailed study, focusing on a narrow area of artistic skill? Take the short, routine art course *if* you feel confident that it won't set back your creative ability.

How can you judge whether you're well grounded? Unless you're firmly grounded in the concept of the Eskimo artists, I'd say you're not ready. When they carve ivory, they don't begin by deciding what they're going to do. They start by wondering what's inside the ivory. As they carve, they gradually find it. ("It was there, waiting for discovery and release," says Arthur Calder-Marshall in his book, *The Innocent Eye.*) Are *you* able to draw or paint freely, intuitively, without fixed purpose? If you've achieved this freedom, then you're ready for the discipline of academic art training.

Visit an art museum

One way of anticipating the problem of low ebb is to go regularly to an art museum. Because masterpieces can be studied again and again, they become an infinite source of inspiration. Avoid museum fatigue, however. Walk through a museum as if it were a beautiful garden; a look here, a look there, and only on occasion, a leisurely stop to concentrate on the particular. Approach a given painting, not tensely, not determined to wrest everything at once, but in a spirit of quiet repose and reflection, allowing art to unfold its secrets.

Keep a check list with you to refresh your memory on what to look for. Quietly enjoy the painting's emotional message first. Then look for the main shape motifs and submotifs; the rhythmic relations; the great variety of noble shapes; texture; sensitivity of line; the color relationships; the contrasting values of light and dark; the warm and cool relations; the small area of intense color against the large areas of muted tones. Observe how the artist directs your attention, in many instances, through the movement of arrows in and around the painting; how the negative spaces relate to each other; the varied forms and movement (in the third dimension) within the stage; the interlocking relationships; the combining of two and three tension planes; the distortion for emphasis; the small shapes against the large ones. Feel the air around objects, their weight, the force of gravity, the solidity of ground underfoot.

Use the blocking-out test. Study small patches or small areas of color by cupping your thumb and forefinger to make a peephole. When you've finished looking at the picture as a whole, use a magnifying glass to observe textural details.

In one museum visit, don't attempt to study more than one or two paintings in detail; otherwise you'll tire quickly. Let it be fun and not a strain.

Note that not all paintings are rectangular in shape. Some are oval; others, designed for special decorative purposes, have unusual shapes. Notice how the check list points were handled by the artist to accommodate the unusual shapes.

Study art books

If you live far from an art museum, I suggest that you analyze illustrations of paintings in art books; all kinds, modern as well as old masters. Naturally, the originals will evoke reactions which book illustrations can hardly hope to duplicate. Yet, sitting comfortably in a chair with an art book in your lap, has certain compensations. You can study the illustrations at your ease. You can turn the book in all directions to analyze the pictures for geometric shape-motifs. Checking for light and dark value relationships is simpler because the illustration is smaller than the orig-

inal painting; the whole can easily be seen at a glance.

Directly after a visit to a museum, or after a look at an art book containing exciting illustrations, observe how objects around you suddenly look different. The commonplace becomes vivid and fresh. You see forms and colors around you which you've never seen before. Such exciting impressions may well start the creative juices flowing again. And when they do, you'll feel in complete harmony with the universe once more.

In conclusion

I suggest that you start to reread the book. Try it once again. Find out what you may have overlooked. A second reading will reveal how far you've come in accepting new concepts. With a healthy mental attitude, you'll find a way to solve new creative problems as they arise.

Finally, a word about Pop Art, Op Art, or new forms of art you cannot understand. Don't concern yourself too much with them. It's always taken years to properly evaluate anything new. You've enough to do for the present, just solving your own problems. The important point is that all artists have the right to experiment, to attempt to go beyond themselves to create in new ways. Out of such ferment, really great new forms of artistic expression eventually appear.

Index

Edited by Donald Holden
Designed by James Craig
Composed in ten point Times Roman by Cooper & Cohen, Inc.
Printed and Bound by The Haddon Craftsmen, Inc.